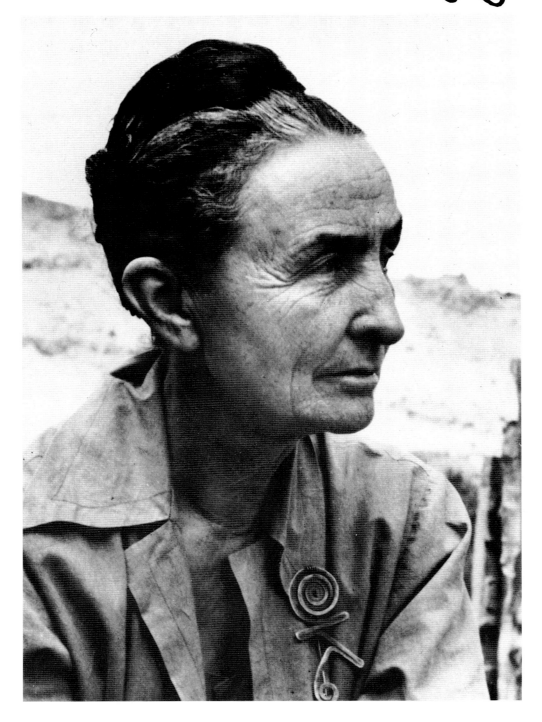

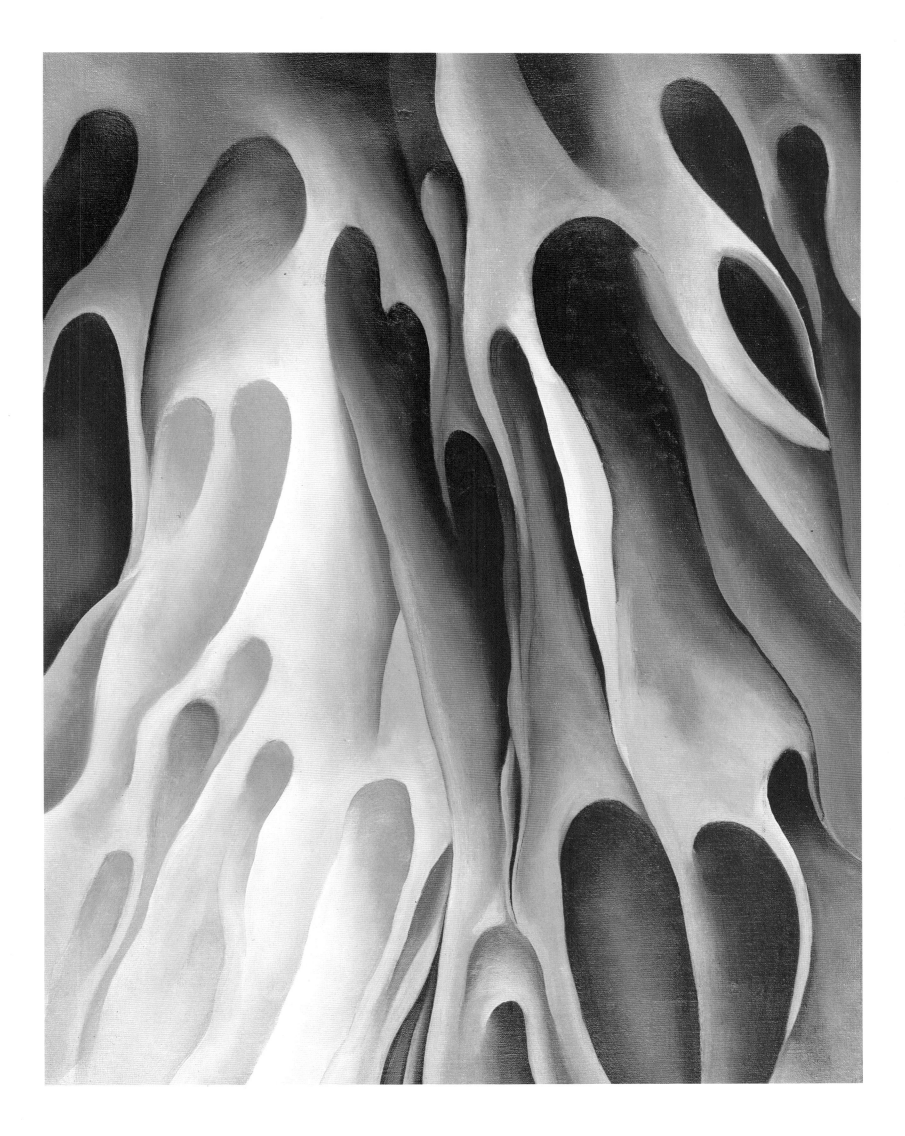

Georgia O'Keeffe

MARIA COSTANTINO

SMITHMARK

This edition published in 1994
by SMITHMARK Publishers Inc.,
16 East 32nd Street,
New York, New York 10016

SMITHMARK books are available for bulk purchase for sales promotion and premium use. For details write or telephone the Manager of Special Sales, SMITHMARK Publishers Inc., 16 East 32nd Street, New York, NY 10016. (212) 532-6600.

Produced by Brompton Books Corp.,
15 Sherwood Place,
Greenwich, CT 06830

ISBN 0-8317-5156-8

Printed in China

10 9 8 7 6 5 4 3 2 1

Page 1: Georgia O'Keeffe in 1962.

Page 2: Red and Pink 1925
Oil on canvas, 16×12 inches
Private collection

Pages 4-5: New York East River 1928
Oil on canvas, 12×32 inches
Alfred Stieglitz Collection, Bequest of Georgia O'Keeffe, 1986, (1987.377.3), The Metropolitan Museum of Art, New York, NY

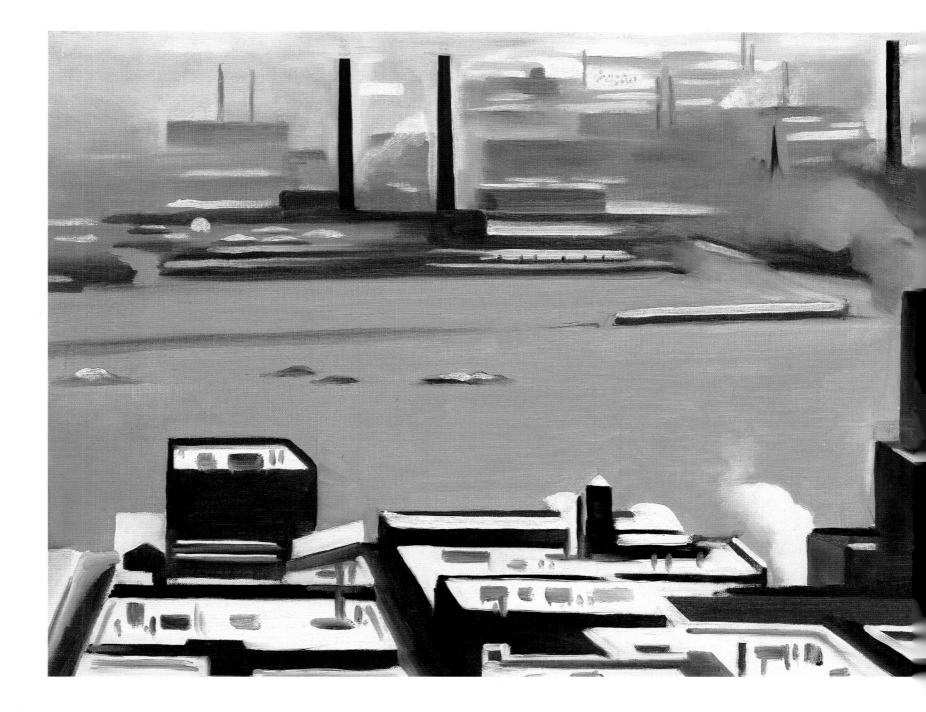

CONTENTS

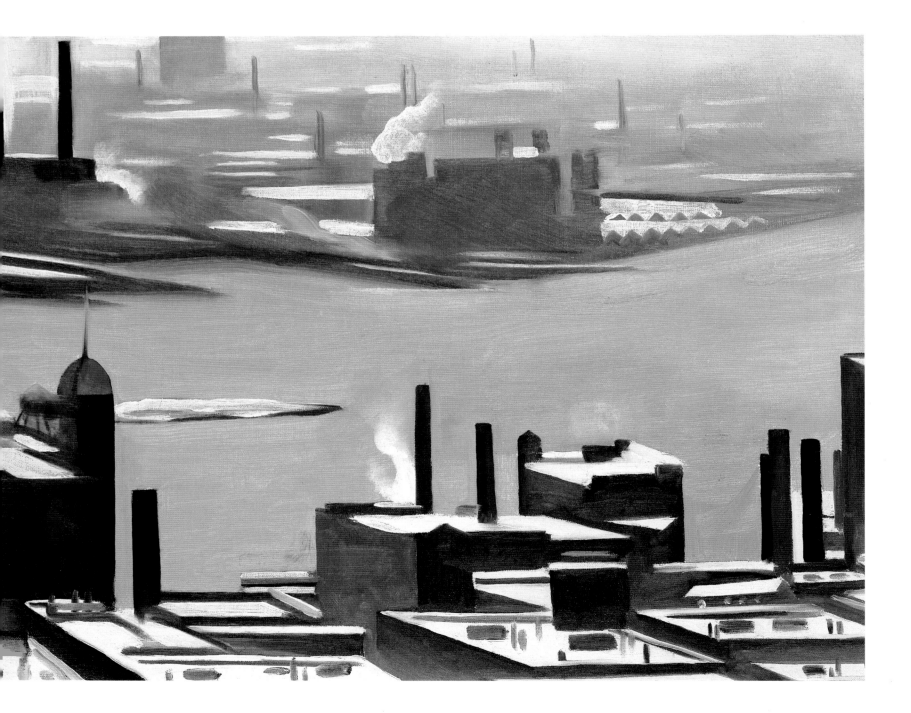

INTRODUCTION

Acknowledged as one of the leading American painters of the twentieth century, Georgia O'Keeffe was also a prolific artist, producing more than 900 works during a career which began in earnest in the 1910s and was to continue into the late 1970s. The paintings for which O'Keeffe is best known – the flowers, the bones and the desert landscapes of the American Southwest – in fact characterize the works she completed only from the mid-1920s to the 1940s. In the early years of her career, her close personal and professional relationship with the photographer Alfred Stieglitz brought O'Keeffe into contact with European modernism but, throughout her life, O'Keeffe would maintain a fierce independence which would distance her work from associations with any particular artistic movement. This independence was further strengthened by her near-total physical isolation when she moved to New Mexico in the late 1940s, and also by her repeated refusal to exhibit in group shows that might have linked her work with a specific artistic group or movement, or even in shows that were arranged to acknowledge women artists' contribution to the arts. O'Keeffe was constantly stating that she was **not** a woman artist: she was an **artist**.

Born on 15 November 1887 in Sun Prairie, Wisconsin, the first daughter and second child to be born to Ida and Francis O'Keeffe was named Georgia Totto O'Keeffe in honor of her Hungarian grandfather George Totto. While the world outside the O'Keeffes' farmhouse was rapidly industrializing – particularly in the eastern United States and in Europe – in the more rural southwestern parts of America, the country had yet to be tamed. In fact, U.S. federal troops had still to engage in the last great Indian war. In Sun Prairie, farm life continued just as in the days when the O'Keeffe forebears first began homesteading there in 1848, just a couple of months after Wisconsin formally entered the Union as a state, and Georgia's grandparents Pierce and Catherine O'Keeffe emigrated from Ireland following the

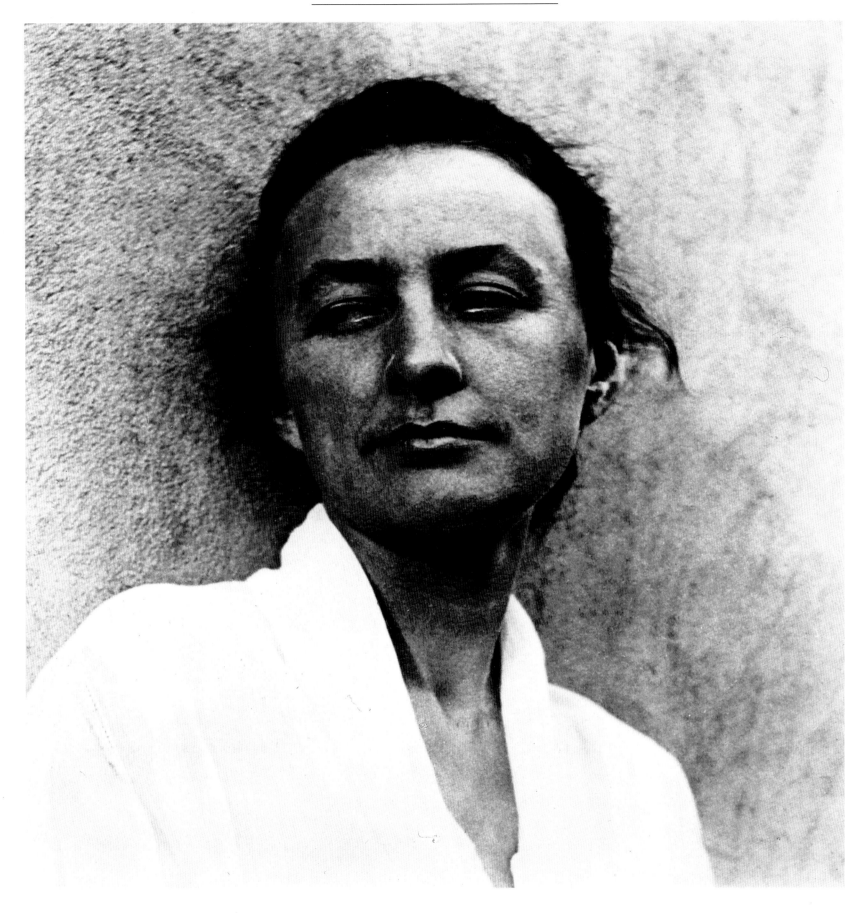

Left: Sun Prairie in Wisconsin. This house – since destroyed – was believed to have been O'Keeffe's birthplace.

Above: Georgia O'Keeffe *c.* 1930 Paul Strand, photo, gelatin silver print, 7⅞ × 7¹⁄₁₆ inches *National Portrait Gallery, Smithsonian Institution, Washington, D.C.*

collapse of their wool business. Traveling via the Great Lakes, the family arrived in Wisconsin where, for less than a dollar an acre, Pierce O'Keeffe bought his first tract of land alongside the Kushkanong River. Four sons were born to the couple: Boniface, Peter, Francis (Georgia's father) and Bernard. Around 10 years after the O'Keeffes settled in Sun Prairie, George Victor

Totto and his wife bought land adjoining the O'Keeffe farm. Reputedly a count from Budapest, George Totto had fled to America after the failed Hungarian uprising against Austrian rule in 1848. Totto's wife Isabel, on the other hand, could trace her ancestry back to a Dutchman who had arrived in New York in 1637. In the 1870s George Totto abandoned his family and returned to Hungary, leaving his wife and six children to fend for themselves. In the early 1880s Isabel Totto moved her family to Madison, where she no doubt hoped for a brighter future for herself and her children.

Georgia's father Francis was aged around 30 when he seriously began his courtship of the fourth Totto child, Ida. The Totto family was in favor of the match, in part because Francis also wanted to buy the Totto land in Sun Prairie that had been left idle since George Totto left for Hungary. Ida, however, seemed to have little enthusiasm for the marriage or, indeed, the prospect of returning to her childhood home, which was still a simple farming community far removed from the cosmopolitan university town of Madison to which she had become accustomed. Nevertheless, a few months after Ida had turned 20, the couple were married, and within six months Ida was pregnant. For the next eight years, the young woman who loved to read, and who had wanted to become a doctor, was either pregnant or nursing a child.

Only the births of the first two O'Keeffe children, Francis and Georgia, were entered in the public records, but there were more: a few months after Georgia's second birthday, Ida was born; 16 months later came Anita; and the following year, another brother, Alexis. With her enthusiasm for books, and her determination to educate all her children, her mother, Georgia remembered, would regularly read aloud to her children. Since Francis was the eldest, many of the stories chosen were from boys' books: stories about pioneers, or cowboys and Indians, which were usually set in Texas or in the territory of New Mexico, ironically, both areas in which Georgia would later live and work.

Although she later admitted that she had received all the attention that any child needed, at an early age O'Keeffe was convinced that she was not a "favorite" child. Not close to her elder brother, and believing herself to be too grown up to play with her young sisters, O'Keeffe recalled in her autobiography *Georgia O'Keeffe* that she was happiest on her own, a trait that would later develop into a fierce independence. Because O'Keeffe spent much of her time alone, her parents were unaware that she possessed any artistic talent – in fact, the family believed that, if anyone, it was the young Ida who had that talent. In later years, Ida's own paintings and her description of herself as an artist would become a source of tension between the O'Keeffe sisters. Nevertheless, when Georgia was 12 years old, her mother arranged for private art lessons for her daughters, and painting began to fill O'Keeffe's need for privacy and individual freedom.

While O'Keeffe was growing into her teenage years, her large extended family began to decline: both her grandmothers had died, and tuberculosis had killed three of her paternal uncles. O'Keeffe's father became obsessed with the belief that T.B. would kill him as well. During the particularly harsh winter of 1898-99, when the mercury dropped to -30°C and when, without snow cover, the frost was four-and-a-half feet deep, the well iced over and the family's food supplies were freezing, Francis O'Keeffe decided to sell the farm and move to a milder climate. His wife, Ida, now close on 40 years old, who had always been restless on the farm and had recently given birth to another daughter, Claudia, was highly agreeable to the move, and was delighted with the prospect of settling in Williamsburg, Virginia, a small but cultured collegiate town, the home of the long-established College of William and Mary.

Below left: Portrait of Claudia
1905
Oil on canvas, 12×10 inches
Bequest of Claudia O'Keeffe, 1987, Museum of Fine Arts, Museum of New Mexico, Santa Fe, NM

Below right: My Auntie 1905
Ink on paper, 5½×5 inches
Bequest of Claudia O'Keeffe, 1987, Museum of Fine Arts, Museum of New Mexico, Santa Fe, NM

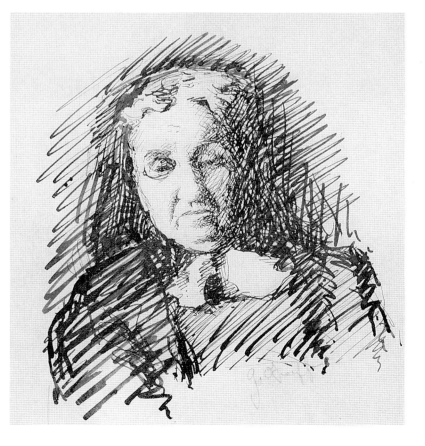

In the fall of 1901, a few months before O'Keeffe turned 14, she was sent to the Sacred Heart Academy, an exclusive convent boarding school on the outskirts of Madison. On top of the tuition fees of $80 a year, O'Keeffe's family paid an extra $20 for art tuition. The following fall, in 1902, O'Keeffe was taken away from the school – for reasons unknown – and her younger sisters Anita and Ida were enrolled instead. While her parents, her brother Alex, and younger sister Claudia left for Virginia to get themselves settled into their new white clapboard house, O'Keeffe and her brother Francis were sent to live with a Totto aunt, Lola, and were enrolled at Madison High School. According to O'Keeffe's memoirs, it was here that her art teacher displayed a jack-in-the-pulpit plant for the students to study, and where, for the first time, she was to paint a living thing rather than copy pictures or draw from plaster casts. Twenty-five years later, O'Keeffe would return to the subject of the jack-in-the-pulpit in a series of oil paintings.

When school finished in 1903, the two O'Keeffes left Wisconsin to join the rest of their family in "Wheatlands," the new Williamsburg home. In the fall Francis was enrolled in the College of William and Mary, and a tutor was hired for the younger children. Georgia O'Keeffe, however, was sent as a boarder to the Chatham Episcopal Institute, some 200 miles away.

It was at Chatham that O'Keeffe's artistic talent was noticed and encouraged by her teacher and school principal, Elizabeth May Willis. At the end of her senior year O'Keeffe was awarded a special diploma in art, as well as the school's art prize for her watercolor of red and yellow corn. O'Keeffe, however, was far from the model student. While she did play basketball for the team, was made treasurer of the tennis club, and was among the handful of elite girls initiated into the Kappa Delta sorority, her independent, impulsive streak often caused O'Keeffe to be bored; after teaching a school friend how to play, she illicitly kept a poker game running!

In June 1905 O'Keeffe graduated from high school, but only after she had retaken the spelling test several times before passing; she complained later in life that her poor spelling had been a constant source of irritation to her. Both O'Keeffe's art teacher and her mother wanted her to continue to develop her artistic talent, but it was still regarded as very advanced for a girl to study in the higher art schools, the main reason being that it was not considered proper for young ladies to draw the nude body. Mrs. Willis, who had studied at art school herself, seems to have been able to dispel any doubts that O'Keeffe's mother may have had regarding the propriety of art schools, and consequently, in September 1905, O'Keeffe was enrolled at the school of the Art Institute of Chicago, one of America's leading and largest art museums. It was agreed that O'Keeffe would live with her uncle, Charles Totto, and his wife Alletta (known as Aunt Ollie), whose apartment was within walking distance of the school.

"I have never understood why we had such dark olive-green rooms for art schools," O'Keeffe would later recall about her year at the Institute, which was immensely proud of its collection of European paintings housed in a Renaissance-style building, the steps of which were flanked by magnificent bronze lions. In addition to encouraging its students to study in Paris, considered the artistic capital of the world, the Institute also adopted the competitive French teaching system whereby students' work was ranked by number each month, according to merit. Those students who gained the highest marks won the right to the best seats in the studio for the next drawing pose, and were quickly promoted.

O'Keeffe was assigned to an elementary drawing class led by John Vanderpoel, which often took place in the main gallery of the Institute, and where students would sketch the statuary. At the end of the first month O'Keeffe was surprised to learn that she was ranked fourth out of 44 students, upon which she was moved to an intermediate class. Again, she competed well: she ranked fifth in December, seventh in January, and then first in her class in February. In the meantime, in preparation for the advanced class, O'Keeffe registered for an anatomy class. As she would later recall, she blushed hotly at the sight of the male model, nude except for a skimpy loincloth, who posed for the students while the instructor pointed out details of his anatomy. Although she did eventually become used to the experience and overcame her initial embarrassment, O'Keeffe would never develop an interest in painting the human body, whether male or female.

After classes finished in June, O'Keeffe left Chicago and headed home to Virginia. Her father had once believed that he had moved his family to a healthier climate, but malaria, smallpox and other diseases flourished in the warm, wet climate of Williamsburg. In the summer, O'Keeffe was struck down by the dreaded typhoid fever. Only at the end of September 1906 was she out of danger, and though she had survived the fever, the illness had taken its toll: her long hair had fallen out, and she was forced to wear a lace cap to conceal her baldness. She was also too weak to return to art school in Chicago, and spent the next year at home with her family during which, because of setbacks in his business, O'Keeffe's father was planning to put Wheatlands up for sale. Money was tight, and in the spring of 1907 a letter of recommendation from the Art Institute of Chicago to O'Keeffe read in part: "Miss O'Keeffe is a young lady of attractive personality and I feel that she will be very successful as a teacher of drawing." This suggests that O'Keeffe may have been preparing for a teaching job in order to earn a living. Nevertheless, in September 1907, O'Keeffe boarded a train heading east to New York to study at the Art Students' League on West 57th Street, where her early mentor, Elizabeth May Willis had also studied.

At the League O'Keeffe took portrait and still-life classes under William Merritt Chase. A successful painter in his own right, Chase was also attempting to establish art as an "honorable" profession in America, in order to make American art less provincial, and to teach what he thought were the best of the European methods and generally to encourage a spirit of innovation, originality and progress.

Chase's teaching method required that his students create a new painting each day, one on top of the other on the same canvas until it was too overloaded with paint to continue. This, Chase believed, encouraged the individuality and the swift, bold approach that he so much admired in the work of his friend, the society portraitist John Singer Sargent. Chase's own best-known paintings are light-filled studies of women against landscaped backgrounds, often painted at his artists' colony at Shinnecock Hills, but his reputation in Europe was, in fact, secured by his paintings of still lifes. Chase's influence on O'Keeffe is evident in her early painting *Rabbit and Copper Pot* (1907), which won her the Chase Scholarship and the opportunity to study at the League's summer school at Lake George in upstate New York.

Speicher also taunted her with words she would never forget: "It doesn't matter what you do," he said, "I'm going to be a great painter and you will probably end up teaching painting in some girls' school." O'Keeffe further remembered that she only agreed to model for Speicher after she saw that the model arranged for her life class was rather unattractive! Ironically, although O'Keeffe would indeed spend time teaching in a girls' school, not all of Speicher's prophecy came true: while he certainly did achieve renown, O'Keeffe would become more famous than him.

Left: An outdoor sketch class of students at the Art Institute of Chicago, pictured in 1918, 12 years after O'Keeffe had studied there.

Below: William Merritt Chase, O'Keeffe's tutor at the Art Students' League, posing in front of a still life and a portrait - both genres for which he was famous.

O'Keeffe was often asked to pose for her fellow students in the portrait class. Although she could earn a dollar for a four-hour pose, she frequently refused because she would have to miss one of her own classes. O'Keeffe did agree on one occasion to sit for Eugene Speicher after he had blocked her entrance into the women's life class and had teased her by saying that she could not pass until she sat for him. O'Keeffe recalled that

Speicher's finished portrait of O'Keeffe shows an unsmiling girl looking directly at the viewer and dressed in what would become her trademark black and white. The portrait won Speicher a $50 prize and his first formal recognition as a portrait painter. Published the following year in the League's catalog of student works, this portrait of Georgia O'Keeffe hangs today in the members' room at the League.

During the winter which O'Keeffe spent at the League, she and her fellow students heard many stories about the controversial drawings by the French sculptor Auguste Rodin that were on display in a small gallery run by the photographer Alfred Stieglitz. Born in Hoboken, New Jersey, Stieglitz had studied photography in Berlin in the 1880s, and had achieved such technical photographic feats as the first photographs taken in the rain, during a snowstorm, and at night. On his return to America, Stieglitz battled to elevate photography from the level of a craft to that of an art form in its own right. Following his expulsion at the turn of the century from a group of rather more conventional photographers, Stieglitz opened The Little Galleries of the Photo-Secession at 291 Fifth Avenue in New York, in order to exhibit the works he preferred. The Rodin drawings marked the beginning of Stieglitz's shows of avant-garde art which his friends like Edward Steichen sent him from Europe, and which had never before been exhibited in America.

O'Keeffe and a group of student friends decided to visit "291." When they arrived, some students deliberately asked provocative questions in order to hear Stieglitz unleash one of his famous passionate speeches in defense of avant-garde art. O'Keeffe recalled, however, that she was intimidated by Stieglitz, and consequently withdrew from the group and waited alone in a corner of the gallery. Furthermore, she remarked that she had been unimpressed by the Rodin drawings.

When O'Keeffe returned home to Williamsburg at the end of the summer in 1908, it soon became evident to her that her father's business affairs were in a worse shape than she had expected. It also became apparent that her family could not afford for her to return to the Art Students' League for another year. In later years O'Keeffe would proudly state that it was she who opted not to return to New York, because she was rejecting the use of realism for its own sake, and also disliked the idea of following other artists' styles: "Rather than spend my life on imitations, I would rather not paint at all," she later told Ernest Watson in a 1934 interview for *American Artist*.

Two days before her twenty-first birthday, in November 1908, O'Keeffe left Williamsburg, this time for Chicago, to live with her Totto relatives and to look for a job. In Chicago she found work as a commercial artist in the then youthful advertising industry, mainly drawing lace and embroidery for dress advertisements. Since most of the advertisements were for

Left: William Merritt Chase pictured alfresco with his students at Shinnecock Hills, c.1901. By this time expert opinion considered Chase one of the country's leading painters.

Right: Eugene Speicher, a contemporary of O'Keeffe's at the Art Students' League, captured on film while hard at work. Speicher lived to rue his prophesy that O'Keeffe would "probably end up teaching painting in some girls' school" (although, in fact, she did just that for a while).

daily newspapers, illustrators who could work quickly were in great demand, and O'Keeffe's training in Chase's painting classes no doubt stood her in good stead. Despite her evident skills, O'Keeffe was unhappy with this work and, two years later, contracted measles which temporarily affected her eyesight, forcing her to give up the detailed illustration work that she anyhow disliked. Around 1910, O'Keeffe arrived back in Williamsburg where her mother was ill with T.B. and the family fortunes were declining even further. Things appeared desperate, but O'Keeffe's Chatham teacher came to the rescue: in the spring of 1911, Elizabeth May Willis took leave of absence from work for a few weeks, and asked O'Keeffe to teach in her place.

In around 1912 the family was reunited in Charlottesville: O'Keeffe's sisters Ida and Anita had been students at the University of Virginia's summer schools for several years, and her mother had been moved to the sanatorium there around 1910;

she now took in student boarders to lodge in her house. In the summer of 1912 O'Keeffe enrolled in a drawing class at the university, taught by Alon Bement. Bement was an associate professor of fine arts at Columbia University's Teachers College in New York where he worked alongside Arthur Wesley Dow. Dow's method of art instruction, unlike that used at most schools, had very little to do with copying nature or the styles of the masters. Instead Dow had devised a series of exercises that allowed even those students who were unable to draw to master the basic principles of design. The exercises included dividing a square, working within a circle, and executing a drawing within a rectangle and then balancing the composition by adding, moving or eliminating elements. Through Dow's books, *Composition* and *The Theory and Practice of Teaching Art*, O'Keeffe became acquainted with the underlying aesthetics in painting and the principles of abstraction. O'Keeffe enrolled in Bement's advanced class for the remainder of the six-week summer session. Bement was impressed by his new student, awarding O'Keeffe the near-perfect final grade of 95. More importantly, he asked her to become one of his teaching assistants the next summer and, in the meantime, offered to help her find schoolteaching work, even though O'Keeffe lacked a degree and (except for the few weeks filling in at Chatham) any prolonged teaching experience.

Left: Alfred Stieglitz 1907
Frank Eugene, from *Camera Work*,
Number 25, 1909,
Photogravure, 6½×4⅜ inches
*The Chrysler Museum, Norfolk,
Museum Purchase 84.73.7*

Below, left and right: These charming studies of O'Keeffe's sisters Ida (right) and Anita (left) were made in 1912. The sisters were also artistically inclined, and both girls studied at the University of Virginia's summer school.

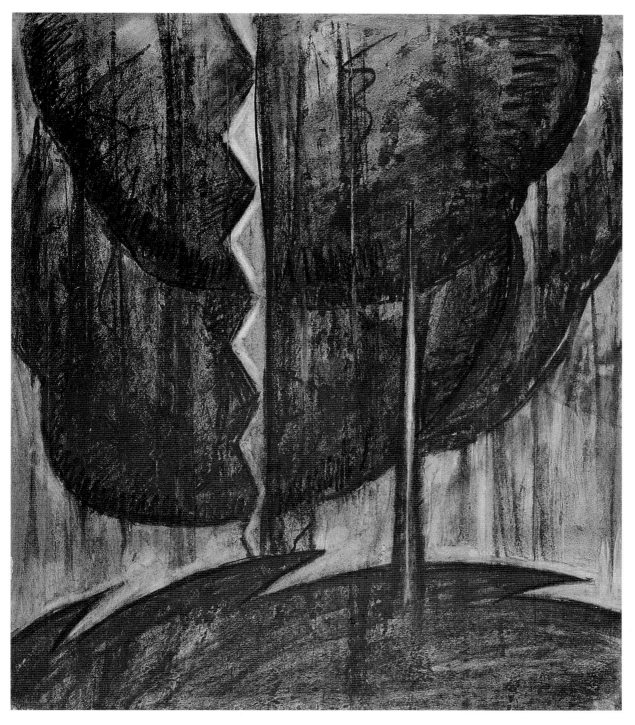

Left: Thunderstorm 1917-20
Arthur G. Dove,
Charcoal on paper, 21×17¾
inches
*The University of Iowa Museum of
Art, Iowa City, IA*

Right: O'Keeffe's great friend and critic, Anita Pollitzer, pictured here in 1934, by which time she was vice chair of the National Women's Party. As well as giving O'Keeffe feedback about her work and being responsible for introducing Stieglitz to O'Keeffe's charcoals, Pollitzer encouraged O'Keeffe's interest in feminism.

A connection with an old Chatham school friend brought O'Keeffe news of a vacancy for a drawing supervisor in Amarillo, Texas, and she jumped at the opportunity. On 15 April 1912, the *Amarillo Daily News* announced that the school's drawing work that year "will be under the supervision of Miss Georgia O'Keeffe, who has the highest degree known to her profession." Bement, it seems, was happy to exaggerate O'Keeffe's credentials. In early August, as soon as the summer school ended, the 25-year-old O'Keeffe headed west for Texas.

Texas was then still cattle country – oil and gas had yet to be pumped – and Amarillo was a rowdy frontier town with a population of around 15,000, made up of a mix of merchants, lawyers, cowhands and saloon girls. At the time, Amarillo boasted more bars than churches and, in addition to gunslingers and cardsharps, Texas also had its fair share of natural dangers, in the shape of tornadoes, dirt storms and prairie fires, as well as a constant wind that drove up the dust unceasingly. Nevertheless, the vast, sparsely populated land, wilder than

the Wisconsin prairies, made O'Keeffe euphoric: "That was my country – terrible winds and a wonderful emptiness."

Her job was also challenging, for much of what Bement had taught was unsuitable for Texan schoolchildren. For example, one of his exercises called for maple leaves to be arranged in a seven-inch square, but most of the very few trees in Amarillo were locusts, with leaves too small to be of use and, instead of fruit or flowers, which were beyond the means of most of the students, all that the children could afford to draw were the pebbles they had found. Nevertheless, O'Keeffe was still anxious to support Dow's methods, and remained opposed to copying from books. She told her students not to spend their money on the expensive books that had been recommended by state educationalists. In the spring of 1913, when the state legislature passed a law requiring the use of the books selected by the state educational commission, O'Keeffe stubbornly refused to comply and, despite a long struggle, by the end of the school year no books had been purchased.

Each year for four summers from 1913 to 1916, O'Keeffe returned to Charlottesville to teach drawing at the university, where one of her students was her sister Anita. When she was not teaching, O'Keeffe took walking and camping trips through the mountains and, in her small basement studio at her family's home, she painted pictures of the hollyhocks that grew in the back garden, and also a watercolor bordering on abstraction, called *Tent Door at Night*.

Through Bement O'Keeffe was introduced to some of the new writings on art, in particular, Wassily Kandinsky's *On the Spiritual in Art*, and Jerome Eddy's *Cubists and Post-Impressionism*, in which O'Keeffe saw her first abstractions by the American painter Arthur Dove. Bement was also constantly encouraging O'Keeffe to study directly with Dow in New York, and although she enjoyed her Texas life, she knew that at some stage she would have to bow to the state over the issue of the textbooks. By the end of the summer of 1914 O'Keeffe had resigned her position in Amarillo and, at nearly 27 years old, headed once again to New York, this time to study at Teachers College at Columbia University.

New York had changed considerably in the seven years since her last stay: new radical newspapers were being published, early feminists like Ida Rauh and Neith Bayce were agitating for votes for women, and artists were experimenting with the abstract art forms that had shaken the American art world to its roots in 1913, when hundreds of European and American such paintings were exhibited at the Armory Show. Fortunately for O'Keeffe (who had not seen the Armory Show), Dow was open-minded and had a greater tolerance for experimentation than many of her former instructors at the League. Dow had, in fact, studied with Gauguin and other Post-Impressionists, and was a great collector of Japanese prints, whose flattened forms he greatly admired. Since O'Keeffe had neither studied abroad nor been subject to many European influences, she became increasingly impressed by Dow. In 1977 O'Keeffe was to say: "Filling a space in a beautiful way – that is what art means to me."

O'Keeffe was much older than many of her classmates at Teachers College but, despite the difference in their ages and in their temperaments, O'Keeffe formed a long-lasting friendship with Anita Pollitzer. Anita was a member of the militant National Women's Party, which marched on Washington, D.C., the day before Woodrow Wilson was inaugurated as President in 1913. Encouraged by her friend, O'Keeffe joined the N.W.P. and continued her membership for 30 years.

O'Keeffe also occasionally visited 291, and went to a show of drawings by Braque and Picasso which was presided over by Stieglitz, whom O'Keeffe found still intimidated her. As in her childhood, O'Keeffe still preferred to keep her distance – particularly with strangers – rarely showing her deepest feelings. Nevertheless, the attraction of 291, and later of Stieglitz himself, made it difficult for O'Keeffe to stay away. On a later visit to the gallery to see a show by the American painter John Marin, Stieglitz seems to have convinced O'Keeffe that it was possible to make a living solely from being an artist.

With only a few weeks left before the start of the summer school in Virginia, and after a stimulating winter in New York, O'Keeffe was both frustrated with her work and becoming increasingly discontented with Dow and Bement's approach. When she began the summer classes she rebelliously told her students to ignore Bement's advice about painting. O'Keeffe had simply outgrown Bement: his suggestions for reading material were no longer required, as she began to search out for herself links with the avant-garde. She now subscribed to the radical Greenwich Village newspaper *The Masses*, edited by Max Eastman, and continued her association with Stieglitz and 291 by subscribing to the quarterly magazine *Camera Work*, and also to the satirical *291*, which lampooned conventional art institutions. O'Keeffe even decided that her friend Anita Pollitzer could give more useful and constructive criticism of her work than Bement, and in the summer of 1915 she began sending Anita examples of her drawings and watercolors.

After summer school ended, O'Keeffe had to find work, and toyed with the idea of returning to New York. However, she was finally offered a position at a teachers' college for women in Columbia, South Carolina. Characteristically aloof from the atmosphere of "southern-belle" femininity – she thought most of her colleagues were "vacuous" – O'Keeffe spent much of her free time outdoors, walking in the foothills of the Appalachians and gradually becoming absorbed in her own painting, for which she found she had plenty of time, yet wrestling with the

question of whether to paint for herself or for others. Revealingly, she wrote to Anita Pollitzer: "I believe I would rather have Stieglitz like something – anything I had done – than anyone else I know of . . ."

In her frustration, and in an attempt to free herself completely of any former influences, O'Keeffe decided to work only in black and white until she had examined all the potentials, and had exhausted all the possibilities, of working in this manner. On 1 January 1916 Anita Pollitzer received a roll of charcoal drawings in the mail from South Carolina. O'Keeffe had asked Pollitzer not to show them around at Teachers College, where Anita was now an instructor, so she took them to an empty classroom and locked the door. Anita later recalled in an interview in the *Saturday Review* in 1950: "I was struck by their aliveness. They were different . . . These drawings were saying something that had not yet been said." Although O'Keeffe was extremely sensitive about who saw her work, Pollitzer interpreted her friend's earlier letter as a desire for approval from the great Stieglitz himself, and therefore bravely took O'Keeffe's charcoals to the 291 gallery. Legend has it that, after looking at the drawings several times, Stieglitz declared: "At last, a woman on paper," and added that he would not mind showing the work in the gallery. Anita wrote excitedly to O'Keeffe, confessing what she had done. O'Keeffe replied, thanking her, and also wrote to Stieglitz, bluntly asking him what he liked about her work. Stieglitz, however, replied that he would have to tell O'Keeffe in person.

O'Keeffe was once more becoming restless. She was offered a teaching job in Texas, but it required her to take Dow's teaching-method course first. For O'Keeffe this was a good enough excuse to return to New York, and she promptly resigned her position in South Carolina. In New York she lodged with Pollitzer's uncle off Park Avenue and enrolled in Dow's class. Still aloof – she took her meals at college and never once spent an evening with her hosts during her entire three-month stay – O'Keeffe's distinctive features were further set off by her now habitual black clothes.

Between April and May Stieglitz exhibited the Berlin abstractions of Marsden Hartley at 291, and O'Keeffe visited the show – Stieglitz even lent her one of Hartley's Maine paintings after she had expressed an interest in it. It is very likely that O'Keeffe had taken her drawings back to Stieglitz: when the Hartley show was dismantled he decided to show 10 of O'Keeffe's charcoals alongside the work of two male artists, Charles Duncan and Rene Lafferty. O'Keeffe, however, was not aware of this exhibition until in the college cafeteria one day a student asked if she was "Virginia O'Keeffe." O'Keeffe replied that she was not, but the student informed her that someone of that name was having a show at 291. O'Keeffe realized that Stieglitz had exhibited her work – without her permission and without even getting her name correct – and headed off to 291 for an angry confrontation. When she arrived, she found that Stieglitz was away on jury service, but she stayed at the gallery long enough to see that her drawings were, in fact, on show

in the largest of the gallery's rooms, while Duncan and Lafferty's work was relegated to the smaller gallery spaces. O'Keeffe's debut at 291 was to mark a turning point in her life, both personally and professionally. From this event can be dated the beginning of her association with Stieglitz, whom she would eventually marry, and her reputation as one of America's leading artists, which she would continue to build upon.

A few days later, O'Keeffe returned to confront Stieglitz, who explained that because he had found the drawings so wonderful he had felt that he just had to show them and, furthermore, he wanted to see more. The angry confrontation between them evidently did not take place, as the pair left for lunch together soon afterward.

Stieglitz had correctly predicted that O'Keeffe's work would cause a sensation, and word soon spread among the cognoscenti and the curious. Many were shocked by the "sexuality" of what they saw; Mabel Dodge Luhan even brought along psychoanalysts to see O'Keeffe's work. Indeed, the explicit sexual imagery which many believed could be found in O'Keeffe's paintings was an interpretation that Stieglitz himself helped to foster at the same time as he defended O'Keeffe's work. Stieglitz extended the show until July, but by this time O'Keeffe had left New York to teach summer school for the last time at the University of Virginia.

It was the first time that O'Keeffe had been home since her mother's death in May, and her family was now scattered: her brothers had long since departed, her father went wherever he could find work, her youngest sister Catherine (born when O'Keeffe was seven) was a nurse in Wisconsin, while Anita had married a Texan. Only Ida, who was an art teacher, and Claudia, who was still at high school, remained at home. In August 1916 O'Keeffe left Virginia and headed west to her new job as head of the art department at West Texas State Normal College in Canyon, Texas. Because she was the only teacher in the art department, O'Keeffe found, much to her delight, that she was responsible for the selection of all the books, prints and art materials required, and promptly ordered copies of Dow's books. Again, however, she made few attempts at joining in the social life of the Canyon community. The only person whose opinion she really cared about was Alfred Stieglitz, and she would often send him a selection of watercolors and drawings with the long stream of letters with which they kept in touch. In November 1916 Stieglitz included O'Keeffe's work in another show at 291, a group show of established "regulars" at the gallery: Arthur Dove, John Marin, Marsden Hartley and Abraham Walkowisz.

With O'Keeffe in Canyon was her 17-year-old sister Claudia – before her mother's death O'Keeffe had promised her that she would take responsibility for her sister. The Texan landscape still attracted O'Keeffe, and the two sisters would often hike out to Palo Duro Canyon. With her sister for company, O'Keeffe had little need for anyone else.

Although Stieglitz had recommended that she continue to work in black and white, O'Keeffe was slowly returning to

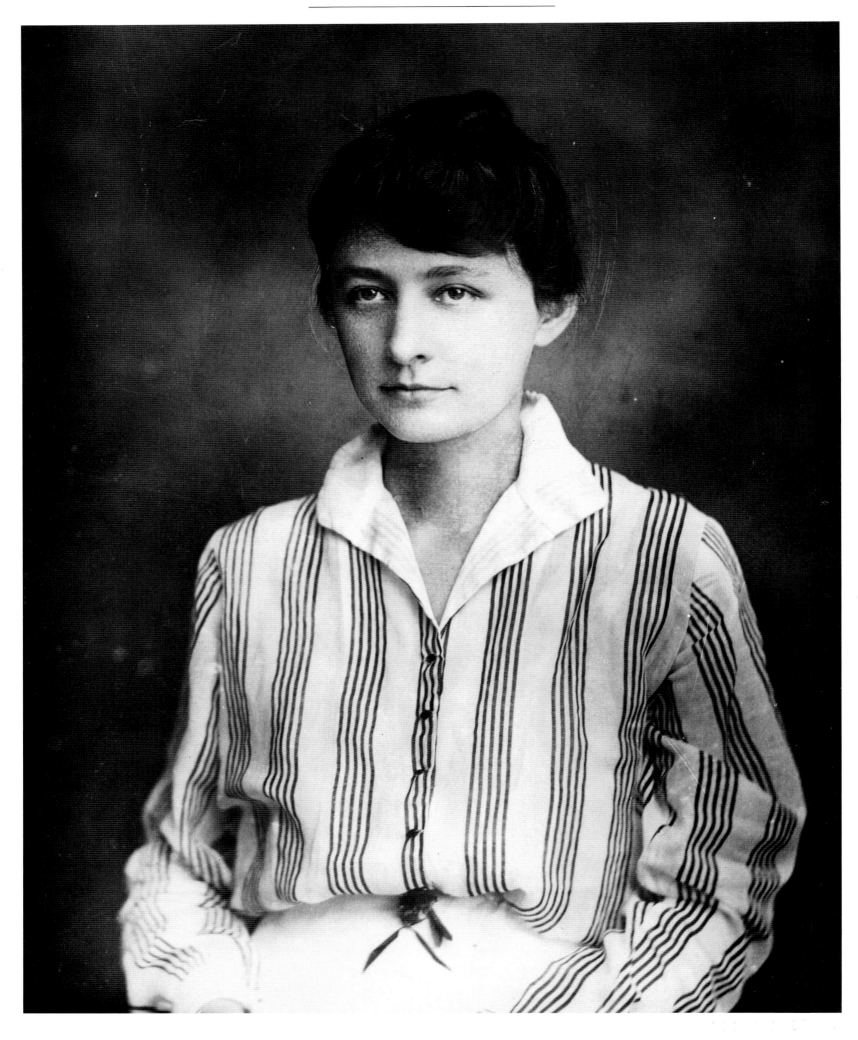

Above: This photograph of the 28-year-old O'Keeffe dates from 1915, the year in which she taught summer school in Virginia and accepted a teaching post in South Carolina.

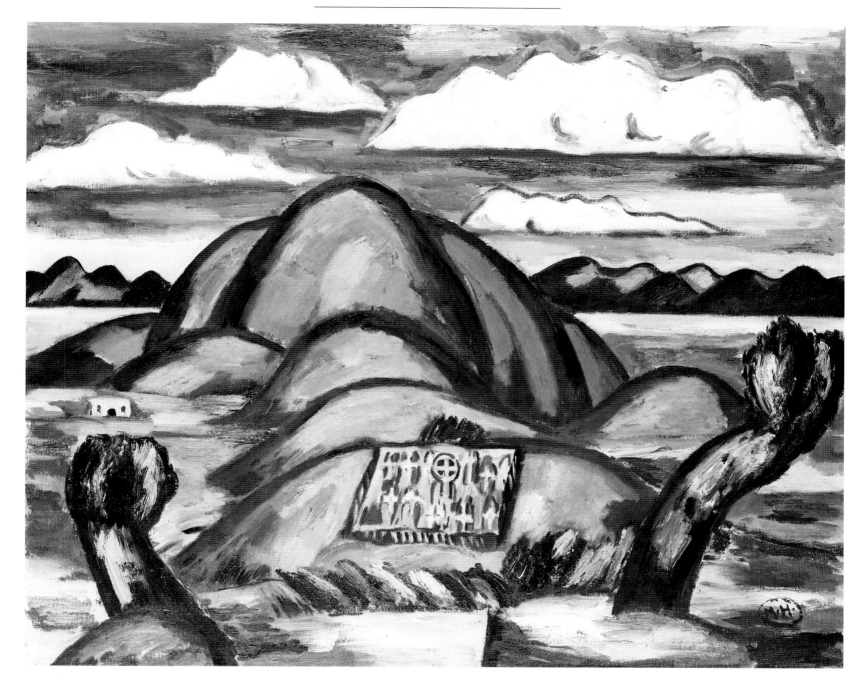

color, using watercolors, a medium in which she would work almost exclusively for the next three years before moving on to oils. *Blue Lines X*, a work influenced by oriental calligraphy, was among O'Keeffe's first efforts in watercolor: a simple arrangement of two parallel, vertical lines – one angled at the top – resting on a broad horizontal band, initially drawn in in charcoal. It was this painting that Stieglitz would interpret as a symbol of the relationship between man and woman and, during O'Keeffe's absence from New York from June 1917 to June 1918, he had the watercolor hung over his desk at 291. O'Keeffe's solitude in Texas, and her awareness that Stieglitz might exhibit her work the following year, produced a 15-month period of concentrated artistic activity: at least 50 watercolors are recorded as being completed.

On 3 April 1917 Stieglitz did indeed show O'Keeffe's work again, but this time it was to be her first solo show. Because no accompanying catalog was produced, it is uncertain exactly which, or how many, of her paintings were exhibited, but from extant contemporary photographs, it seems that the show was principally made up of Texan watercolors, including pure abstractions such as *Blue Lines X*, semi-abstract landscapes such

as *Evening Star III*, and some closely observed still lifes. As well as the charcoal drawings there was also a single piece of sculpture: a rather phallic form modeled in Plasticine. Once again O'Keeffe's work created quite a stir: essays written after the show by Stieglitz's close friends Marsden Hartley and the critic Paul Rosenfeld extolled O'Keeffe as a sexually liberated woman who was expressing her liberation through her art. Although O'Keeffe co-operated with Stieglitz in the promotion of her work, she strongly resented the publicity that Stieglitz "managed" – in particular his contention that her work symbolized female sexual feelings.

The spring issue of *Camera Work* indicated that its next edition would contain a selection of O'Keeffe's work, but the issue never appeared. Three days after O'Keeffe's show opened, the United States declared war on Germany and entered World War I. The outbreak of hostilities between his American homeland and Germany, where he had studied in his youth, deeply affected and depressed Stieglitz. Furthermore, he was burdened by the personal conflict between himself and his wife, Emmeline Obermeyer, the heiress to a brewery fortune. Stieglitz had lived apart from his wife and daughter Kitty for

some time, and their relationship was further strained when Prohibition cut into his wife's brewery dividends: Emmeline had supported her husband's artistic career, even though she did not share his passion for photography and art. When his assistant, Marius de Zayas, broke with him and opened his own modern-art gallery in Manhattan, Stieglitz was forced to realize that 291 was no longer the sole center of the avant-garde in New York. Opting not to renew his lease on the building that housed 291, Stieglitz decided to close the gallery doors for the last time at the end of O'Keeffe's show. This he did, and is said to have remarked: "Well, I'm through, but I've given the world a woman."

From Stieglitz's letters O'Keeffe was aware of his mood, and knew that her show would be the last at 291. At first it seemed impossible that she would be able to go to New York to see the exhibition: her teaching would not end until the last day of the show, and she had agreed to stay on in Canyon to teach the summer school. When classes recessed, however, O'Keeffe had

the strong desire to go to New York – perhaps she had been encouraged by the news that one of her paintings had sold – and she impulsively left Texas and headed for 291.

Although Stieglitz had photographed the show before dismantling it, he nevertheless insisted on rehanging it for O'Keeffe to see. He also introduced her to several artists, such as John Marin and the photographer Paul Strand, and thereafter O'Keeffe was considered part of Stieglitz's inner circle of artists. Soon Stieglitz asked O'Keeffe to model for him, and he began to photograph her face, her hands and her body; indeed, O'Keeffe was to become Stieglitz's photographic obsession in his "portraits" of her, executed over two decades. In his 1921 exhibition Stieglitz would include the controversial prints that made the intimacy between the photographer and his model very apparent. Moreover, by his inclusion of nude and semi-nude studies of O'Keeffe in poses that echoed the forms contained in her own abstractions (Stieglitz often photographed O'Keeffe against the background of her paintings), he further established his belief in the link between O'Keeffe's body and the perceived "sexuality" of her work. Thereafter, much to O'Keeffe's regret, critics would continually interpret her paintings in these, Stieglitz's terms.

After a few days in New York, O'Keeffe departed for Texas and her first summer in the Southwest. At the end of the

Left: Cemetery New Mexico
c.1924
Marsden Hartley,
Oil on canvas, 31⅝×39¼ inches
Alfred Stieglitz Collection, 1949, The Metropolitan Museum of Art, New York, NY (49.70.49)

Below: Evening Star 1916
Watercolor, 13⅜×17¾ inches
The John Hill Morgan Fund, The Leonard C. Hanna, Jr. Fund, and Gifts of Friends in the Honor of Theodore E. Stebbins, Jr., B.A. 1960, Yale University Art Gallery, New Haven, CT (1978.4)

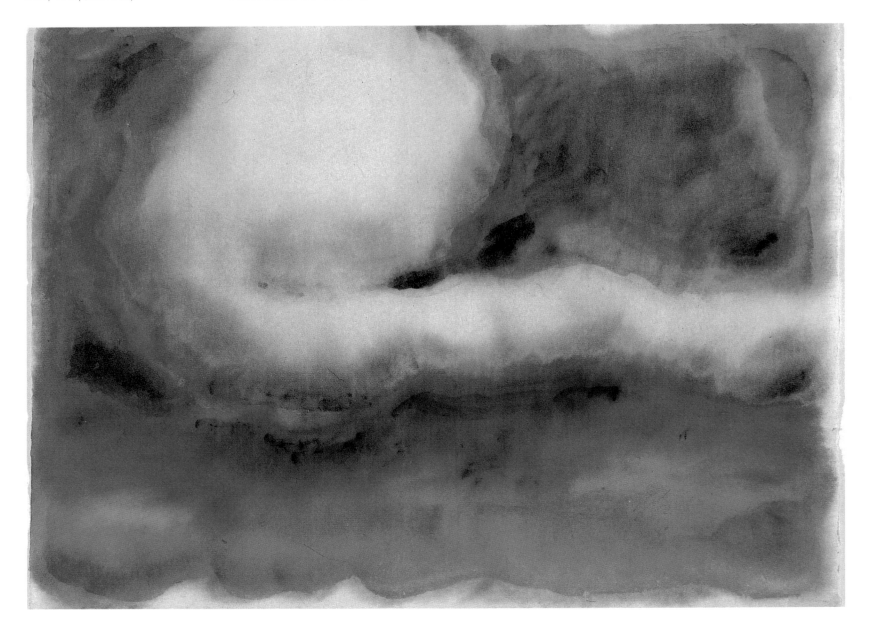

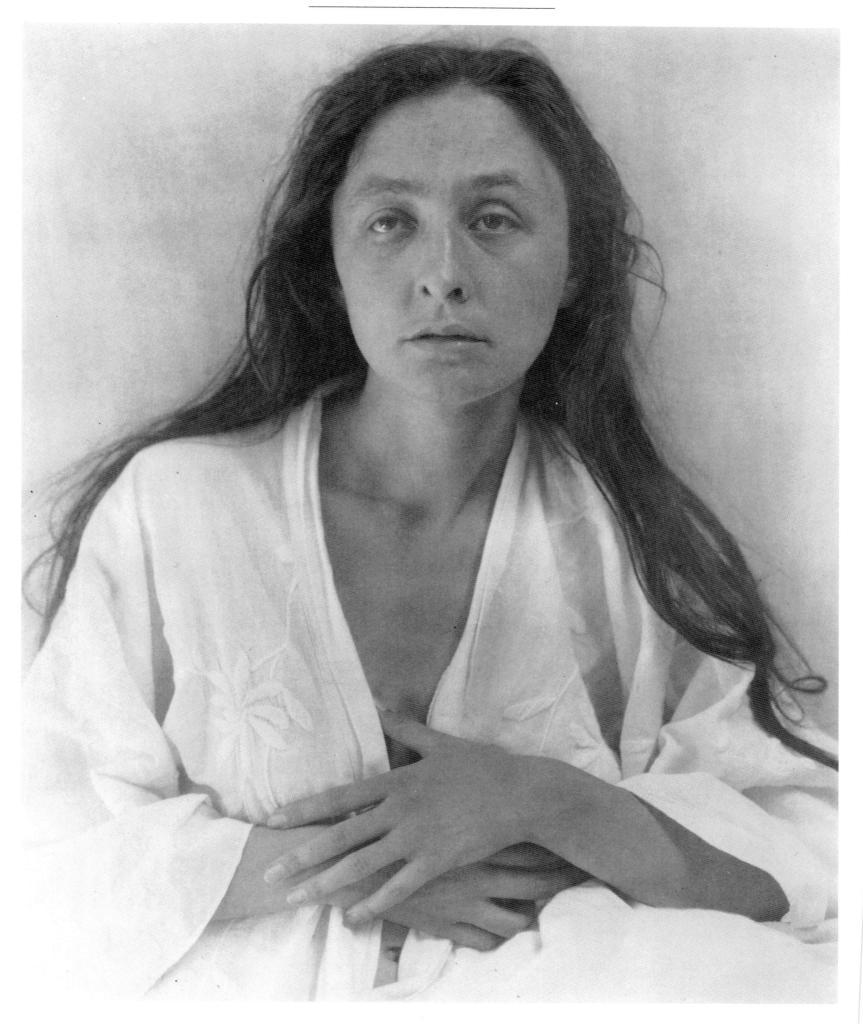

Above: A Portrait (4) [Georgia O'Keeffe] 1918
Alfred Stieglitz, Chloride, 4×5 inches
Courtesy Museum of Fine Arts, Boston, MA

Right: Later Lake George: Storm over the Hills 1921
Alfred Stieglitz, Photograph, 7¾×9½ inches
The Alfred Stieglitz Collection, Philadelphia Museum of Art, Philadelphia, PA

summer school there was a month free before the start of the full semester, so O'Keeffe and her sister planned a trip to the Colorado Rocky Mountains. Bad weather and floods had caused the direct route to Denver to be closed, so the pair decided to travel via Albuquerque, New Mexico, where O'Keeffe got her first glimpse of the landscape of the Sangre de Cristo Mountains. En route O'Keeffe painted what she saw, and the pair stopped in Santa Fe, one of the oldest towns in America and also a thriving artists' colony. "I loved it immediately," O'Keeffe later recalled, "from then on I was always tying to get back." Her journey back to New Mexico would, in fact, take another 12 years.

Back in Canyon, O'Keeffe tried to avoid the raging war fever prevalent in the United States, and continued to devote herself to painting and to teaching. But in Canyon there was little room for nonconformity. When Claudia left to teach students in Spur, Texas, in December 1918, O'Keeffe was more alone than ever before and experienced a period lasting three months when she completely lost the will to paint. A harsh winter also brought with it a bout of influenza, and she was forced to cancel her classes after Christmas. Two conflicting newspaper reports exist from this period: one reported that O'Keeffe had been ill for two weeks, the other that she had visited Amarillo. Whichever account was true, O'Keeffe was granted leave of absence, and traveled to Waring in south Texas where she stayed with a friend, Leah Harris. When O'Keeffe wrote to Stieglitz that she had been ill and had left her job, he urged her to come to New York. On his behalf, his niece Elizabeth offered O'Keeffe the use of her New York studio, which Stieglitz had also been using as a darkroom. Despite her absence, by April Stieglitz's feelings for O'Keeffe had become apparent to his family, and he moved out of the bedroom he shared with his wife and began to sleep in the study.

Worried that O'Keeffe might have tuberculosis, the disease that had plagued her family, and that she was not painting, in May Stieglitz sent Paul Strand to Texas to fetch her. Strand waited patiently in Texas until O'Keeffe had made up her mind whether or not to return with him. After the cross-country railroad journey, during which it was said that the young Strand became infatuated with O'Keeffe, the couple arrived in New York at dawn on 10 June to find Stieglitz waiting anxiously for them. It was clear that O'Keeffe's affections were for the older

man, in spite of the difference in their ages – Stieglitz was 24 years older than O'Keeffe – and in their personalities.

In New York, a tired and still sick O'Keeffe moved into Elizabeth Stieglitz's apartment at 114 East 59th Street, where she was visited every day by Stieglitz. A month after her arrival in the city, O'Keeffe and Stieglitz had become lovers and were sharing the small apartment. After 25 years of enduring a mismatched marriage, Stieglitz instructed his brother-in-law, George Engelhard, to begin divorce proceedings.

In the summer Stieglitz took O'Keeffe with him to "Oaklawn," his family's summer home at Lake George in the Adirondack Mountains, where his widowed mother, Hedwig Wenner Stieglitz, ruled the roost. Once Stieglitz and O'Keeffe had arrived at Lake George it was obvious to all that the couple were indeed in love, and Hedwig, who had always disliked Stieglitz's wife Emmeline, took O'Keeffe under her wing. There were, however, to be casualties of the new relationship, including, in particular, Stieglitz's affectionate relationship with his daughter Kitty. Emmeline had insisted that O'Keeffe should not be at Lake George when Kitty visited, and it seems that on one occasion Stieglitz forgot the rule. When Kitty arrived and became upset, Stieglitz and O'Keeffe quickly left

for New York; sadly, Stieglitz's relationship with his daughter continued to deteriorate.

At Lake George O'Keeffe enjoyed a long period of quiet and solitude in which to paint, predominantly in oils, and, as her technique improved, her canvases became larger and lighter in tone. Both Stieglitz and O'Keeffe were concerned that a return to teaching in Texas would now surely impede her painting. Stieglitz had little money of his own: Emmeline had been the financial mainstay of 291, and he had always rejected the idea of taking photographs for money (he even refused to allow prints to be reproduced). Yet Stieglitz came to the painful realization that he was already close to old age and was ill-equipped to take care of O'Keeffe. In the end, Stieglitz was able to secure a loan of about $1000, allowing O'Keeffe to resign her teaching job at West Texas State Normal College.

O'Keeffe's work from this period reflects her happiness: the couple would often be inspired by the same subjects, such as clouds, landscapes and details of buildings. There were also O'Keeffe's brightly colored abstractions, for example, *Music – Pink and Blue I* (1919), which Stieglitz once again interpreted as erotic; he even photographed the phallic Plasticine sculpture that O'Keeffe had modeled some years earlier in front of the

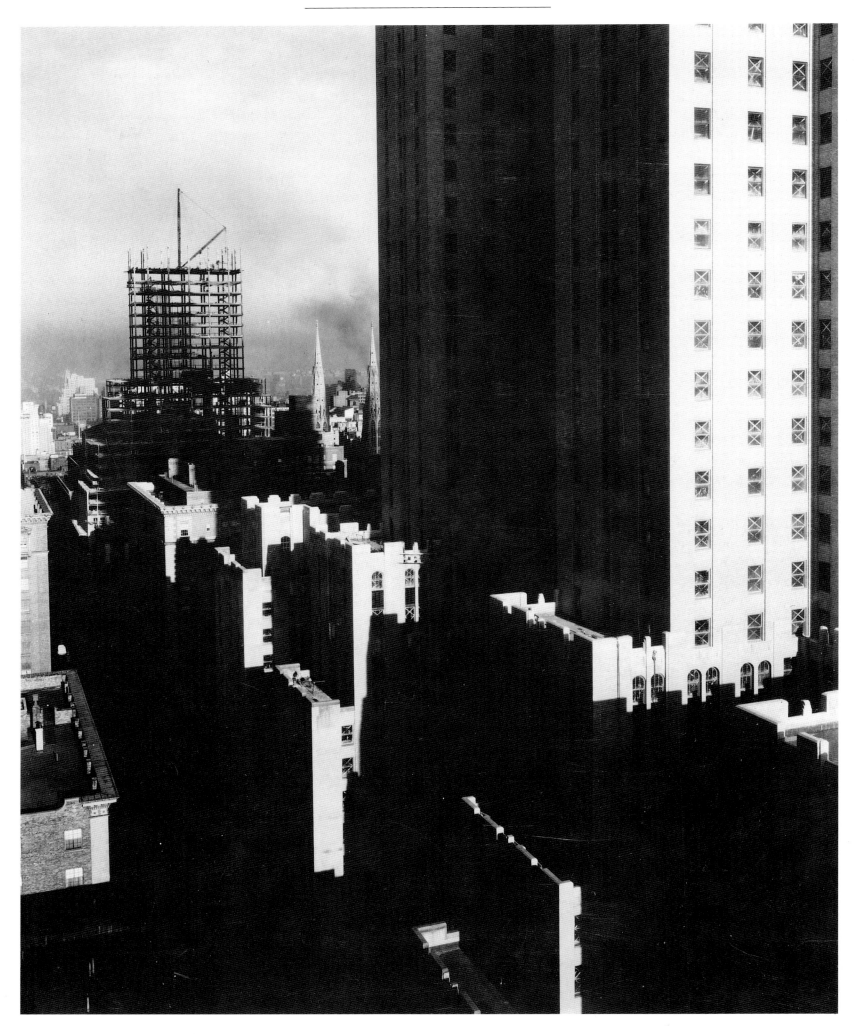

Left: Stieglitz's silver-chloride print of O'Keeffe in 1918, showing her distracted from her intense study of a garden plant.

Above: Stieglitz's starkly architectural view from the Shelton Hotel; their apartment provided a stimulating panorama for both photographer and artist.

painting, as if to make the association more apparent. Friends who visited their New York studio apartment would be shown the photographs which Stieglitz had taken of O'Keeffe, and when the word spread that he was working again, Mitchell Kennedy, president of the Anderson Galleries, offered Stieglitz two large rooms for a retrospective exhibition. Of the 145 prints on show, nearly one-third were of O'Keeffe – although many of the more "intimate" photographs were withheld. Despite the fact that O'Keeffe had not had an exhibition herself for a few years, Stieglitz's photographs of her brought her firmly back to the attention of the critics.

In the spring of 1921, the painter Arthur Carles asked Stieglitz to arrange a show of modern art at the Pennsylvania Academy of Fine Arts. Carles did not want women artists' work to be included in the show, but because Stieglitz was on the hanging committee, it was his will that finally prevailed: among the 27 artists' work on show (which included three women artists), O'Keeffe was represented by more paintings, including *Red and Pink* and *Black Spot*, than any other artist.

In the summer of 1922 Stieglitz arranged for another solo exhibition of O'Keeffe's work, this time at the Anderson Galleries and, in January 1923, the exhibition opened with 100 paintings on display, 90 of which had never been exhibited before. As in her shows in "the old days" at 291, O'Keeffe's paintings were not titled, only dated and numbered, and in general the works captured her new optimistic mood and her more confident, mature style. The many abstractions on show included those inspired by music, by the seasons (particularly spring), and of leaves seen through and under the water of Lake George. In her paintings of apples and canna flowers, O'Keeffe's palette was overwhelmingly red and white. As Stieglitz had foreseen, the show established O'Keeffe as an artist in her own right, and $3000-worth of paintings were sold almost as soon as the show opened. This success ensured that O'Keeffe's initial one year as a full-time artist living in New York would now extend to 30 years. Encouraged, the couple decided to show simultaneously at the Anderson Galleries in early 1924: O'Keeffe had the large room in which to show 51 paintings, while Stieglitz used two smaller rooms to show his photographs of cloud formations.

Although Stieglitz openly told people that O'Keeffe wanted to have a child, he was, in fact, convinced that she should not, for he believed motherhood would divert her energies from painting. By the summer of 1923, O'Keeffe seems to have conceded to Stieglitz's wishes not to have a child. On 9 September 1924 Stieglitz's divorce became final, and he began to insist that O'Keeffe marry him. While he sincerely seemed to want O'Keeffe to inherit his estate, it is also likely that he wanted to continue maintaining his influential hold over the younger woman. Reluctantly O'Keeffe agreed to marry him, although in her mind she reasoned that there was no need to do so, since they had been living together since 1918, and had weathered all the "scandalous" gossip about their relationship. In December 1924 Stieglitz and O'Keeffe were finally married; she was just

37, he almost 61. Since Stieglitz's divorce decree banned his re-marriage in the state of New York, the couple married quietly in New Jersey, with George Engelhard (Stieglitz's lawyer brother-in-law) and the painter John Marin as witnesses. No wedding rings were exchanged and, bowing to O'Keeffe's feminist beliefs, the words "love, honor and obey" were omitted from her vows.

After 291 closed in 1917, Stieglitz had still managed to keep alive his dream of showing American avant-garde art. In early 1925 the Anderson Galleries was the venue for a large group show entitled "Seven Americans" (plus "X," an unknown artist), of 159 works, including photographs by Stieglitz and Strand, and paintings by Marin, Dove, Demuth, Hartley and the sole woman, O'Keeffe. Although the works varied in style, all were inspired by nature and were influenced to a greater or lesser degree by the abstract art movement. At the close of the show, Stieglitz was reluctant to let the works be stored away, and negotiated the rent on a small room at the Anderson Galleries as a permanent exhibition space. The Intimate Gallery opened its doors to the public in December 1925.

In 1924 O'Keeffe completed the first painting in a series that would contribute further to her already considerable fame. She had always enjoyed painting flowers, but her canvases now showed blooms of gigantic proportions and, in addition, these flowers were never wholly realistic. Rather than being mere botanical studies, O'Keeffe maintained that the paintings expressed her personal feelings about the flowers. In the following years O'Keeffe would continue the floral theme, painting irises, daisies, orchids, lilies and jack-in-the-pulpits – the same flower which she had seen in her art class in Madison. Despite her best efforts, however, O'Keeffe's flower paintings were still interpreted as veiled representations of male and female genitalia, interpretations that O'Keeffe felt trivialized her work, but which nevertheless encouraged great numbers of the public to go to her shows.

In 1925, O'Keeffe and Stieglitz moved from the small apartment on East 59th Street into the newly completed Shelton Hotel, one of New York's first true skyscrapers. After the death of Stieglitz's mother in 1922, O'Keeffe had taken on the responsibility of running the Lake George house for half of the year. Oaklawn had been sold, and the Stieglitz family contributed to the purchase of a new property, a large farmhouse conversion at Lake George. Understandably, O'Keeffe did not want to be burdened with similar responsibilities in New York for the rest of the year. The Shelton suited O'Keeffe's domestic arrangements: it provided a cafeteria and a maid service, which freed her from household chores and provided her with time to paint. From the balcony of their top-floor apartment on the north-

Right: Radiator Building, Night, New York 1927
Oil on canvas, 48×30 inches
The Alfred Stieglitz Collection, The Carl Van Vechten Gallery of Fine Arts, Fisk University, Nashville, TN

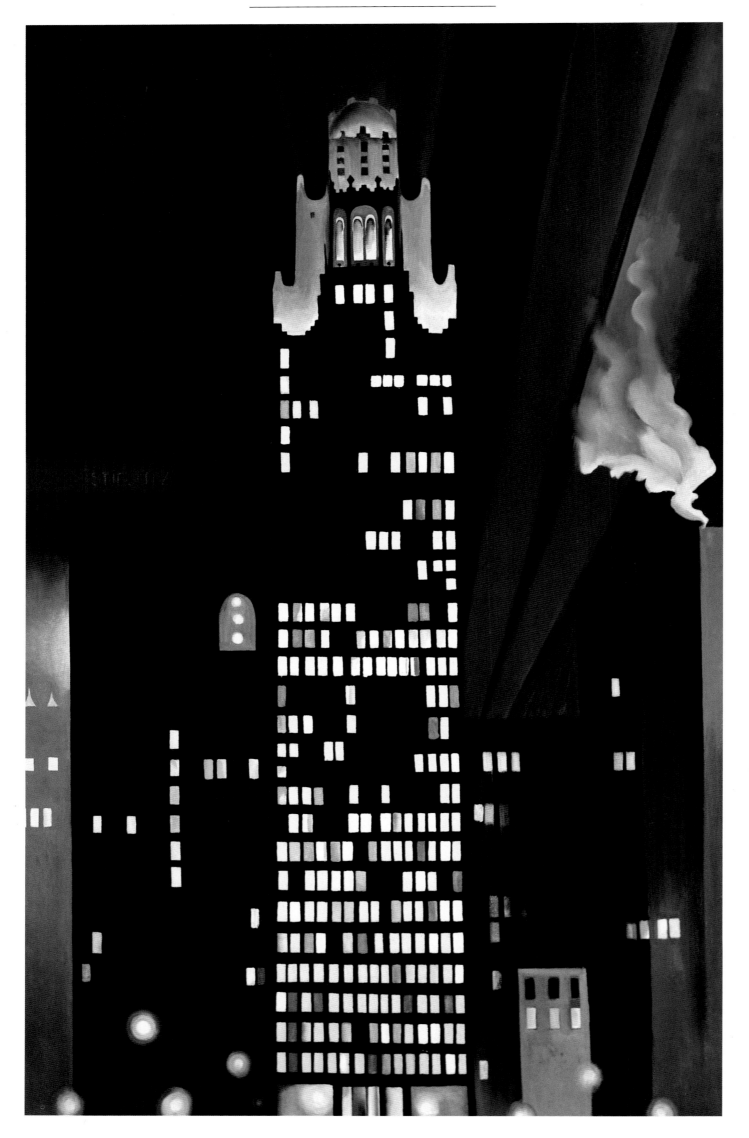

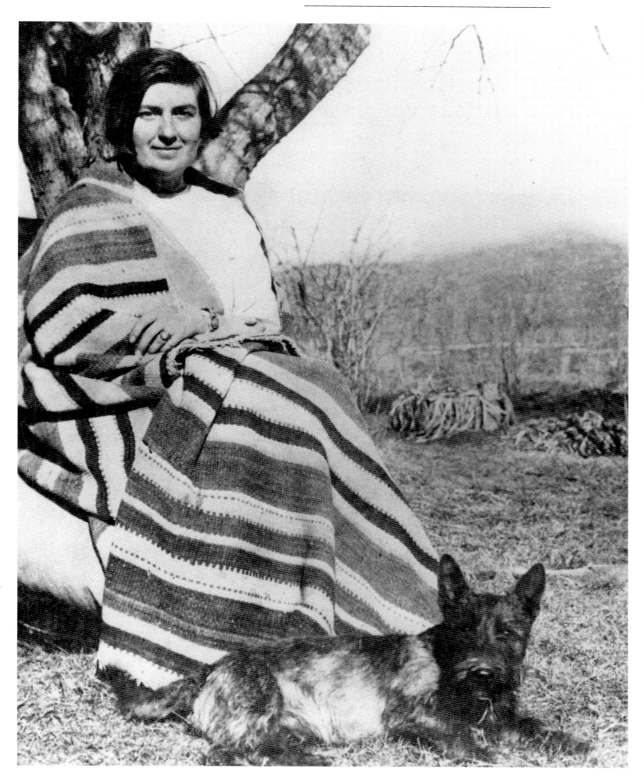

Left and far right: New York heiress Mabel Dodge Luhan (left) and her Native American husband Tony Luhan (far right). Mabel enjoyed patronizing the arts, and bullied O'Keeffe and Beck Strand into staying with her in Taos.

eastern corner of the building, O'Keeffe could see the trees of Central Park and across the Hudson River to the New Jersey cliffs. To the east the view was of the barges on the East River, the cars crossing the Queensboro Bridge, and the factories and smokestacks on the far side of the river. Meanwhile, all around the Shelton itself new skyscrapers were being constructed: the Chrysler Building (77 stories high), the Empire State Building, and one building that really fascinated O'Keeffe, the American Radiator Building. Surrounded by the growing city, O'Keeffe began to paint it, in spite of objections from Stieglitz, who contended that nature was the more feminine sphere, and that even male artists had had difficulty in depicting the architectural structures of the metropolis. Stieglitz was later forced to admit that he was wrong. For the "Seven Americans" show in 1925, O'Keeffe thought that she had found the perfect venue to exhibit her first cityscape painting, and insisted that it was

hung between two windows. The painting was sold immediately for $1200. In the next five years O'Keeffe painted approximately 20 cityscapes and skyscraper scenes, most of which were nightscapes, such as *City Night* (1926), with a small moon squashed against giant black walls, and *New York with Moon* (1925), where the moonlight competes with a streetlight. Moreover, O'Keeffe's cityscapes are eerily unpeopled.

During this period O'Keeffe moved between realism and abstraction: at Lake George, where she would spend the summer, she painted many scenes from nature, such as *Lake George, New York*, and also began experimenting with still-life subjects, like *Three Eggs in a Pink Dish* (both now in the Museum of Fine Arts at the Museum of New Mexico). Finding a loose shingle from a barn roof against which she placed a sea shell, O'Keeffe began a series of paintings based on this theme. Some paintings in the series were realistic; later she returned to

executing near-abstract studies of the shapes and colors of the two elements.

Every new experience was potential material for O'Keeffe's paintings: in the summer of 1927, for example, she was operated on for a benign lump in her breast, and she claimed to have painted *Black Abstraction* soon afterward, as she recalled the experience of lying on the operating table and the effects of the anesthetic.

In 1927 36 new O'Keeffes were exhibited, and in the first few days $17,000-worth of paintings had been sold. It would be in the following year, however, that O'Keeffe's reputation as an artist, and also her own belief that she could make a living solely by painting, was confirmed. A collector living in France, who preferred to remain anonymous, offered to buy six small paintings of calla lilies that O'Keeffe had painted in 1923. The collector had asked the price and Stieglitz, annoyed and wishing to change the subject, asked the then outrageously high sum of $25,000. To his astonishment, the price was accepted without argument. On 6 April 1928 the story of the sale appeared in the *New York Times* and was picked up shortly afterward by the tabloids. The *New York Evening Graphic* published a picture of O'Keeffe, accompanied by a banner line proclaiming: "SHE PAINTED THE LILY AND GOT $25,000 AND FAME FOR DOING IT!" Many of the articles went on to comment on O'Keeffe's appearance – her hair fastened in a knot on top of her head and her black clothes – rather than commenting on her work, as the more intellectual art magazines did. For O'Keeffe it was her first experience of widespread newspaper publicity, and she disliked it intensely – even though she claimed that she never read reviews.

As time passed, O'Keeffe became increasingly tired of Lake George. A solitary person, she needed long periods of isolation and privacy in which to paint, but the Lake George house was often occupied by Stieglitz's extended family of in-laws and their children. Stieglitz, however, was set in his ways, and would not tolerate the idea of vacationing anywhere else. In her frustration, the Stieglitz family became the object of O'Keeffe's fury, and she often ridiculed them, once even slapping a small child who had dared to call her "Auntie Georgia." Finally she began avoiding the family altogether, to the extent of snubbing them at mealtimes.

In the summer of 1928 relations between Stieglitz and O'Keeffe became even more strained: Stieglitz had begun to suffer from kidney trouble and, possibly out of fear, refused to allow O'Keeffe to leave him to visit relatives in Wisconsin. He finally relented, and in July O'Keeffe departed for a month-long visit. Almost as though she was trying to reach back into happier times, O'Keeffe painted a red Wisconsin barn and silo near Portage. She was becoming acutely aware of her need to travel to find new subjects, and also that this urge was totally at odds with Stieglitz's own working methods, which revolved around the New York-Lake Georgia axis. When she returned to New York, O'Keeffe found Stieglitz ill: he had suffered a heart attack in September, and O'Keeffe now found herself unable to paint

while she cared for her sick husband. Consequently, her 1929 exhibition at the Anderson Galleries proved to be a disappointment, with few new works on show.

During the winter of 1928-29, the English painter Dorothy Brett, along with Mabel Dodge Luhan and her Native American husband Tony, visited New York from Taos, New Mexico. Brett urged O'Keeffe to think seriously about spending a summer in the west, even if it was to be without Stieglitz. O'Keeffe was prompted to take stock of her life: she was 41, and for the past 11 years had been with Stieglitz at Lake George, a place that he knew did not inspire her, and where she had not painted all winter. Stieglitz, however, was not ready for them to vacation apart, and was unwilling to let O'Keeffe go. Nevertheless, he relented, possibly because O'Keeffe had persuaded Paul Strand's wife Beck to accompany her – Stieglitz had known Beck (who was the daughter of the backer of Buffalo Bill's Wild West Show) since the early 1920s. Thus it was that on 1 May 1929 O'Keeffe and Beck Strand left New York for New Mexico.

Soon after O'Keeffe and Beck arrived in Santa Fe, the couple bought tickets to see the San Felipe Indian Corn Dance, about 40 miles to the south. When they arrived at the pueblo they were spotted by Mabel Luhan, who insisted that they visit her at her home in Taos, an artists' colony 70 miles to the north of San Felipe. Luhan was a New York heiress and collector – of

people – and after moving to Taos she continued her tradition of inviting artists and writers (among them D. H. Lawrence and Willa Cather) to visit, earning herself the nickname of "The Empress of Mabel-town." Beck Strand, who had been one of Mabel's house guests three years earlier, was unenthusiastic about the prospect of returning: Mabel, she explained to O'Keeffe, had a bossy nature and was given to interfering in the private lives of her guests. As the story goes, Mabel was undaunted by O'Keeffe and Beck's hesitancy, and the next morning showed up at their hotel announcing that she had already sent their traveling cases to Taos, thus ensuring that they had to come with her. (How Mabel managed to achieve this without O'Keeffe or Beck knowing is a mystery that has never been resolved!)

O'Keeffe and Beck were lodged in the Pink House, and O'Keeffe was also loaned an adobe studio with large windows. From here she could look out over the meadows to the sagebrush, and beyond to the brooding Taos mountains. O'Keeffe, in addition to enjoying the landscape and the climate, was pleased to meet people unconnected with Stieglitz's small circle of New York friends: she became friends with William "Spud" Johnson, who published woodcuts by local artists in his newspaper *Laughing Horse*, as well as the former pianist Ansel Adams, who was taking photographs for the Sierra Club. That summer O'Keeffe also stayed with Dorothy Brett at Kiowa Ranch, the property which Mabel Luhan had given to D. H. Lawrence. One night O'Keeffe lay under a giant pine watching the stars and she later recreated the experience from memory. The painting *The Lawrence Tree* was to remain one of O'Keeffe's personal favorites.

O'Keeffe wanted to explore the landscape further, and she wanted to do it on her own. With the proceeds from the sale of her painting *Shell and Shingle VI* (which sold for $6000), O'Keeffe bought a black Model A Ford in Taos, where she was taught to drive firstly by Tony Luhan, and then by George Collier (who also showed her a place called Ghost Ranch, where O'Keeffe would eventually do some of her finest work), and finally by the ever-patient Dorothy Brett.

During her explorations of New Mexico, O'Keeffe often came across mysterious, heavy, primitive crosses. The local inhabitants told her that these were the crosses of the Penitente, a secret religious society that had originated in medieval Spain, which practiced flagellation and staged mock crucifixions. O'Keeffe painted a series of works depicting the black crosses, and also began a series of paintings based on the theme of the mission church at Ranchos de Taos.

Meanwhile, back in New York, Stieglitz was fearful that O'Keeffe's love of the Southwest would prove stronger than her feelings for him, and he spent much of his time writing to her. By July his worried letters and telegrams so troubled O'Keeffe that she reluctantly made plans for an early return to the east.

In August O'Keeffe arrived at Lake George to find Stieglitz in improved health and in a much better mood – he had become interested in flying and had taken several trips over the lake in a

small airplane. The weather was good, and O'Keeffe had long, uninterrupted hours in which to work on the paintings she had begun in Taos, and even to begin some new works. On their return to the city however, Stieglitz and O'Keeffe became aware of the generally downward trend in people's moods: on 29 October the stock market began to slump, and by the end of 1929 it had taken a $15-billion drop. Although they remained calm, both Stieglitz and O'Keeffe knew that the collapse would affect the art market, and Stieglitz furthermore believed that he

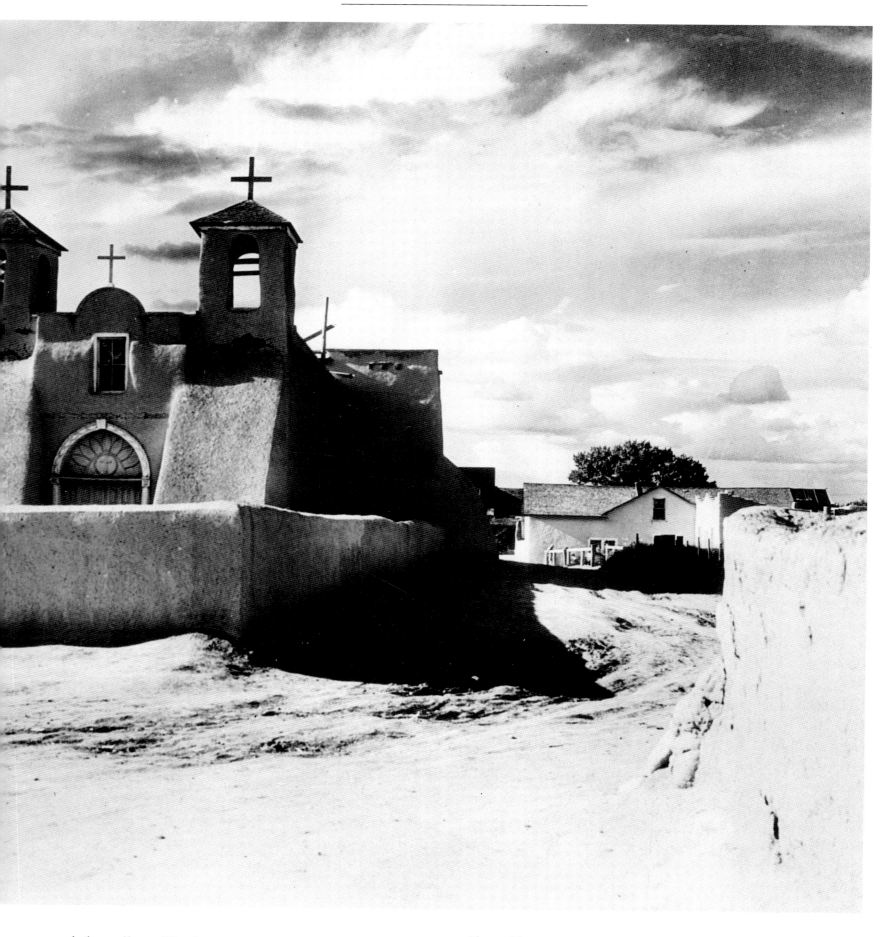

needed a gallery. The Intimate Gallery had closed after four seasons because the building which housed both it and the Anderson Galleries was being sold, and Stieglitz's paintings and photographs were now in storage.

Thus it was that in December 1929, on the seventeenth floor of a modern sky-scraper at 509 Madison Avenue and 53rd Street, An American Place was launched, and in early 1930 O'Keeffe's exhibition opened there. Two-thirds of her paintings were inspired by New Mexico, and her new subject matter

Above: The mission church at Ranchos de Taos, New Mexico, which is estimated to have been built in around 1776. It would prove a never-ending source of inspiration for O'Keeffe.

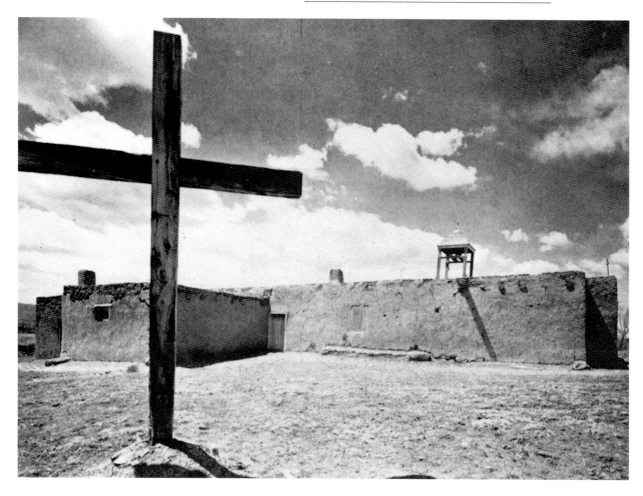

Left: The morada (the meeting-house of the Penitentes) which stood behind Mabel Dodge Luhan's house in Taos. Pictured in the foreground is one of the primitive crosses which O'Keeffe painted many times.

Right: The awe-inspiring, rugged hills of New Mexico, which dwarf the figures in the foreground of the picture, and whose majesty O'Keeffe sought to capture time and time again.

succeeded in startling the critics. Most agreed that she had been fired by her western trip, though some said that her paintings of the black crosses were "hysterical," and others panned what they called her "garish" colors. As usual, O'Keeffe either did not read the reviews or chose to ignore them, for she continued to paint in a similar style, regardless of the negative reactions.

In April O'Keeffe spent a week by herself painting in Maine in a cabin overlooking York Beach and the sea. From there she went to Lake George, where she began the series of seven paintings based on the jack-in-the-pulpit flower theme. Realizing that Lake George was no longer her world, O'Keeffe, despite Stieglitz's unhappiness at the idea, determined to return to New Mexico. While Stieglitz always knew that O'Keeffe would return to the west for the sake of her art, he was still melancholic; he became increasingly depressed, possessive, and developed a worsening hypochondria. Fewer people were gravitating toward him, and some of his disciples became disillusioned, particularly after he had attacked government subsidies for artists while he himself continued to live largely on what many believed was unearned income.

Back in New Mexico, O'Keeffe planned to stay well clear of Mabel Luhan in order to maintain her independent existence – despite the fact that she was still living and working in Mabel's studio. O'Keeffe was becoming increasingly fascinated with the dry, sun-bleached bones that she found scattered over the desert floor. These were viable alternatives to the few flowers that were available during the dry summer of 1930 and, by the end of August, O'Keeffe had collected a large pile of bones which she shipped back to Lake George for later use when she returned there in early September.

Tensions between O'Keeffe and Stieglitz continued: he was anxious about her health, her aptitude as a driver (she had only recently formally passed her driving test), and her need to travel. By 1932 Stieglitz's photographs of O'Keeffe often caught the tensions between them: in most pictures O'Keeffe has been caught scowling or glaring at the camera. Tensions were further aggravated by Stieglitz's interest in the 26-year-old Dorothy Norman. Stieglitz had first met Norman in 1926, and in 1930 their friendship had intensified. Stieglitz had always claimed that he enjoyed female company and, perhaps because his own daughter Kitty had been committed to a mental institution, saw Norman as a doting daughter figure. He began to photograph Norman in a manner reminiscent of some of his early photographs of O'Keeffe. Both were dark-haired women with distinctive profiles, and at one time Norman even posed dressed all in black. Whatever their relationship, the fact should not be overlooked that Norman worked hard at freeing Stieglitz from the routine day-to-day secretarial and bookkeeping tasks that were required to run An American Place. Furthermore, in a period of great economic depression, Norman's fund-raising skills were remarkable; she negotiated a guaranteed rent and a three-year lease on the gallery space, thereby securing its future. Deeply grateful to her, Stieglitz officially appointed Norman the gallery's business manager in 1933. O'Keeffe, however, continued to resent the younger woman and, fearing that she was losing her husband, was unable to paint throughout the winter of 1930-31, after which she resolved to return to the Southwest for at least two months.

In the previous summers O'Keeffe had painted the hills near Alcade, a valley village 40 miles south of Taos. In 1931 she

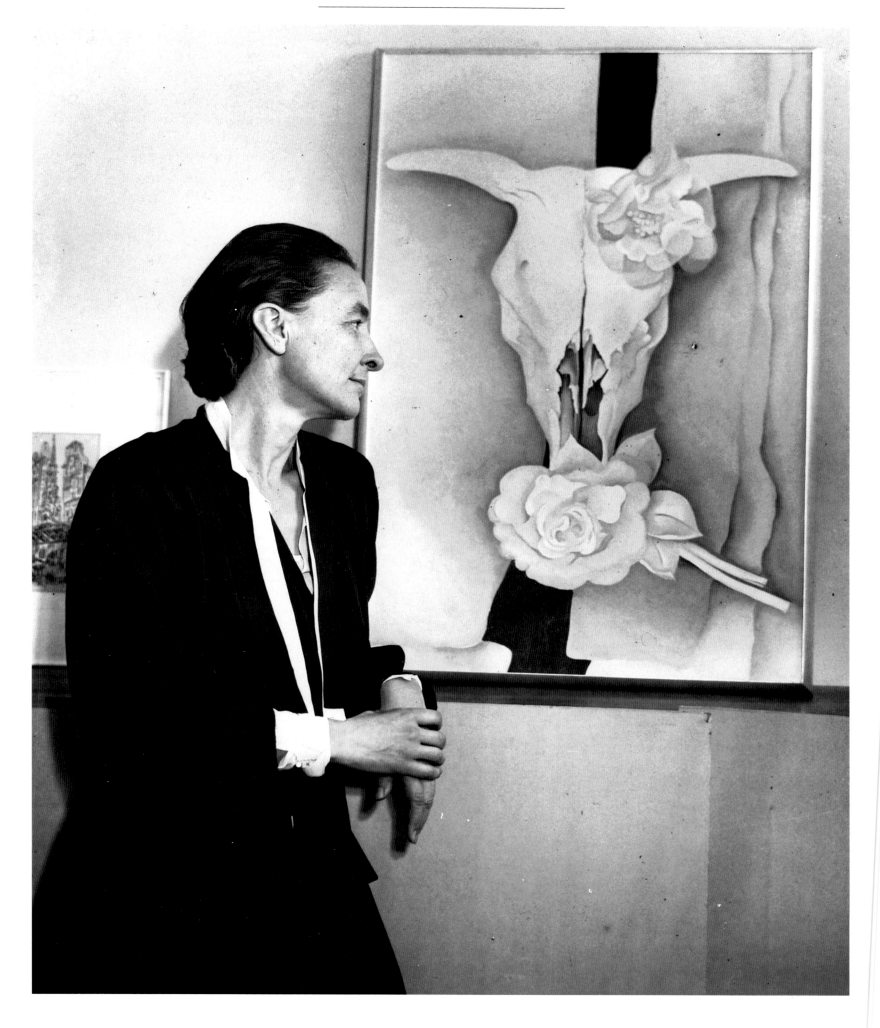

Above: O'Keeffe contemplates her controversial painting, *Cow's Skull with Calico Roses*, at An American Place on 29 December 1931.

Right: Although they were married for over 20 years (from 1924 to 1946), Stieglitz and O'Keeffe remained relatively independent of one another, pursuing their own interests.

returned there, and rented a cottage on the H. & M. Ranch owned by the poet and painter Marie Garland. Using her Model A Ford as a mobile studio (by removing the rear seat of the vehicle O'Keeffe was able to transport quite large canvases), O'Keeffe was able to resume work, completing paintings like *Desert Abstraction*.

Around July 1931 O'Keeffe returned to Lake George to work with the bones and skulls that she had shipped there from the west. One day, after setting up a horse's skull on a table, O'Keeffe was toying with some artificial flowers that she had found in New Mexico. According to the story, O'Keeffe was called to the door, and on impulse stuck the flowers into one of the skull's empty eye sockets. Later she recalled that when she

returned and saw the arrangement: "I was so struck by the wonderful effect of the rose in the horse's eye that I knew that here was a painting that had to be done."

O'Keeffe's exhibition at the end of 1931 provided the art establishment with more shocks: some critics found the skull-and-flower paintings sinister and morbid, but O'Keeffe did not see them that way: "I have used these things to say what it is to me the wideness and the wonder of the world I live in." She also said that she was excited about America when she painted *Cow's Skull – Red, White and Blue*, with its patriotic colors.

In 1932 O'Keeffe traveled further into the "wide world," taking her first trip outside the United States. Accompanied by Stieglitz's niece, Georgia Engelhard, O'Keeffe traveled to

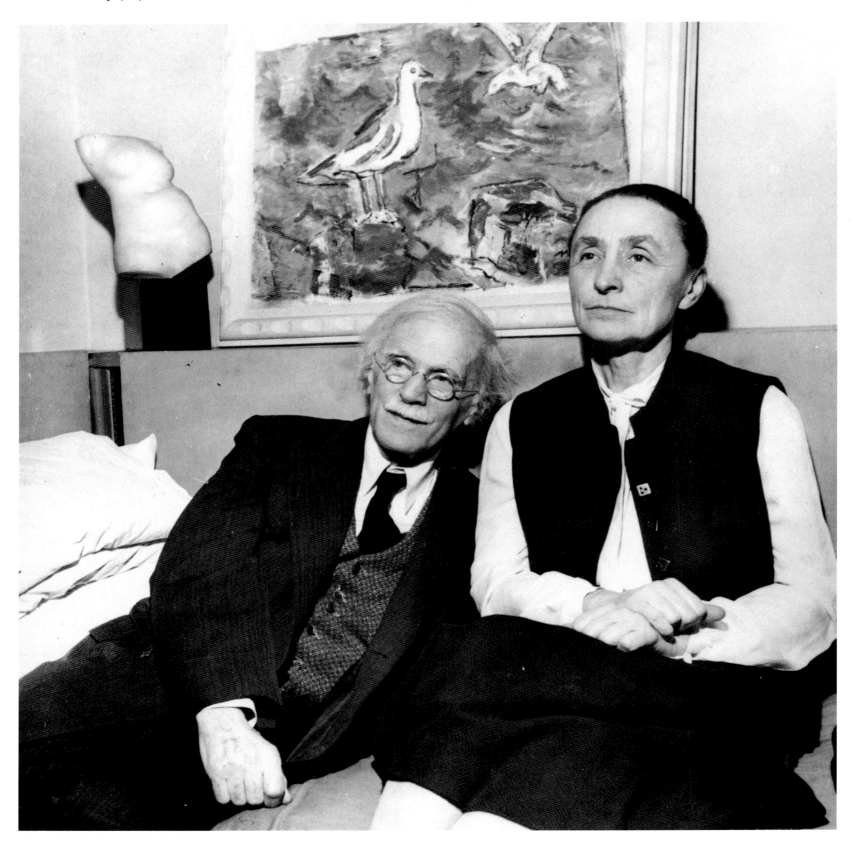

Canada, to Montreal and the Gaspé Peninsula, pausing to paint the barns, the mountains and the sea. But the ocean did not have the same intensity for her as the desert, although she did paint the mariners' crosses which she saw there, the monuments to those who had lost their lives at sea. Furthermore, the climate was much less pleasant for O'Keeffe, and she never returned to the region and afterward rarely painted the sea.

Stieglitz continued to find himself at odds with O'Keeffe, particularly in early 1932, when he learnt that she was planning to paint a mural for the ladies' powder room at the newly built Radio City Music Hall in New York. O'Keeffe was hurrying to finish the first 7×4-inch panel of the three-part mural – Manhattan – whose forms recalled her earlier easel paintings of the New York skyline. Although not really a competition, O'Keeffe's scheme was selected for the mural, and she was invited to execute her work on the walls of the designated room. O'Keeffe accepted the invitation and signed a contract agreeing to the Depression-level fee of $1500. Stieglitz was outraged, and tried unsuccessfully to arrange for O'Keeffe to receive an additional $5000 expenses. His main concern was that the contract would ruin O'Keeffe's established art-market value – something that he had carefully managed for the past 16 years.

O'Keeffe had been led to believe that she would begin work on the mural in August, but the powder room was still being constructed in that month. She was finally able to begin work in November. A few days later, and only weeks before the music hall was due to open, O'Keeffe and Donald Deskey, the designer in charge of the overall decorations to the building, went into the room to inspect the rounded wall which had been covered in canvas. To their horror, a small section of the cloth began to detach itself from the wall as they watched. After months of waiting, O'Keeffe lost control, becoming furious, and then hysterical. The following day Stieglitz informed Deskey that O'Keeffe had suffered a nervous breakdown, and was in a sanatorium – she was actually back at Lake George. Deskey quickly replaced O'Keeffe's mural scheme with one by the Japanese-born painter Yasuo Kuniyoshi, ironically, a mural featuring gigantic O'Keeffe-like foliage and white flowers.

In early December 1932 O'Keeffe returned alone to New York, suffering from headaches. Although she was staying in the luxurious penthouse apartment in which her sister Anita now lived with her husband and daughter, O'Keeffe's health did not improve and, on 1 February 1933, she was admitted to Doctor's Hospital for treatment of psychoneurosis, remaining there until 25 March.

Before her official discharge from hospital, O'Keeffe did manage to visit her show at An American Place. Because of the time spent on the preparations for the Manhattan mural and her subsequent illness, only 13 new paintings were on show, the majority of which had been done the previous year in Canada. Filling out the exhibition was a selection of her best work from the previous few years; as usual, the critics praised the show highly. When she finally checked out of the hospital, O'Keeffe called a longtime friend of the Stieglitz family, Marjorie Con-

tent, and told her that she needed to get away. Content and her teenage daughter were going to Bermuda for the Easter vacation and invited O'Keeffe to join them; she was accordingly picked up at the hospital and taken directly to the ship. The sunshine and vibrant colors of Bermuda did much to improve O'Keeffe's health and spirits – in fact, she extended her stay by a further two weeks until the end of May – but she still had no desire to paint, and was to remain artistically inactive well into 1934. That year's show at An American Place was a retrospective of her work from 1915 to 1927, and surprisingly proved to be the most popular of all her shows. One of her Taos paintings – Black Flower and Blue Larkspur – was sold to the Metropolitan Museum of Art (O'Keeffe's first sale to the major New York museum), which helped to bolster her confidence and her reputation and also enabled Stieglitz to put aside their financial worries. Although she was still not painting, O'Keeffe's physical and mental recovery was well under way and her relationship with Stieglitz had improved. Nevertheless, O'Keeffe still found it difficult to stay in New York, and that winter she returned to Bermuda. Although she had packed her paints and brushes for the trip, she was only able to manage some pencil and charcoal sketches.

Returning to New York at the end of April, O'Keeffe stayed in the city for only three days before going to Lake George. Stieglitz now realized fully how important it was for O'Keeffe to return to the Southwest and, in June 1934, O'Keeffe headed once again for New Mexico. She was determined to learn more about Ghost Ranch, the reputedly haunted place which George Collins had pointed out to her, but to which they had been unable to find the road. One day, while shopping, O'Keeffe spotted an automobile with the initials "GR" on the side. She hung around and waited for the driver, who told her that the automobile did in fact belong to Ghost Ranch, and also gave her directions to it, about 40 miles away. The next day O'Keeffe set off in her black Ford along the miles of bumpy, potholed roads to the track marked by a cow's skull that pointed the way to the ranch. Ghost Ranch turned out to be a working dude ranch owned by Arthur Newton Pack, the publisher of Nature magazine, where, for $80 a week (a huge sum of money at the height of the Depression), wealthy city folk could relax in relative luxury after they had acted out their fantasies of the Wild West. Although O'Keeffe disliked the idea of the company of pampered guests, her feelings for the land around the ranch encouraged her to return the next day to stay. During her first weeks at Ghost Ranch, O'Keeffe hiked, rode on horseback and drove her car for miles, searching out places to paint, and collecting bones, unusual rocks and gnarled branches of long-dead trees.

At the end of the summer she asked Spud Johnson, whom she had met on her earlier visits to the state, to drive her back east. O'Keeffe had now established a pattern of work that would rarely be broken until Stieglitz's death: each spring she set off for New Mexico, and in the fall returned to New York, the back seat of her car full of new paintings.

Right: Stieglitz discusses O'Keeffe's *The Bone* with a group of students at an exhibition at the New York School of Industrial Arts in 1936.

While O'Keeffe's 1935 show contained only nine new works, they were among some of her best: *Blue River, Red Hills and Pedernal*, reflecting her love of the land she painted. The 1936 show was larger, containing 17 new works. Among the paintings of a sunflower, a turkey feather and studies of Hopi kachina dolls, blossoms and bones also made a reappearance in *Ram's Head, White Hollyhock, Hills* (1935). Like O'Keeffe's later painting of 1937, of an elk's skull and antlers floating over the New Mexican mountains (*From the Faraway Nearby*), *Ram's Head, White Hollyhock, Hills* was interpreted by some critics as the symbolic representation of the opposing forces of life and death, or even of man and woman. Some even went as far as to suggest that the paintings symbolized O'Keeffe's own triumph over her recent illness. Always at pains to dismiss psychological interpretations of her work, O'Keeffe insisted that the compositions "just sort of grew together."

Returning to the Shelton Hotel after nearly two years' absence, O'Keeffe found that she needed more space than their two small rooms allowed. She had also tired of the view from the apartment. Stieglitz, now often bedridden, continued to abhor any even slight change to his well-established routine, and only in the fall of 1936 was he finally persuaded to move into a penthouse apartment at 405 East 54th Street. The new apartment consisted of a few large rooms, with a wraparound terrace that offered magnificent views of the East River and the Queensboro Bridge, as well as unobstructed views of the sky. On Saturday nights it remained Stieglitz's custom to bring back to the apartment the friends who lingered at An American

Place at the end of the day and Marin, Dove, Hartley, Emile Zoler, James Melquist and William Einstein were frequent visitors. Einstein was particularly interested in introducing O'Keeffe to the sculptor Alexander Calder, and, soon after the two met, Calder sent O'Keeffe a large brass brooch that was fashioned to spell "OK," the same letters that O'Keeffe used in lieu of her signature on her canvases. Years later O'Keeffe had a copy of the brooch made in silver to match her gray hair, and wore it when she went to Calder's retrospective exhibition shortly before his death.

After seeing Stieglitz settled in at Lake George in 1937, O'Keeffe once again set off for Ghost Ranch. When she arrived in July without having arranged for her accommodation beforehand, she found to her anger that the ranch was full. Arthur Pack suggested that she stay at Ranchos de los Burros three miles away, a house that Pack had originally built for his first wife (who had run off with their children's tutor). The building was a simple U-shaped adobe structure in a secluded location, but was surrounded by stunning views. O'Keeffe later said of the place: "As soon as I saw it, I knew I must have it," and that summer O'Keeffe produced a number of paintings, including *The House I Live In* and *My Front Yard*, as well as a series of paintings depicting the Pedernal, a flat-topped mesa in the Jemez Hills about 10 miles away.

O'Keeffe's work continued to be shown at An American Place, where it still attracted the more sophisticated art audiences. But her work was being increasingly included in numerous group shows in America and abroad, which brought

Left: Mrs. Chester Dale, a noted patron of the arts, shares a quiet moment with O'Keeffe at a New York exhibition of glass designs in 1940.

Right: In 1942 O'Keeffe collected an honorary degree from the University of Wisconsin. Here she is pictured dressed in academic regalia with Hu Shik and Edgar Robinson. Another notable recipient was General Douglas MacArthur.

her to the attention of the more general public. Her reputation as America's greatest woman painter remained undiminished, and in 1936 the cosmetics magnate Elizabeth Arden commissioned a massive O'Keeffe painting of four white jimson flowers for $10,000 for her New York exercise parlor. An O'Keeffe painting of a petunia already graced Arden's art deco 5th Avenue apartment. She also created a lily design for the Steuben Glass Company, to be engraved on crystal bowls which sold for $500 apiece, while early in 1938 *Life* magazine ran a photostory on O'Keeffe. One day, when she was collecting her car from a garage after repair, O'Keeffe recalled that the mechanic exclaimed "Why, I know you." He went on to explain that he had cut a reproduction of her *Horse's Skull with*

Pink Rose painting out of a magazine and had pinned it to his living-room wall. As a result of being so widely known, more commercial companies approached O'Keeffe and, in the summer of 1938, the advertising agency N. W. Ayers asked her to be one in a series of artists who were visiting Hawaii as the guests of their client, Dole Pineapple Company. In exchange for the trip, O'Keeffe would present Dole with two paintings to be used in their advertising. O'Keeffe accepted, perhaps because she knew that there were hundreds of unusual flowers that grew only on the islands and nowhere else on the planet.

In early February 1939, with her annual exhibition hung, O'Keeffe took the railroad to the west coast and boarded a ship for Honolulu. There she painted hibiscuses, lotuses, ginger

flowers, fish-hooks, and the landscapes of the Iao Valley on the island of Maui, but not one single pineapple. O'Keeffe claimed that she had been denied the opportunity of doing so in the pineapple-pickers' village (her escort explained that, according to island custom, "integration" was frowned upon), and that the specimen given to her instead had to be rejected because it had been "manhandled." When she returned to New York, O'Keeffe decided to present Dole with a small oil of a red ginger flower and a painting of a green papaya tree. Dole accepted the first painting but not the papaya – the company claimed that it advertised a rival company's product – and asked O'Keeffe for a pineapple painting. O'Keeffe replied angrily that had she known that she had to paint a pineapple she would never have accepted Dole's invitation. Nevertheless, a budding pineapple plant was flown to New York and O'Keeffe grudgingly fulfilled her obligation, even though she later claimed that she did, in fact, find the plant interesting. O'Keeffe's next exhibition contained paintings of the exotic Hawaiian flowers, but few sold and she rarely exhibited them again.

After her return from Hawaii in April 1939, O'Keeffe was once again irritable and tense, often suffering from headaches, and in May she was ordered to rest by her doctor. During this time she was named as one of the most outstanding women of the past 50 years by a committee of the New York World Fair,

and her painting *Sunset, Long Island* was the sole image chosen to represent New York State at the fair. In August 1939 O'Keeffe was again well enough to visit Lake George, and by October she was painting again.

In the summer of 1940 O'Keeffe returned to New Mexico, only to find that strangers had rented Ranchos de los Burros. Feeling that the house truly belonged to her, O'Keeffe offered to buy it from Arthur Pack for $6000. The subsequent deed of sale, dated 30 October 1940, detailed that O'Keeffe's eight or so acres were bordered to the south and northwest by Pack ranch land, and to the east by Canyon National Forest – all areas which O'Keeffe believed would be safe from future development because of the lack of water in the area. At last O'Keeffe owned the house of her dreams, and that summer she painted pictures of it – an adobe wall, a patio post, a chimney. The house's structure immediately became subordinate to the views, and by 1943 the walls in every room had been broken through and replaced by huge panes of glass. Nevertheless, Ranchos de los Burros was not an easy place in which to live: there was no electricity except for that provided rather erratically by a temperamental generator, the water had to be pumped by hand, and the nearest telephone was in Española, about 40 miles away. The journey into town for supplies was always difficult and sometimes impossible, particularly when

flash floods ripped through the arroyos and turned the drainage ditches into raging rivers. Soon O'Keeffe realized that she needed help and hired a housekeeper, Maria Chabot (who seemed to have a knack when it came to the generator), leaving O'Keeffe free to paint for as long as she liked.

Often O'Keeffe and Maria hiked, rode horses, or traveled by car to camp overnight in order to watch the sunset over the mesa. From 1940 O'Keeffe painted the gray-white formations of ancient lava ash near the village of Abiquiu, which she called "The White Place." A hundred and fifty miles to the northwest of the ranch was Navaho country, where rolling dark hills occupied the dry, desolate region. This O'Keeffe nicknamed "The Black Place," and captured it in a series of paintings.

When America entered World War II, life at Ranchos de los Burros became even harder: gasoline was rationed, and coupons were required to buy butter and meat. Many of Pack's ranch-hands, who usually helped with the heavier jobs on O'Keeffe's land, were gone – enlisted or conscripted into the armed forces. Having been criticized in Texas for her apparent lack of patriotism – actually her lack of enthusiasm for the war – during World War I, O'Keeffe was greatly surprised to learn that she was to be honored in 1941 alongside General Douglas MacArthur, the Commander of the Pacific Forces, with an honorary doctorate from the University of Wisconsin. O'Keeffe, who otherwise had little contact with her family, went to the ceremony with her 87-year-old Aunt Ollie, who

had paid O'Keeffe's art-school fees when she first started studying seriously.

Each fall O'Keeffe returned to New York in time for Stieglitz to arrange her annual exhibition. In 1942 Daniel Catton Rich, curator of painting at the Art Institute of Chicago, asked to stage O'Keeffe's first major retrospective show. O'Keeffe agreed, and in January 1943 arrived in Chicago to oversee her first important show outside Stieglitz's An American Place. The Chicago show was to include paintings from every stage of her career, with 61 works dating from 1915 to 1941 on show. Unhappy with the pale violet-colored walls in the exhibition galleries, O'Keeffe demanded that they be painted white. Furthermore, she insisted that the Institute was obliged to purchase one of her paintings for its collection. Acceding to all her demands, the Institute selected *Black Cross, New Mexico* (1929) for its collection.

In the summer of 1943, O'Keeffe began a series of paintings which she called "The Bones and the Blue." She had found a cow's perfect pelvic bone, and took great pleasure in looking through the oval holes at the sky and the landscape. The pelvis would be featured in a number of paintings – in close-up like her flowers, sometimes frontally, sometimes in profile against the blue of the sky, and sometimes with the hollow sockets filled with the familiar motifs of flowers, the moon or the Pedernal. When the pelvis series was shown for the first time in 1944, it was interpreted by many as O'Keeffe's "wartime" statement,

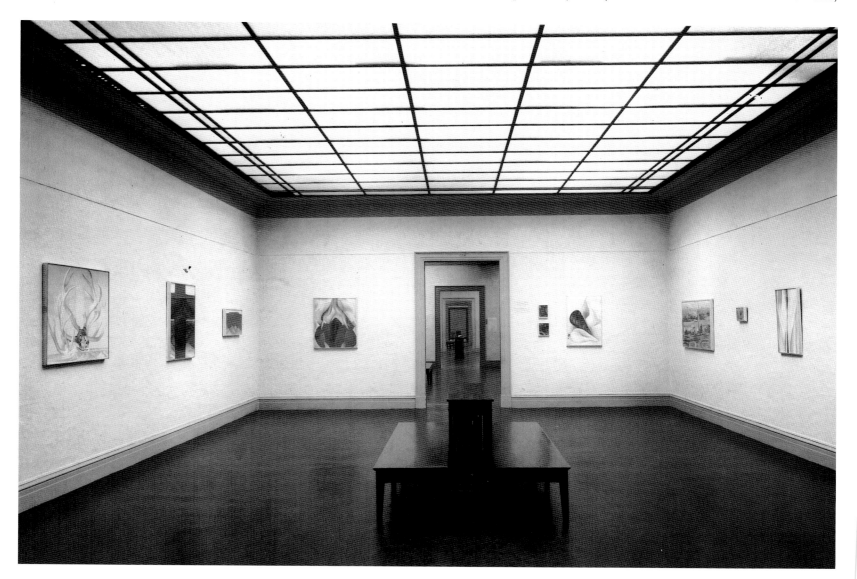

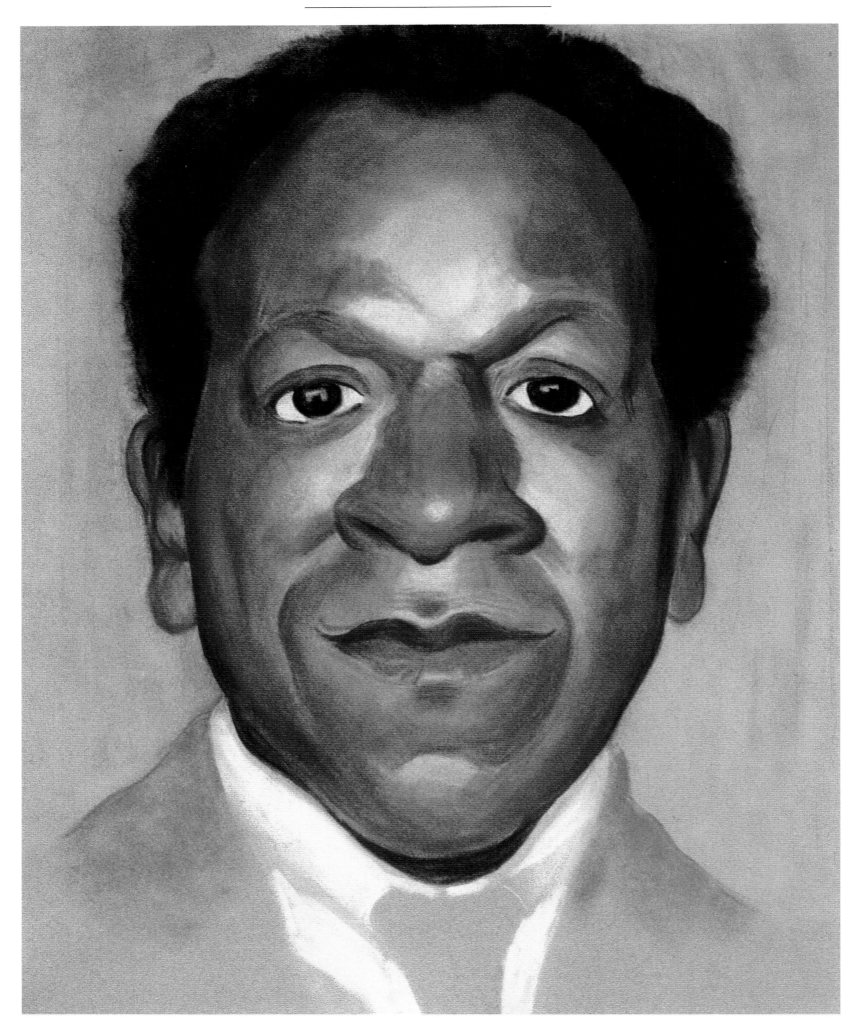

Left: In 1943 the Art Institute of Chicago staged O'Keeffe's first major retrospective. Covering 26 years of work, the exhibition was organized independently of Stieglitz. The Art Institute found O'Keeffe very demanding and consequently difficult to deal with.

Above: Portrait of Beauford Delaney early 1940s
Pastel on paper, 15¼×11½ inches
The Regis Collection, Minneapolis, MN

mainly as a result of her essay in the exhibition catalog in which she attempted to explain the motivation for the series. Although O'Keeffe maintained that the paintings were of abstract forms, her statements in the essay confirmed many people's views that the pictures had been painted with an awareness of the war raging around her. For example, O'Keeffe wrote that the bones were "most wonderful against the blue – the blue that will always be there as it is now after all man's destruction is finished."

Now in her late fifties, O'Keeffe had in the back of her mind the awareness of her own and Stieglitz's advancing age, and the realization that she would soon have to prepare for a life completely without her husband. Stieglitz, who was now in his eighties, and whose health had deteriorated, was weak and unable to walk, except for very short distances. Now he spent much of his time napping in a back room of An American Place. O'Keeffe likewise was tired, and found Ranchos de los Burros heavy work. She decided that she needed a particular abandoned property in the village of Abiquiu, partly because of its water rights, and partly for its fertile garden and surrounding three acres of land. The crumbling hacienda – part villa, part pigpen – was bordered by the road from Española to Ghost Ranch on one side, and on the other by an arroyito called *El Ojito del Meurto* [the Little Eye of the Dead] and a livestock corral. While the house was being fixed up – with some difficulty, as most of the building materials in the area were being requisitioned for the construction of the atomic research center at Los Alamos – O'Keeffe camped out nearby. The finished, all-white studio, with large glass walls, afforded views down the Chama River Valley where there were plenty of subjects for O'Keeffe to paint.

In early June 1946 O'Keeffe left New York and Stieglitz as usual – traveling for the first time by air – for New Mexico. In July her car was flagged down by the boy who worked in the Española telegraph office, and she was handed a cable telling her that Stieglitz had suffered a cerebral thrombosis and was now in a critical condition. O'Keeffe drove straight to Albuquerque airport and caught the first flight east. At the hospital she found Stieglitz in a coma. He died in the early hours of Saturday, 13 July 1946. The same day, O'Keeffe determined to bury her husband with simple dignity and, after some delay (most of the appropriate "stores" were closed for the weekend), she found a pine casket, but hated the pink satin lining so much that she spent the night ripping it out and replacing it with plain white linen. After his cremation, O'Keeffe buried Stieglitz's ashes at the foot of a pine tree on the shores of Lake George. Outwardly calm and self-possessed, O'Keeffe's grief was evident only to the very few who were close to her.

O'Keeffe was named in Stieglitz's will as both the main beneficiary and executor of his entire estate, and she now found herself faced with the mammoth task of finding "homes" for his collection of 850 works of modern art, hundreds of photographs, and thousands of letters and documents. O'Keeffe spent the next three winters in New York settling the estate, finally deciding that the bulk should go to the Metropolitan Museum of Art in New York because it was this city that Stieglitz had considered his own. The Art Institute of Chicago received the second-largest donation, while an archive was established at Yale University's Collection of American Literature to house Stieglitz's vast collection of documents. With all this to be done, it is not surprising that O'Keeffe had very little time to do any painting.

The summer of 1948 was somewhat easier for O'Keeffe, and she was able to spend more time working. The heavy spring rains in the Southwest had watered the ground and encouraged the native yucca to send forth its dramatic white flowers. One of O'Keeffe's pictures from this time was a very large canvas – about four feet by seven feet – called simply *Spring*, depicting blossoms and bones floating in front of the Pedernal. Instead of shipping her paintings back east as she had done when Stieglitz was alive, O'Keeffe now kept her work in New Mexico.

The following year O'Keeffe was elected to the National Institute of Arts and Letters, along with such luminaries as e.e. cummings and Christopher Isherwood. To O'Keeffe the honor was indeed a great one, since at that time only about one-tenth of the Institute's members were women, and her election to it proved that the official art establishment had recognized both her work and women's contribution to the arts.

After Stieglitz's death O'Keeffe tried to keep An American Place going, but without her husband's enthusiasm for the project, she knew it would fail. In the fall of 1950 O'Keeffe showed 31 paintings there, in what was to be An American Place's last exhibition. Now no longer needing to show her work each year to make her living, O'Keeffe decided to return to New Mexico to live there year-round. Before she left New York, however, she painted the picture that she had always meant to do but had never got around to: *Brooklyn Bridge*.

Although she retreated to a life of solitude, seeing friends only in vacations, and otherwise being content to do paintings of her house, rendering the door, the patio and the windows over and over again on canvas, O'Keeffe now found that she had to deal with the public and with art dealers on her own, something that Stieglitz had always taken care of on her behalf ever since her first show back in 1916. In the 1930s Stieglitz had "lent" artists' works for group shows arranged by Edith Halpert at the Downtown Gallery, and now it seemed natural to O'Keeffe to settle herself with Halpert, particularly since O'Keeffe would be the only woman artist represented. During the 1950s O'Keeffe showed only three times under Halpert's auspices – a reflection of her relatively sparse and less important output at this time. Furthermore, the Downtown Gallery received very little publicity when compared to her big museum-staged retrospectives of the 1940s. It seemed as though the

Right: Brooklyn Bridge 1948
Oil on masonite, 47¹⁵⁄₁₆ × 35⅞ inches
Bequest of Mary Childs Draper, The Brooklyn Museum, Brooklyn, NY

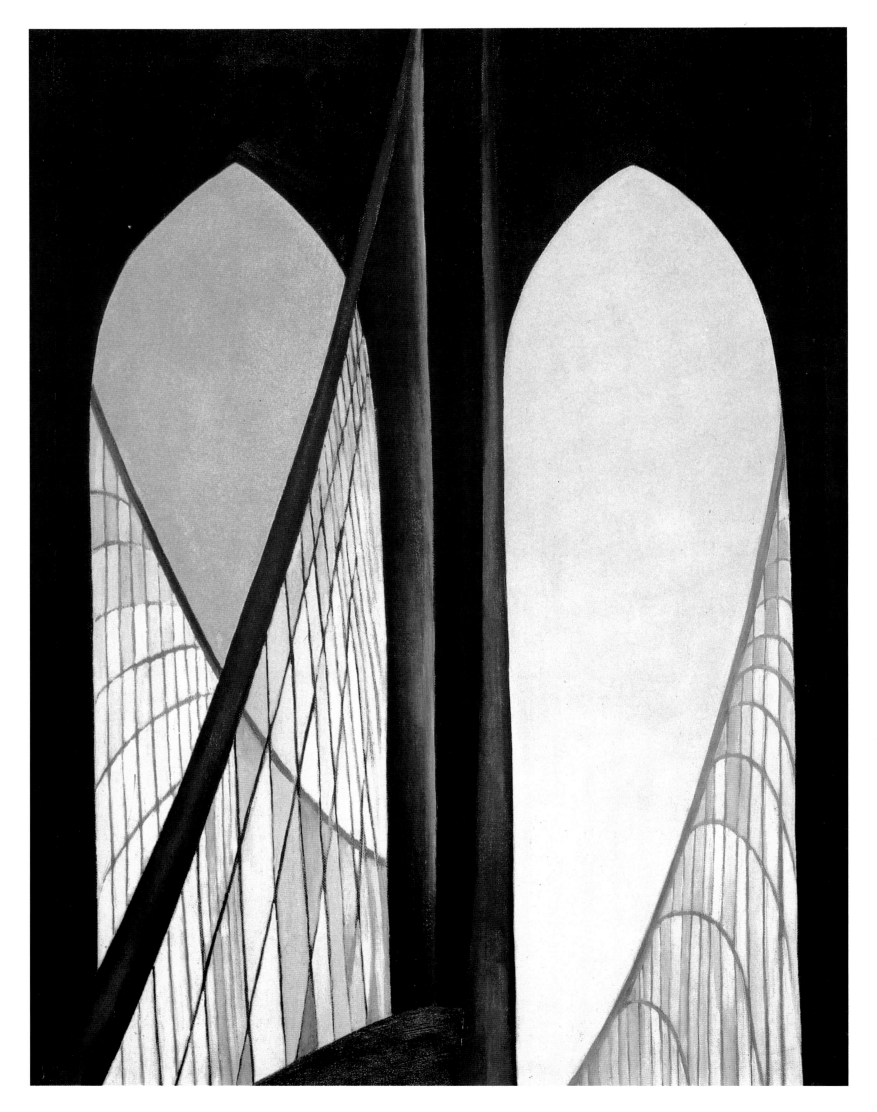

Left: In 1945 O'Keeffe was named a "Maker and Promoter of Progress" by the Women's National Press Club. O'Keeffe is pictured second from left in the back row, along with fellow recipients from all walks of life.

Right: Looking from Garage to Bedroom, Abiquiu, NM *c.*1955
Gelatin silver photograph,
4⁷⁄₁₆×6³⁄₁₆ inches
Anonymous Gift, 1977,
The Metropolitan Museum of Art,
New York, NY (1977.657.2)

American art world was pursuing its interest in American abstract expressionism and was forgetting about O'Keeffe, who meanwhile was discovering that the winters in New Mexico were as exciting as the summers.

If O'Keeffe shied away from human contact, she was devoted to the succession of fierce little Chinese chow dogs, the first of which she had been given for Christmas in 1952. The woman who was not a joiner of clubs became so devoted to the breed that she even joined the International Chow Society!

In the meantime changes were afoot which threatened to disturb O'Keeffe's peaceful, solitary existence. After World War II, Arthur Pack and his family moved to Tucson, having found Ghost Ranch too remote for their needs. By the late 1950s Pack was resolved to sell up, but in 1955 decided to donate the ranch to the Presbyterian Church instead. O'Keeffe was outraged: she was convinced that Pack had promised her first refusal if he ever gave up the ranch, and when she heard of the deal she raced to Pack's house, ignored the church dignitaries assembled there, and said angrily: "Now I suppose this beautiful place will be crawling with people and be completely spoiled. I never had any use for Presbyterians anyhow!" However, the deal went through, and in the end O'Keeffe simply acted as though the "invading" Presbyterians did not exist, ignoring them completely.

O'Keeffe also began to complain about the increasing number of cars, trucks and tourists coming into "her" valley after the war, and contemptuously said of a small, low building erected in Abiquiu that it was "something they call a museum." Finally, when the old road near the Chama River was replaced by a new four-lane highway that was closer to the ranch, O'Keeffe complained that she could hear the noise of the traffic, and that her house could now be seen from the road by curious onlookers. O'Keeffe had always had a difficult time with her Abiquiu neighbors: when she first moved in, the townspeople were wary of the unsmiling stranger dressed in black with the two rather ferocious dogs that barked and bit anyone who came within striking distance. The elk skull and antlers that marked the entrance to her property further aroused their suspicions, and many believed that she was a sorceress! O'Keeffe, of course, stayed aloof from the townspeople, refusing to speak to them in Spanish, and was rarely heard to say the words "thank you" to the staff she hired. Yet in her own way O'Keeffe tried to bridge the gap between herself and the townspeople: when she realized that her well had the only pure water in the region, she spent thousands of dollars on a system to pump water from the hills into the town, and she donated money to enable the local television station to pick up educational programs. She preferred to have the local boys, rather than the girls, do odd jobs for her, and on many occasions sponsored a boy at school in Española or at the University of New Mexico. Nevertheless, her taciturn nature meant that she became annoyed when her demands were resisted.

In the 1950s O'Keeffe began to travel extensively. In 1951 she traveled to Mexico, to the capital, and then on to the south, to Oaxaca, and back via Yucatán and south Texas to see Big Bend National Park. In the spring of 1953, at the age of 66, O'Keeffe set out for Europe for the first time in her life. In Paris she toured the Louvre and in the Midi she saw Cézanne's

Mont Sainte-Victoire but refused to meet Pablo Picasso! In Spain she greatly admired the Goyas in the Prado, and thoroughly enjoyed the bullfights. O'Keeffe was also fascinated by Peru, where she spent two months in the spring of 1956.

On her return to New Mexico she tried to paint what she had seen using working sketches, but in the end she destroyed or threw away many of the worked-up canvases. One of O'Keeffe's canvases was found by a neighbor in the town dump, which he then used to secure a loan for $12,000. One surviving picture, called *Mists – A Memory*, painted in 1957, depicts a volcanic peak in the Andes.

In early 1959, aged 71, O'Keeffe set off again, this time on a three-and-a-half-month trip around the world, with stops in America, Asia, the Orient, the Middle East and Europe. "I prefer the Far East to Europe" she noted wryly, "I like the dirty places of the world." But after seeing the world she decided that her beloved home in New Mexico was as good a place as any, despite the postwar intrusions on her isolation. The only place that came anywhere near Abiquiu, she noted (perhaps because of its isolation) was the rose-red city of Petra in Jordan.

Although O'Keeffe enjoyed being out of the limelight, many of her old admirers were not sure whether she was still painting, while a whole new generation of young Americans were not even familiar with her work. In 1957 *Newsweek* featured O'Keeffe in its "Where are they now?" column, which was fol-

lowed by another article on O'Keeffe in the *Saturday Evening Review*, which claimed that the price of O'Keeffe paintings had subsequently gone into a decline. A letter on O'Keeffe's behalf, written by Daniel Catton Rich, now director of Worcester Art Museum in Massachusetts, emphatically denied the assertion, and persuaded O'Keeffe to hold a major show – the first since Stieglitz's death. O'Keeffe spent most of 1960 preparing for the show, offering opinions and ideas each step of the way, supervising the exact shade of color for the walls, the hanging, and even having the opening date changed so she could take a trip to Japan! The show, her first major exhibition in 14 years, contained a great deal of new work: more than a third of the paintings had been executed after 1946, and many had been completed in the previous two years, including *White Patio and Red Door* of 1960 – a huge canvas, 16 feet by 28 feet, consisting of reddish-colored geometric blocks. Several of the paintings on show were inspired by the views which O'Keeffe had seen during her airplane journeys around the world: for example, *It was Yellow and Pink*, and *It was Red and Pink*. The pleasure which O'Keeffe got from looking down at the rivers that cut through the earth was a theme that she would return to in 1964, in paintings like *From the River – Light Blue*.

Many of the visitors to the show were baffled by the seemingly abstract forms of the paintings, but the Worcester show put O'Keeffe firmly back in the public's eye and, although she

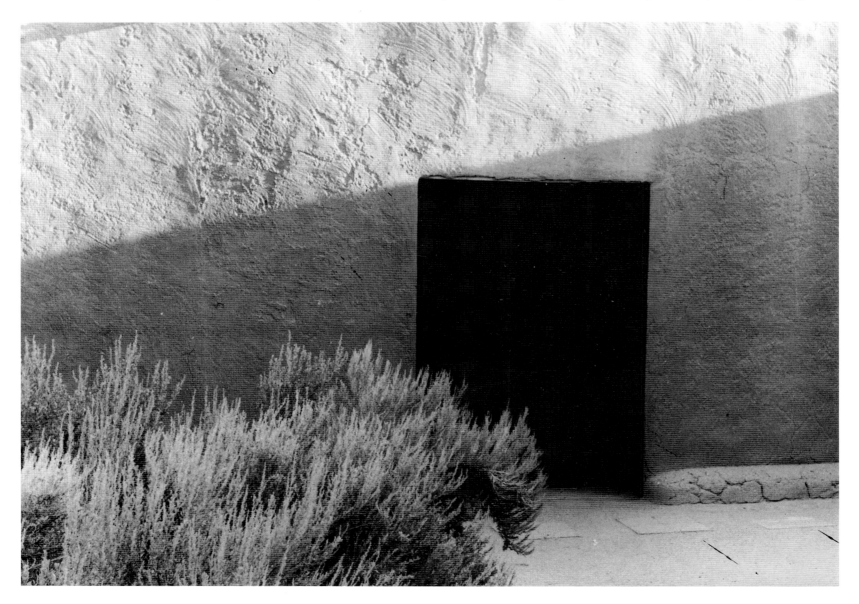

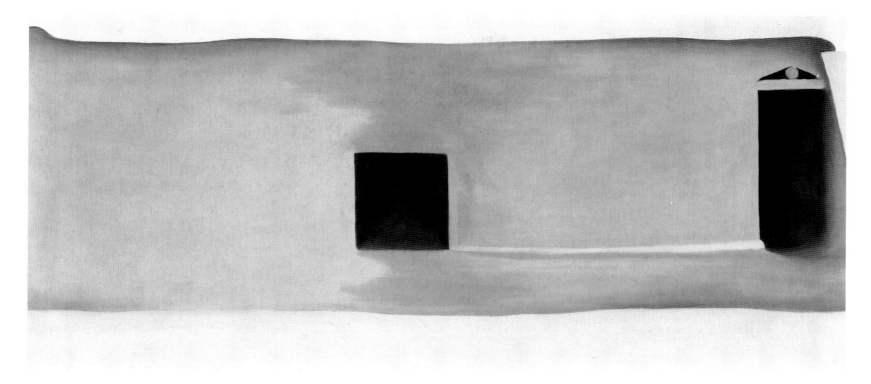

had always disliked giving interviews and meeting the public, she grudgingly tolerated both in Massachusetts, and even presided over a small press conference of art critics. At least one visitor to the show pleased O'Keeffe. She wrote in her autobiography: "One day I saw a man looking round . . . I heard him remark, 'They must be rivers seen from the air.' I was pleased that someone had seen what I saw and remembered it my way."

On her return from her trip to the Far East, O'Keeffe was pleased to learn that her public reappearance had been successful. Many national magazines had covered the show, and some contained color reproductions of her paintings. *Newsweek* heralded her as the "grand old lady of painting," and the fol-

lowing summer *Look* ran photographs of older women who were proclaimed as "Ageless Beauties": Edith Sitwell, Isak Dinesen, Katharine Cornell and Georgia O'Keeffe.

After the Worcester show was dismantled in December 1960, 20 of O'Keeffe's newest drawings and paintings were exhibited in the spring of 1961 at the Downtown Gallery in New York. This show would be O'Keeffe's last at this gallery. For a long time tensions had been growing between Halpert and O'Keeffe, who complained that the prices were set too low, that paintings had been damaged, and that they were being loaned out too frequently. Finally O'Keeffe stopped sending her best paintings to Halpert in New York, preferring to keep them for herself in New Mexico.

Above: In the Patio IV 1948
Oil on canvas, 14×30 inches
Gift of the William H. Lane Foundation, Courtesy Museum of Fine Arts, Boston, MA

Left: Patio with Black Door, Abiquiu, NM c.1955
Gelatin silver print,
4⁷⁄₁₆×6¼ inches
Anonymous Gift, 1977, The Metropolitan Museum of Art, New York, NY (1977.657.1)

O'Keeffe's recent fascination with rivers made it seem natural for her to explore them further, and in late August 1961 she joined a 185-mile raft trip, organized by the nature photographer Eliot Porter, down the upper part of the Colorado River. Despite her age, the 74-year-old painter agilely climbed in and out of the rafts and often helped to row, demanding her fair share of the work load. "If I can't do it myself, I shouldn't be on the trip" she contended. Since there was no time on the 10-day trip to paint, O'Keeffe asked Porter to arrange another trip immediately afterward. In fact, O'Keeffe would return to the Colorado River half-a-dozen times to see the natural wonders of Music Temple, Mystery Canyon and Hidden Passage Canyon. Back in her studio, she painted what she had seen, but seems to have been unsure about the results since she never exhibited the paintings.

On their trips O'Keeffe and Porter would lightheartedly compete to see which one of them could find the best polished riverbed rocks. Often they would raid each other's stores. Once, when Porter found a small but perfectly smooth black stone, the good humor between the pair disappeared. O'Keeffe badly wanted the stone, but Porter refused to let her have it, saying that he wanted to give it to his wife Aline, who was at home. Months afterward O'Keeffe joined the Porters at their home on the outskirts of Santa Fe for Thanksgiving, and saw the prized stone on display on the coffee table. One version of the story says that O'Keeffe put the stone in her pocket when she thought no one was looking, and took it home secretly, after which the Porters let her keep it. Another version has it that she put the stone back, but that the Porters gave it to her anyway. Whatever the truth, O'Keeffe was undoubtedly the same person of whom Stieglitz had said: "When she wants something, she makes other people give it to her."

In the early 1950s O'Keeffe painted some realistic pictures of the landscape, and also of U.S. highway 48, which linked her

Right: The dramatic New Mexican landscape and simple lifestyle of the region's Native Americans held an enormous allure for O'Keeffe. Pictured here is a basic wooden staircase, sited next to a Pueblo Indian oven, thus presenting an interesting contrast in curved and diagonal lines.

private domain to the outside world. In 1963 O'Keeffe turned from the river theme back to focusing on the movement of the road, in paintings like *The Winter Road*. Long ago in Texas she had painted washes inspired by the expansive sky, and when she began her airplane journeys her enthusiasm for the sky became apparent once again. One of the first oils on this theme was a painting of a solid white mass of clouds on the lower two-thirds of the canvas, crowned at the top by the sky. In later paintings the cloud bank was broken up with areas of blue. In June 1965 O'Keeffe began work on the largest canvas of her career: *Sky Above Clouds IV* measured a vast 24 by 8 feet, a total of 192 square feet of canvas, the size of which had been determined by the scale of the inside walls of the garage at the ranch where she planned to paint it. Painting this was something of a race against time: the days were becoming shorter and colder, making work uncomfortable in the unheated garage. Using a ladder to reach the top sections, O'Keeffe gradually worked down the canvas to "table-top" height, to "box height," and then to "chair height," until finally she lay on the floor to work along the bottom edge of the painting – despite the threat of the rattlesnakes which could easily enter the open garage. The finished painting depicted a sky full of white oval clouds stretching into a pink and blue infinity.

The urge to complete *Sky Above Clouds IV* may in part be attributed to another impending retrospective exhibition, this time in Texas, at the Amon Carter Museum of Western Art in Fort Worth in 1966. The show would be the biggest of O'Keeffe's lifetime, with 96 works shipped in from museums and private collections. Parts of the show later transferred to Houston and the University of New Mexico in Albuquerque, where thousands would flock to see O'Keeffe's first major show in her adopted home state. Meanwhile, the 76-year-old O'Keeffe flew to London to visit the British Museum!

During the 1960s bestowals of awards and honors became an annual event for O'Keeffe, but the most prestigious was her election in 1962 to a seat (left empty on the death of e.e. cummings) on the 50-member American Academy of Arts and Letters. Ironically, elevated alongside her was her old classmate Eugene Speicher, as well as the painter Thomas Hart Benton, sculptor Jacques Lipshitz, historian Bruce Catton, and writer Lillian Hellman. Once again, O'Keeffe was in exclusive company: only five of the members were women, and she was the only painter among them.

As she began to exhibit widely again, O'Keeffe's face and name became known to another new generation of admirers. A few months before her eightieth birthday, *Vogue* published an eight-page, heavily illustrated cover story that told of her Southwestern life style.

In 1970 O'Keeffe opened her first major show in New York since Stieglitz's death 24 years earlier, a retrospective at the Whitney Museum, which later traveled to Chicago and San Francisco. As plans for the show got under way, O'Keeffe returned to the theme of rocks, which she had first painted during her "bone" period. Originally the Whitney show was planned for 1969, but was postponed for a year because O'Keeffe insisted on having the largest floor available to show her 121 paintings. She also insisted that the lengthy catalog was ready a month before the show opened, but the delays really occurred when she took it upon herself to supervise personally the hanging of the paintings because she objected to the gallery's original plan to hang them chronologically.

When the show transferred to Chicago and San Francisco it set new attendance records which beat those of every other painter except Andrew Wyeth. Escorting her old friend Blanche Matthias around the show at the San Francisco Museum of Art, O'Keeffe stopped in front of one of her latest paintings, *Black Rock with Blue*. O'Keeffe was used to saying that she had never surpassed any of her early paintings, but on this occasion she told Blanche: "It was the last thing I did, and the best."

One day in late 1971, O'Keeffe suddenly realized that her prized razor-sharp eyesight had gone, and that her vision was

Left: Juan Hamilton, O'Keeffe's right-hand man from the mid-1970s until her demise in March 1986, pictured a few months after her death. Hamilton's inheritance was bitterly contested by O'Keeffe's relatives.

Right: O'Keeffe is shown here in the company of Alexander Calder in 1976, attending a dinner honoring the sculptor at the Whitney Museum of American Art.

blurred. Now she was unable to bring into precise focus many of the images that she loved, and consequently O'Keeffe stopped painting. After consulting several eye specialists, who told her that her problem was common among the elderly, O'Keeffe took to using a magnifying glass to read, in order to overcome her loss of central vision.

One fall day in 1973 a young man, Juan Hamilton, called at O'Keeffe's ranch asking for work. O'Keeffe was accustomed to having strangers – in particular aspiring young artists – drop by for advice, and was equally quite used to turning them away. On the verge of sending Hamilton away, O'Keeffe remembered that she had some canvases that needed to be wrapped for shipping, and asked Hamilton to do the job. Before long O'Keeffe began to rely on Hamilton to do odd jobs around the ranch. Hamilton had been brought up in Ecuador, Colombia and Venezuela, where his father was a Presbyterian missionary, and had returned to the U.S. when he was 15. After graduating from college in Nebraska, Hamilton studied sculpture at Claremont Graduate School in California. As well as giving Hamilton paid work, O'Keeffe also took an active interest in his development as an artist, urging him to focus on his own work in pottery. Hamilton in turn encouraged O'Keeffe to try her hand

once again at sculpture, and consequently she allowed him to teach her to make hand-rolled pots. This experimentation in clay gave O'Keeffe the opportunity to work in a medium that relied as much on touch as on sight and, not surprisingly, O'Keeffe found that the urge to create was as strong as ever. She became so interested in working in three dimensions that for a while she worked with cardboard models for a 10-foot-high white form that she planned to erect at Ghost Ranch.

As time went by, however, O'Keeffe became impatient and increasingly frustrated by her slow progress with clay: she was particularly annoyed when some of her clay pots broke during the firing process. Nevertheless, O'Keeffe was slowly working her way back to painting, and she realized that, even with her dimmed eyesight, she still had better control over brushes and paint than she did over clay. She therefore began to work, first in watercolors, and then later, with the help of a number of studio assistants who mixed paint and did some of the background brushwork, in oils. Many of the paintings from this period, such as *From a Day with Juan* and *Pink and Green Spring* have the same strong shapes and colors that had always marked O'Keeffe's work, and some of the watercolors are surprisingly like those she had painted in the summer of 1916 – in fact, she titled one *Like an Early Abstraction*. In the summer of 1982 O'Keeffe astounded the art world once again by exhibiting an 11-foot-high spiral of black-painted cast aluminum at a show of 20 sculptors' work at the San Francisco Museum. The prototype for this piece was a two-foot-high white plaster model that O'Keeffe had made back in 1945.

Hamilton had entered O'Keeffe's life when she needed him most: his friendship undoubtedly helped to relieve the loneliness of her later years and to overcome some of her frailties and foibles. At Hamilton's urging, the artist who had always worn black now began to appear in public in turquoise, maroon and green. Many have remarked on the O'Keeffe-Hamilton relationship: some say that Hamilton was the child O'Keeffe never had, or the lover that she yearned for, others contend that it was simply a relationship of fellow artists. Whatever it was, it is clear that it was sincere, respectful, and one in which both enjoyed a warm affection for the other.

Because of Hamilton's encouragement, and her now almost insatiable interest in publicity, O'Keeffe overcame her reluctance to write about herself and agreed to publish her autobiography. Despite his lack of publishing experience, Hamilton oversaw the production of her memoirs, and in the fall of 1976 *Georgia O'Keeffe* was published by Studio Books, featuring more than 100 color reproductions – some of paintings never before seen by the public. O'Keeffe's anxiety about the venture only ended when the first copy of the signed and numbered edition arrived at her home and the first positive review was read to her over the telephone from New York. The book sold well, despite its price of $75 and its rather awkward size: opened, the book measured nearly two feet across.

While the production of her autobiography was under way, O'Keeffe allowed a film crew to spend five days filming her in October 1975. She had turned down many similar offers from other film-makers in the past, but accepted P.M. Adato's offer from National Educational Television in New York because she would be allowed to speak for herself. As usual, however, O'Keeffe was uncomfortable with the strange television crew and was impatient with the interviewer, particularly when she felt she was being asked all the obvious questions about herself. Two years later, on her ninetieth birthday in 1977, the award-winning film was broadcast. The previous day O'Keeffe flew to Washington, D.C. to see the film, and to attend a reception at the National Gallery of Art where some of her paintings and Stieglitz's photographs were on show.

The next year 51 photographs of O'Keeffe taken by Stieglitz many years before were shown at the Metropolitan Museum of Art in New York, and this show included some of the nude studies never before exhibited publicly. The selection of pictures had, in fact, been made by O'Keeffe and Hamilton from a large selection of prints spread out before them on the coffee table at Abiquiu. As she stared at the pictures, memories of her marriage to Stieglitz came flooding back and, in the brief essay for the book that accompanied the exhibition, O'Keeffe hinted at their strong mutual attraction and of their often bitter clashes of wills. She wrote that 30 years after his death she still had the same respect for Stieglitz's work as she had had during his lifetime. In 1983, out of respect for Stieglitz's work, O'Keeffe made the grand gesture, at the age of 95, of traveling from New Mexico to Washington, D.C. to see a retrospective exhibition of her husband's work.

As time went by Hamilton came to assume some of the roles that Stieglitz himself had once fulfilled: he handled O'Keeffe's mail, screened her telephone calls and, like Stieglitz had done before him, stood between O'Keeffe and the public. Sometimes he sensed the hostility toward him, particularly from some of O'Keeffe's longtime friends, but the most serious "casualty" of Hamilton's relationship with O'Keeffe was Dorothy Bry. For the 30 years following Stieglitz's death Bry had continued to handle estate matters and care for O'Keeffe's paintings in storage in New York. Bry had also written the catalog for the 1958 Stieglitz retrospective at the National Gallery of Art; had been guest curator of the 1970 O'Keeffe retrospective at the Whitney; and had edited and published *Georgia O'Keeffe Drawings*, a portfolio of 10 drawings signed and numbered by the artist. After O'Keeffe's break with Edith Halpert, Bry had begun to act as her agent, negotiating sales and representing O'Keeffe to the public. Like Stieglitz before her, Bry rarely loaned O'Keeffe's paintings for group shows; avoided selling paintings to speculators or dealers; and continued to maintain high prices for O'Keeffe's paintings by carefully allowing only a few works onto the market each year, saving the best paintings for the best collections. Furthermore, in order to protect O'Keeffe, Bry stipulated numerous conditions: the artist's right of first refusal if the painting came up for sale again; the barring of sold paintings from large group shows; the specification that O'Keeffe's paintings were to be hung only on white walls; the retention of

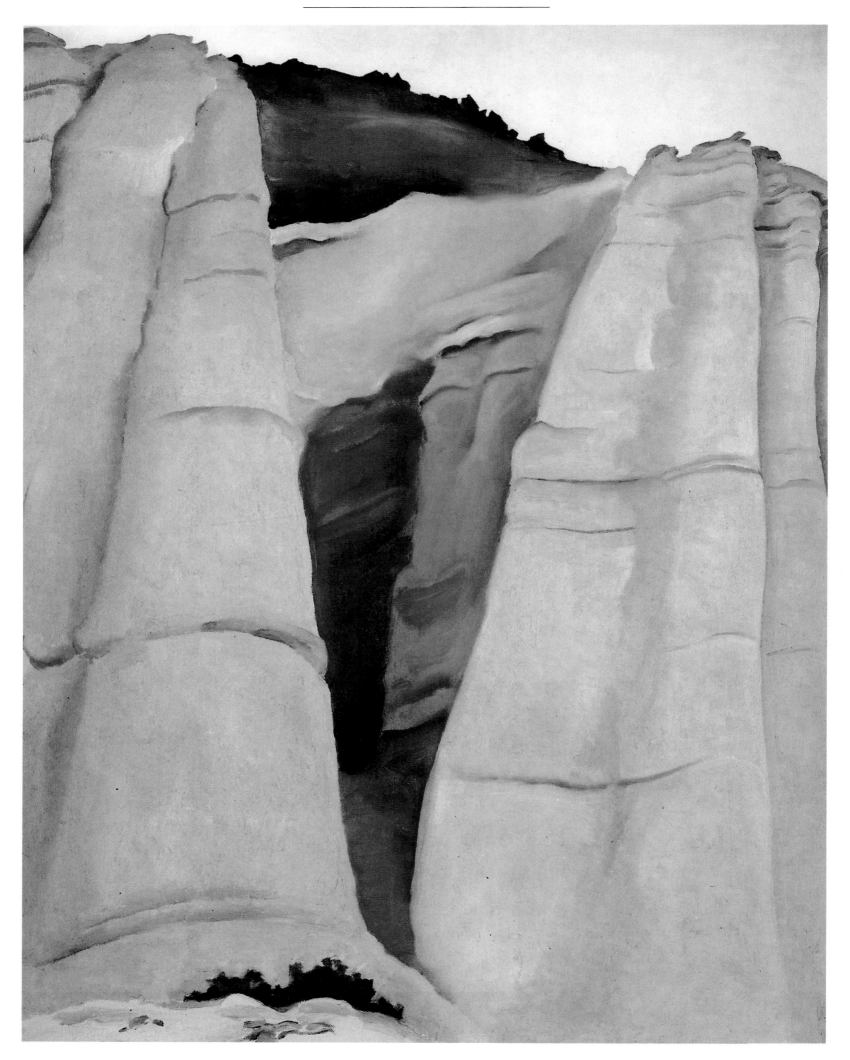

From the White Place 1940
Oil on canvas, 30×24 inches
Acquired 1941,
The Phillips Collection, Washington, D.C.

reproduction rights; and she even insisted on being consulted on any repairs or reframing of her client's paintings. In short, Bry did everything in her power to maintain O'Keeffe's status and integrity as an artist. But, as Hamilton became more important in O'Keeffe's life, he began to negotiate the sale of O'Keeffe's work himself, without Bry's knowledge: in 1975 two paintings were sold by him to a Chicago dealer without the reproduction or resale rights having been safeguarded. O'Keeffe's paintings started to appear without control on book jackets, posters and greeting cards. Tensions began to mount and, in the spring of 1977, O'Keeffe "dismissed" Bry and sued her for the return of all the paintings and property that Bry had kept stored in New York. Bry promptly countersued. It would be five years before they would reach a compromise and an out-of-court settlement.

In the summer of 1979 O'Keeffe revised her will, naming Hamilton as her executor instead of Bry, and deeding him the ranch along with a large number of pastels, drawings, watercolors and oils. Hamilton was also awarded the power to give away any remaining works to charitable institutions. The will was subsequently amended in 1983, and again in 1984, and these later changes strengthened Hamilton's claims to O'Keeffe's estate. After her death, several of O'Keeffe's relatives would legally contest the amended will, claiming that it was never her intention to give her residual estate – worth millions of dollars in works alone – to Hamilton, and not to museums and universities.

During her lifetime O'Keeffe wore her mantle of fame uneasily. Following the television documentary and the retrospective shows, there was a wave of articles about her in newspapers and magazines, and reproductions of her works began to appear everywhere – one of her shell paintings was even used on the cover of a biology textbook! And many made the pilgrimage to Abiquiu: Andy Warhol, Joan Mondale, and even fashion designer Calvin Klein, who arrived by helicopter to find O'Keeffe wearing a cardigan he had sent as a gift some years before. (Photographs of Klein at O'Keeffe's home were later used in an advertising campaign for his clothing.) To ward off uninvited visitors, O'Keeffe constantly changed her already unlisted telephone number, and any brave, unannounced visitors would often find her sharp-tongued or downright rude. Legend has it that when one stranger arrived at her gate and asked to see her, she is reported to have said "Front side!", then turned around and announced "Back side!", turned again, said goodbye and slammed the gate on the astonished visitor. Yet the public image of O'Keeffe would inspire numerous other artists: Mary Beth Edelson created a black-and-white poster called The Last Supper, which portrayed O'Keeffe as a sort of Christ figure or as, in Edelson's own words: "The great mother goddess" of women artists. In 1979 O'Keeffe was the only living woman to be included in Judy Chicago's The Dinner Party, a mixed-media tribute to 39 important women in history.

The price of O'Keeffe's paintings began to escalate in the 1960s and, reminded of Stieglitz's advice never to undersell, O'Keeffe refused to negotiate prices. In March 1973 O'Keeffe's painting Poppies (1950), owned by the Edith Halpert estate, set a new O'Keeffe auction record at Sotheby's in New York when it sold for $120,000. Twelve years later, Sotheby's sold White Rose – New Mexico (1930) for more than $1.25 million.

The high price of O'Keeffe's paintings had always attracted interest: in 1972 O'Keeffe contributed a painting to an auction to raise funds for the McGovern presidential campaign. Soon after the sale the press reported that O'Keeffe's small abstraction was the most expensive in the auction, at $40,000. As a result of thus being publicly associated with the opposition, O'Keeffe earned herself a place on President Nixon's "enemies list." Five years later, however, President Ford awarded O'Keeffe America's highest civilian honor, the Medal of Freedom, in recognition of her work.

In her nineties, O'Keeffe continued her habit of rising at dawn, breakfasting and then going to her studio where her mail and newspaper articles were read out to her by her housekeeper. Sometimes she would walk, accompanied as usual by two fierce little chows. From time to time she saw old friends: she visited Ansel Adams when she went to see his exhibition in Tucson, and traveled to New York to see her old friend Alexander Calder's retrospective at the Whitney. At first she had refused this invitation, but later said that she was glad she had gone, since Calder died soon afterward. In the fall of 1978 the four surviving O'Keeffes – Georgia, Anita, Catherine and Claudia – gathered in Abiquiu. The sisters had never been close: Catherine admitted: "We got along if we didn't see too much of each other." In her old age O'Keeffe's passion was still for Ghost Ranch, but now she was becoming increasingly frail. In her late nineties, Hamilton persuaded her to buy a house in Santa Fe, where she reluctantly moved to be closer to hospital care. Vehemently scorning the fear of death, O'Keeffe liked to say that she would live to be 100 years old. When she passed her ninetieth birthday, she even upped this figure to 125. She said: "When I think of death, I only regret that I will not be able to see this beautiful country anymore, unless the Indians are right and my spirit will walk here after I'm gone."

While she did not live to see her hundred-and-twenty-fifth birthday, O'Keeffe very nearly made it to her original goal. On the morning of 6 March 1986 she was admitted to Saint Vincent's Hospital, where she died a few hours later. At the age of 98 O'Keeffe died simply of old age. When the news of her death reached the town of Abiquiu, a villager rang the bells of the adobe church of Saint Thomas the Apostle, the church that O'Keeffe had painted several times. The following day her body was cremated and, at her request, no funeral or memorial service was held, but her ashes were scattered over the landscape which she had so loved and with which her work will always be identified.

Right: This portrait of O'Keeffe was made when she was 83. She was determined to live to be at least 100 years old, but in the end died in 1986 at the age of 98.

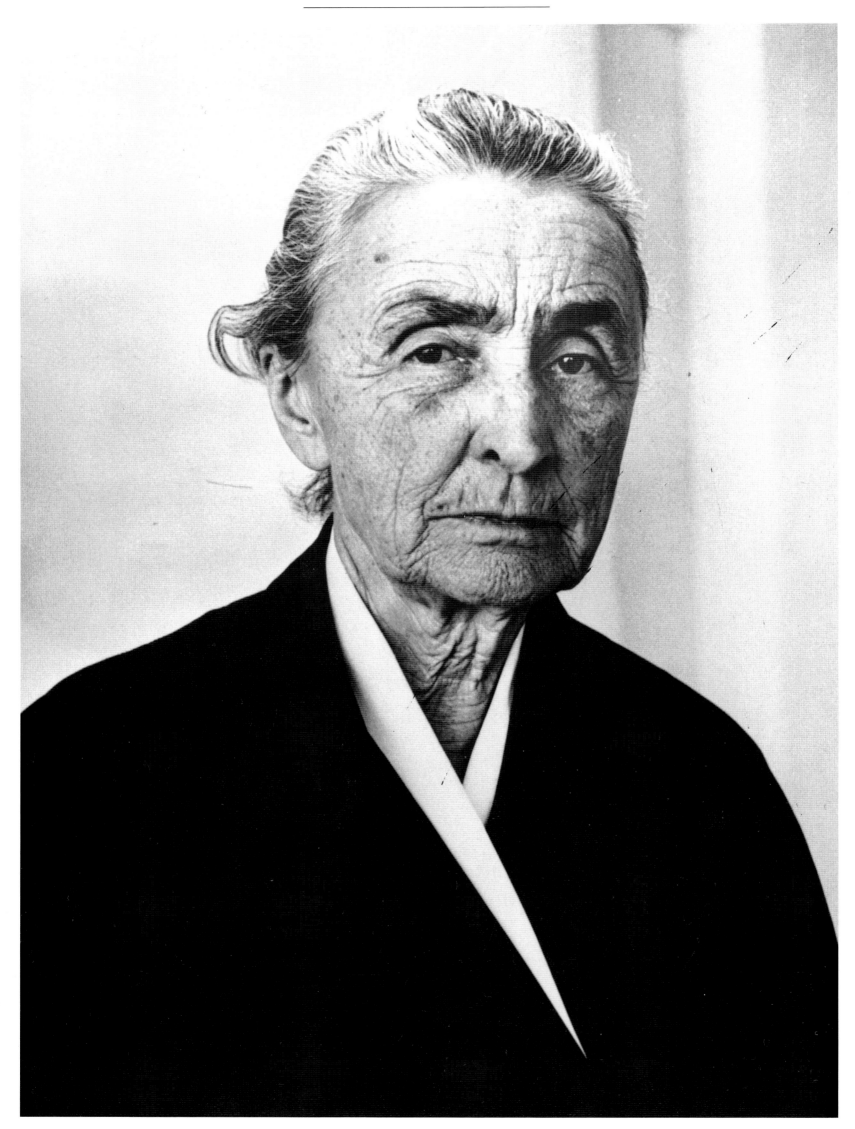

Below:
Pink and Green Mountains I 1917
Watercolor on paper, 8¹³⁄₁₆×11⅞ inches
Letha Churchill Walker Fund,
Spencer Museum of Art, The University of Kansas, Lawrence, KS
(77.43)

Below right:
Pink and Green Mountains III 1917
Watercolor on paper, 8⅞×11⅞ inches
Gift of Mrs. Harry Lynde Bradley,
Milwaukee Art Museum, Milwaukee, WI

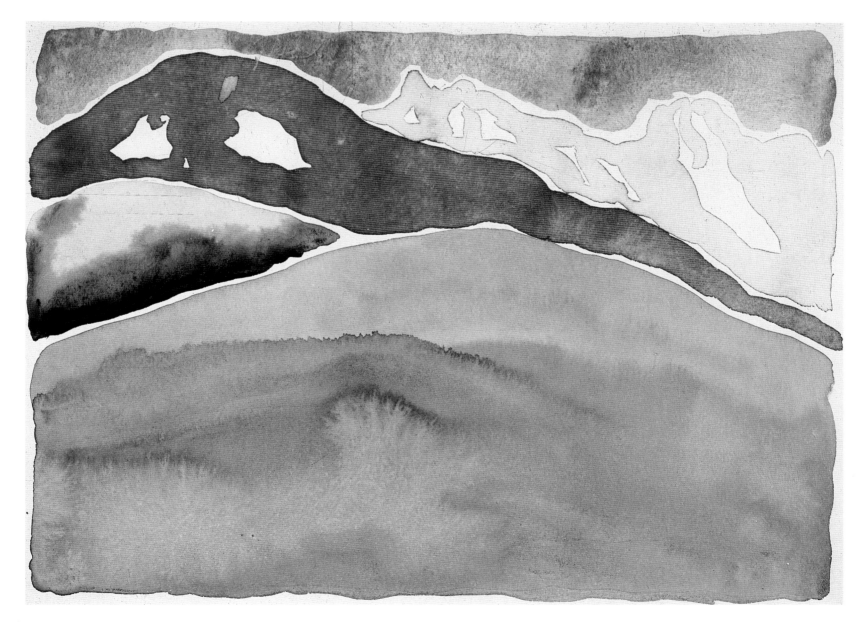

THE EAST

Although O'Keeffe's work was primarily nature-orientated, and architectural subjects were relatively infrequent, they nevertheless appear in her paintings as responses to the time she spent traveling and living in New York. Such paintings, depicting the city skyscrapers and views of the East River, come from the time when she began living at the Shelton Hotel (now the Marriott East Side) in 1925, while a number of paintings of barns record her visits to Lake George, to Wisconsin, and to Canada. As she became more familiar with a place, O'Keeffe's paintings of it became less representational and more interpretative, concerned primarily with her own emotional responses to the things she saw. "You paint *from* your subject, not what you see . . . I rarely paint anything I don't know very well," she recalled.

New York was one subject which O'Keeffe knew very well indeed: she lived in the busiest parts of the city on and off for over 30 years. But, considering the length of her residence in New York, O'Keeffe only focused on the city as a subject for her paintings for a relatively short period, between 1924 and 1929. The only time she would return to the theme was for two later commissions in 1932 and 1948.

A painter whose roots were firmly planted in rural America, O'Keeffe found New York both exciting and emotionally draining, and her often ambivalent feelings about the city are evident in her drawings and paintings. The series of paintings depicting New York skyscrapers and the views of the East River were of subjects visible to O'Keeffe from her top-floor apartment at the Shelton. Through the three largest windows,

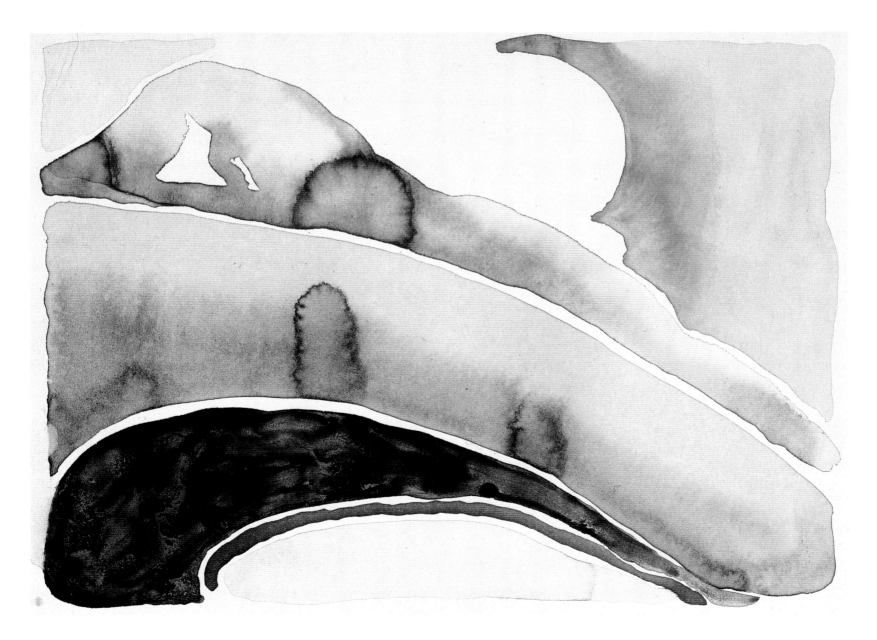

which were left undraped to emphasize the view, O'Keeffe could see the rapidly changing panorama of Manhattan. All around the Shelton, new skyscrapers were being constructed: some stopped below her own thirtieth-floor apartment, while others continued upward to soar above it. Out of the windows to the northwest the view looked over the top of Central Park and across the Hudson River to New Jersey. To the east, O'Keeffe could see the Queensboro Bridge, the East River, and the factories on the opposite bank. But, most importantly for O'Keeffe, her apartment offered unobstructed views of the sky.

At first Stieglitz objected to O'Keeffe's attempt to paint the city, arguing that it was essentially alien to her, and that nature was the more "feminine" sphere. O'Keeffe appreciated that the city was Stieglitz's artistic turf, so to speak: the busy streets and jagged skyline had been a principal source for his photographs since the early part of the century. Undaunted, O'Keeffe went ahead with her work. She was particularly interested in the American Radiator Building, built of black brick and decorated with gold leaf, the pinnacle of which was illuminated at night. This building was recorded by O'Keeffe in *Radiator Building, Night, New York* (1927), and where a red neon sign had originally flashed the words "Scientific American," O'Keeffe mischievously replaced this with the words "Alfred Stieglitz."

The first cityscape that O'Keeffe painted was *New York with Moon*, a geometrical arrangement of tall buildings against the background of a bright blue sky. Many of O'Keeffe's subsequent paintings dramatize the perpendicularity of the buildings seen from both street level and from the apartment. In some paintings the geometrical rendering of the buildings recalls the precisionist approach that can be seen in the works of painters like Charles Demuth and Charles Sheeler, while other paintings, like *The Shelton with Sunspots* (1926, Art Institute of Chicago), present a softer, more romanticized view of the city.

Many of O'Keeffe's Manhattan paintings indicate to the viewer the sense of claustrophobia that O'Keeffe herself often seemed to experience in New York. In *City Night* (1926), for example, a tiny white moon is crushed between the black walls of the city buildings. Most of O'Keeffe's cityscapes were also night scenes, like *New York, Night* (1928-29), where a people-free city is lit by the eerie red glow of electric lights.

Between 1926 and 1928 O'Keeffe worked on a series of 11 known paintings and pastels that depict New York's East River. These works alternatively use both hard-edged and soft-focus styles to convey the changes in the time of day, in light and weather conditions, and in the different seasons. Unlike the skyscraper paintings that depict particular buildings in the city, the East River series focuses on the one section of the New York waterfront that O'Keeffe could see from her apartment windows, or from the roof terrace of the Shelton. The views in these paintings are therefore almost identical, but in each work there are variations of color and mood, as well as alterations to the spacing and alignment of the compositional elements. Absent from the series of East River works are the bright colors which enliven O'Keeffe's nature-inspired works: the colors of

East River from the 30th Story of the Shelton Hotel (1928), for example, are somber and almost monochromatic, limited to blues, grays, browns, black and white.

Nine of the 11 East River paintings are relatively small – narrow works, divided into three horizontal registers. In the lower foreground are the darkened towers and roofs of the buildings along the east side of Manhattan. In the middle register is the river separating Manhattan from Queens and Brooklyn, while the upper register of the background houses the piers and factory smokestacks along the shoreline of Long Island City. The two other paintings in the series, including *East River from the 30th Story of the Shelton Hotel*, are larger, more square in format, and more highly finished, with the architectural details rendered more completely.

Although the vision appears panoramic in these paintings, O'Keeffe was nevertheless selective: from photographs taken by Stieglitz from the Shelton Hotel we can see that the views from the apartment in fact extended farther north, past the Queensboro Bridge and east across midtown Manhattan. When all 11 paintings are seen in chronological order, it becomes clear that O'Keeffe gradually moved away from an atmospheric, abstract interpretation of the scene, to a more detailed, hard-edged realism – an unusual progression in O'Keeffe's serial work.

In contrast to the cityscapes, in her early years the landscapes that O'Keeffe knew best were those of her native Wisconsin, and also those surrounding Lake George, where she spent the summers with Stieglitz. In 1920 an old, weather-beaten wooden shed was fixed up for O'Keeffe's use as a studio, which O'Keeffe called her "shanty." The building, which would be the subject of at least one of her paintings, stood on a steep hill five minutes from the main house at Lake George, and also had an outside platform facing north where O'Keeffe liked to paint. Many of her Lake George paintings were done in the fall, such as *Lake George with Crows* (1921), and her output was enormous: by the time she returned to New York at the end of the fall in 1921, she had completed 25 paintings. Despite the fact that O'Keeffe later said of Lake George: "Very pretty. But it wasn't made for me," she observed closely and painted what she saw, including the barn which could be seen from the kitchen window, or the study where Stieglitz worked.

Throughout the 1920s, O'Keeffe also studied and painted the trees that grew on the Stieglitz property, and she ritually painted the same chestnuts, cedars, pines, poplars, birches and maples, either singly, in groups, or as part of the surrounding landscape. Although her paintings show the seasonal changes, depicting these was not O'Keeffe's primary focus. Instead, she was more concerned with conveying the sense of permanency that was characterized by the tree forms. By the late 1920s, O'Keeffe feared that she was exhausting the subjects available at Lake George, and her works became somewhat repetitive.

In the early 1920s O'Keeffe had been inspired to paint the sea, which she had first seen in early 1920 when she visited some Stieglitz family friends in Maine. Her first sea-inspired

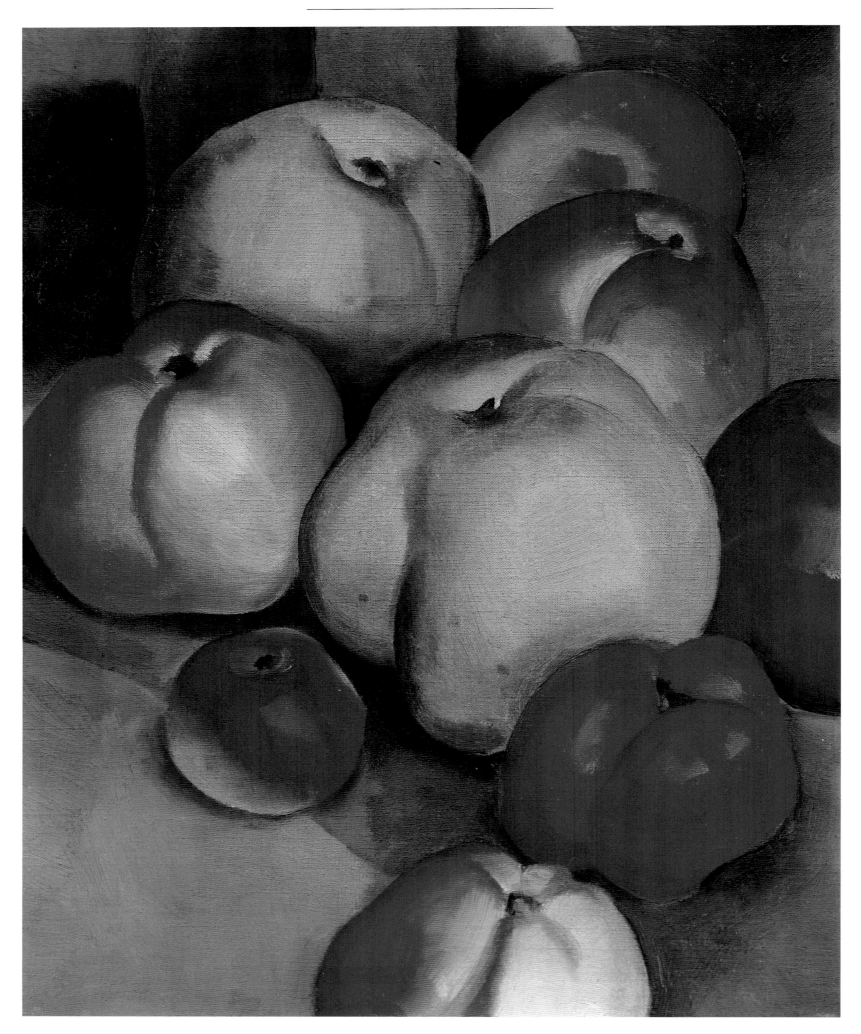

Apple Family A 1921
Oil on canvas, 10×8 inches
Collection of Mr. and Mrs. Gerald P. Peters,
Santa Fe, NM

works were watercolors of the blue-green waves of the Atlantic Ocean, and pastels of stormy seas, like *Lightning at Sea* (1922). In addition, O'Keeffe painted the seaweed and sea shells she collected, which she kept in dishes of sea water to maintain their colors. In *Wave, Night* (1928), O'Keeffe painted the rhythms of the night sea, with a distant lighthouse beacon illuminating the crests of the waves.

In 1932 O'Keeffe traveled farther into the wide world, and took her first trip outside the United States. With Georgia Engelhard, Stieglitz's 27-year-old niece, O'Keeffe drove her Ford 150 miles north of Lake George to Montreal in Canada, and then to the Gaspé Peninsula to search out new places to paint. O'Keeffe claimed that the contrasts of the Canadian countryside – from the lush, green farmland along the St. Lawrence River to the rocky Atlantic coast – were as inspirational for painting as New Mexico, and during the trip she painted the green mountains, the mariners' crosses (memorials to those lost at sea) and white Canadian barns. Unlike O'Keeffe's paintings of the barns at Lake George, in these paintings the structures of the Canadian barns are stark in color, and are precisely delineated. In the near-abstract reduction of structure, shape and line, these paintings resemble the series of drawings, paintings and photographs of barns in Bucks County which had been done 15 years earlier by the artist Charles Sheeler (1883-1965), who was a close friend of both Stieglitz and the photographer Paul Strand.

As in the East River series, O'Keeffe utilized a narrow, horizontal format in *White Canadian Barn II*, and the picturescape is similarly divided into three distinct areas, or zones, of sky, building and ground, with the vertical doorway acting as a device to anchor it to the horizontal movement of the composition. In O'Keeffe's later paintings of the 1950s, the doorway motif would become the main element of her abstract compositions of the patio at her home at Abiquiu.

Skunk Cabbage (Cos Cob) 1922
Oil on canvas, 23⅛×16 inches
Bequest of Kathryn Hurd,
Williams College Museum of Art,
Williamstown, MA (82.22.40)

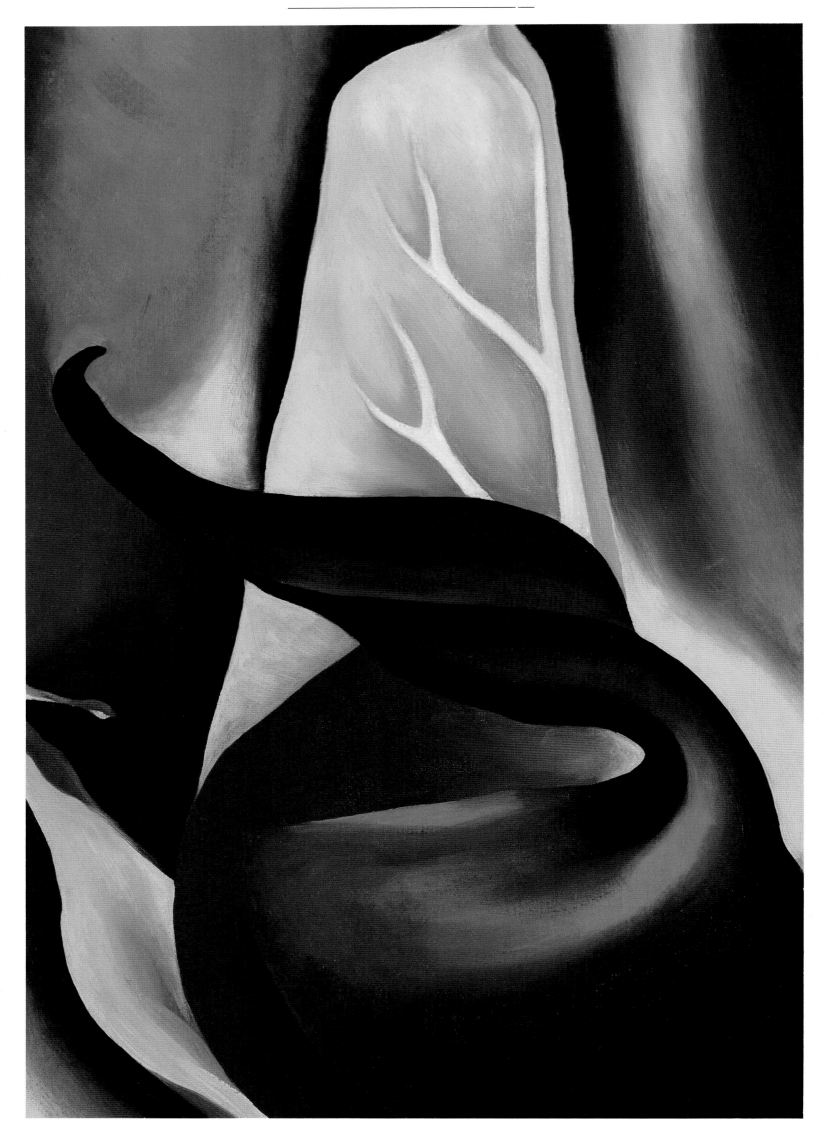

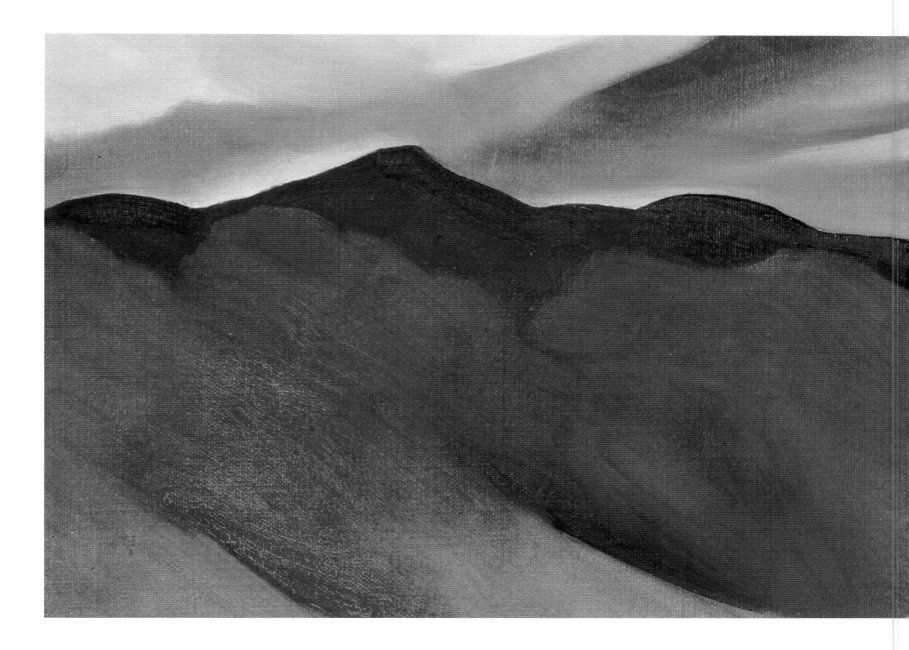

**Mountains to the North – Autumn, Lake George,
New York** 1922
Oil on canvas, 8×23 inches
*Collection of The Evansville Museum of Arts and Science,
Evansville, IN (1966.300)*

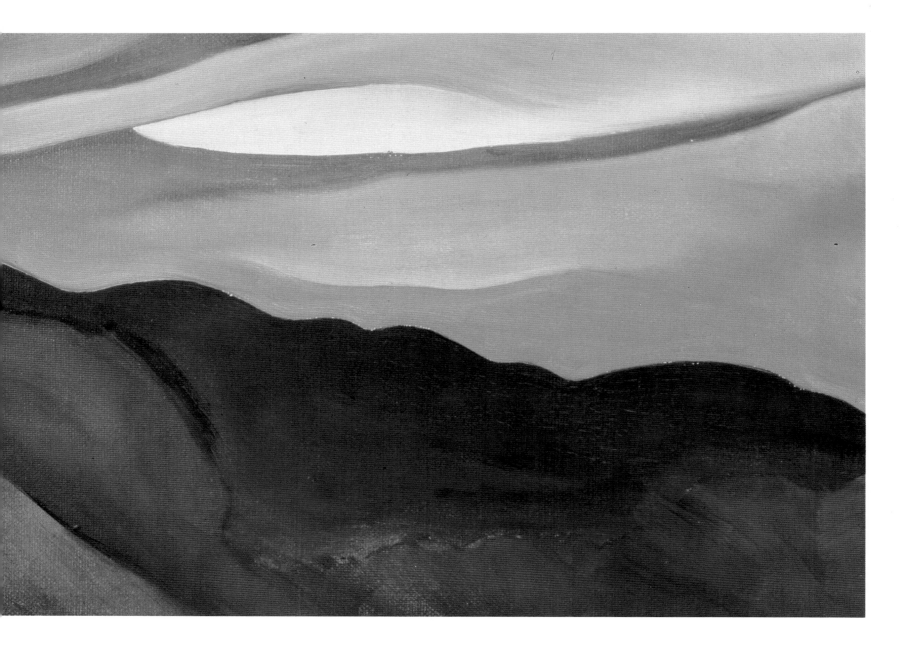

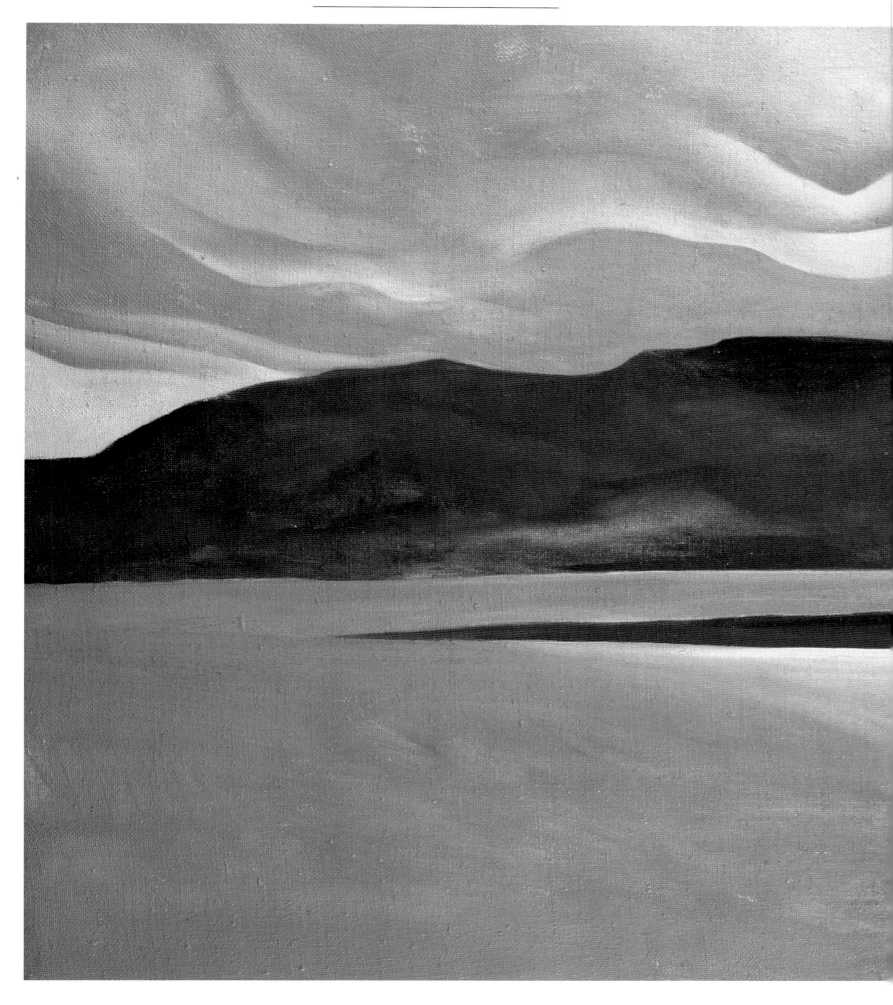

Lake George 1923
Oil on canvas, 18×32¼ inches
The Regis Collection, Minneapolis, MN

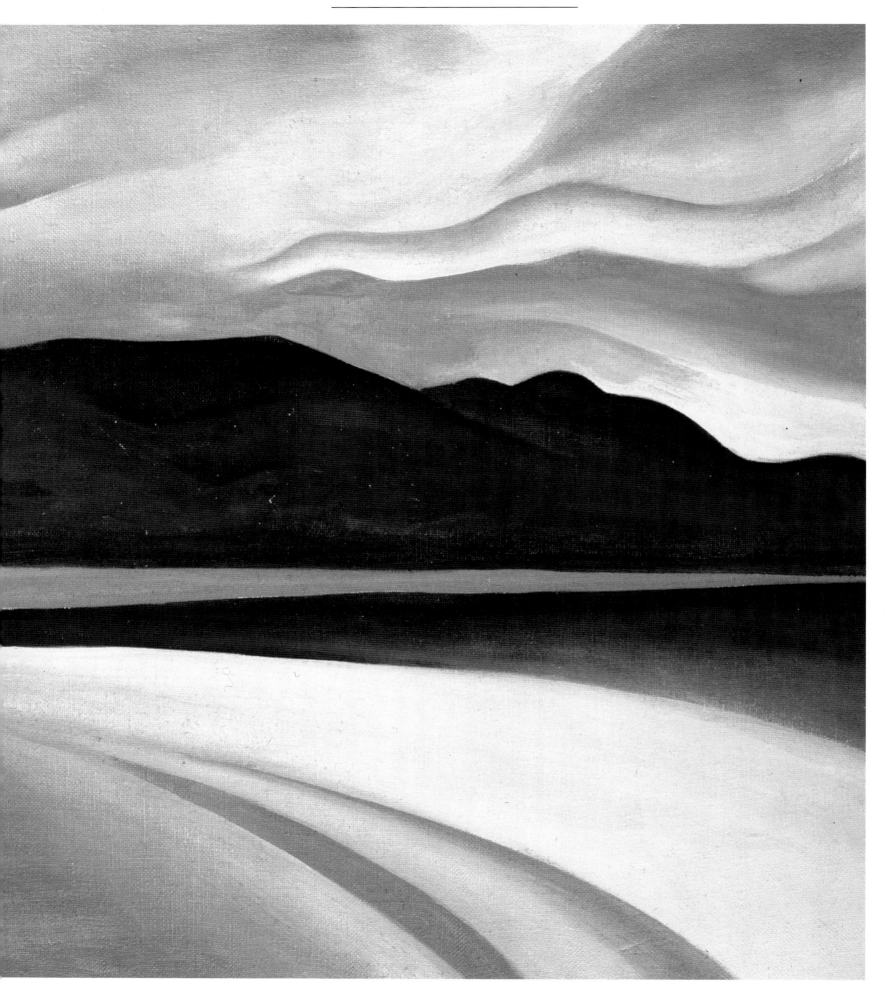

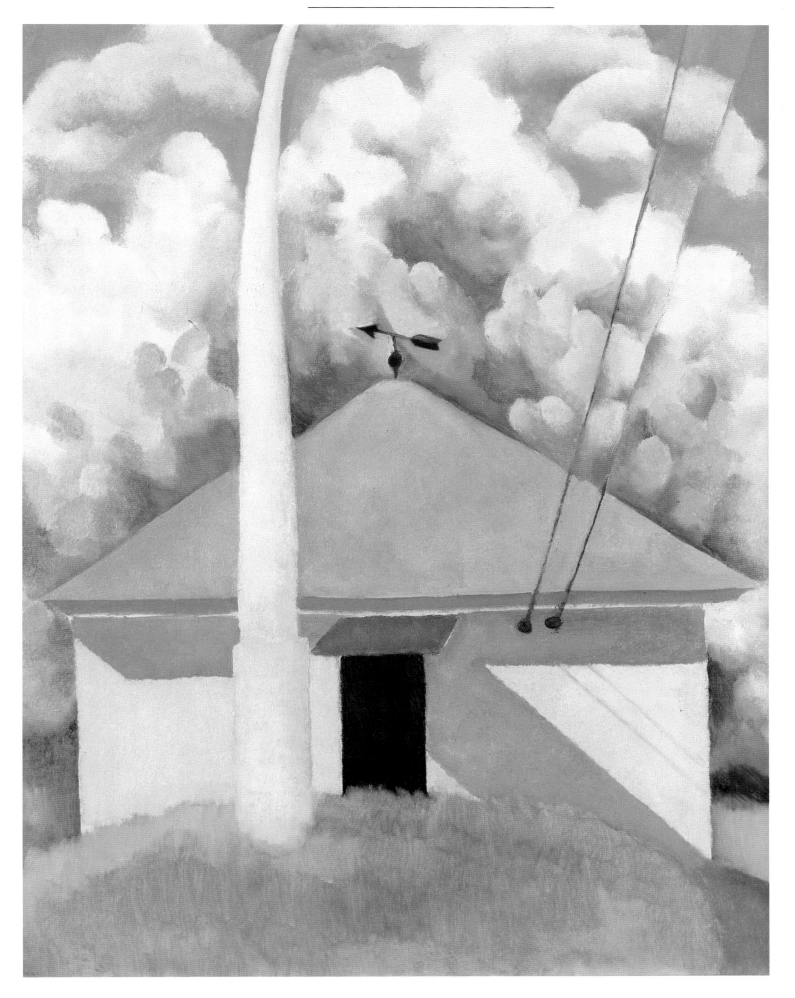

Spring 1923
Oil on canvas, 18×14 inches
Collection Gabriella Rosenbaum
Photograph courtesy of The Art Institute of Chicago,
Chicago, IL (453.1984)

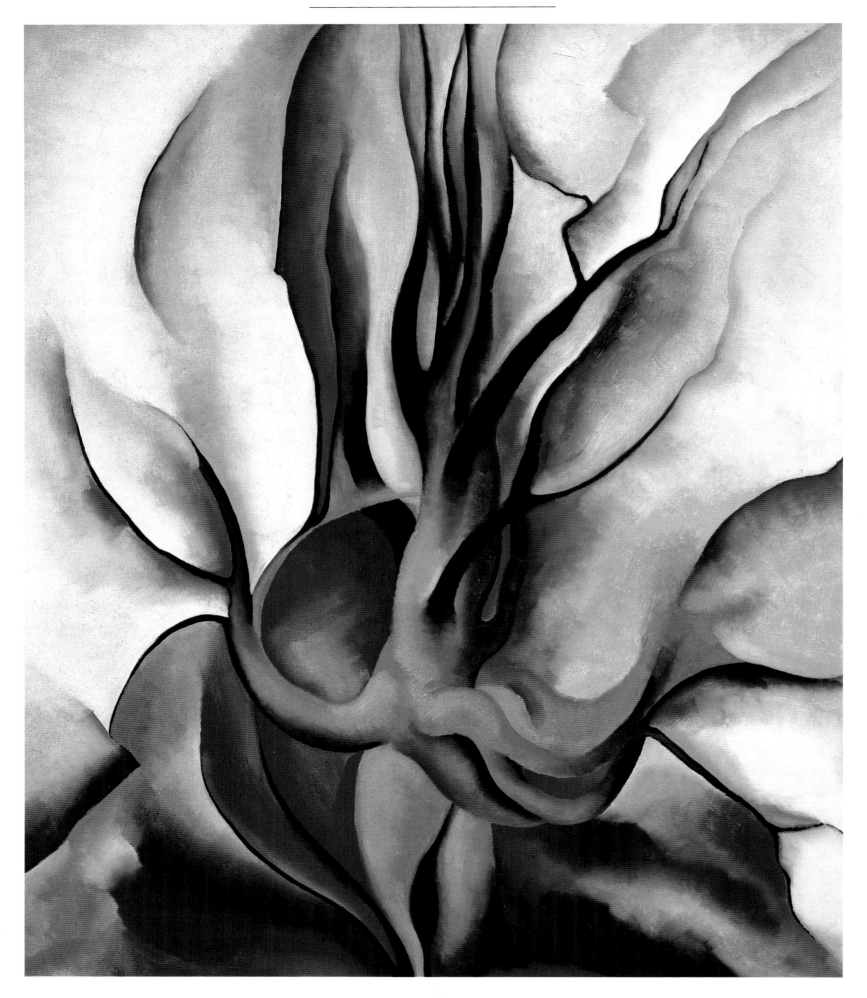

Autumn Trees – The Maple 1924
Oil on canvas, 36×30 inches
Collection of Mr. and Mrs. Gerald P. Peters,
Santa Fe, NM

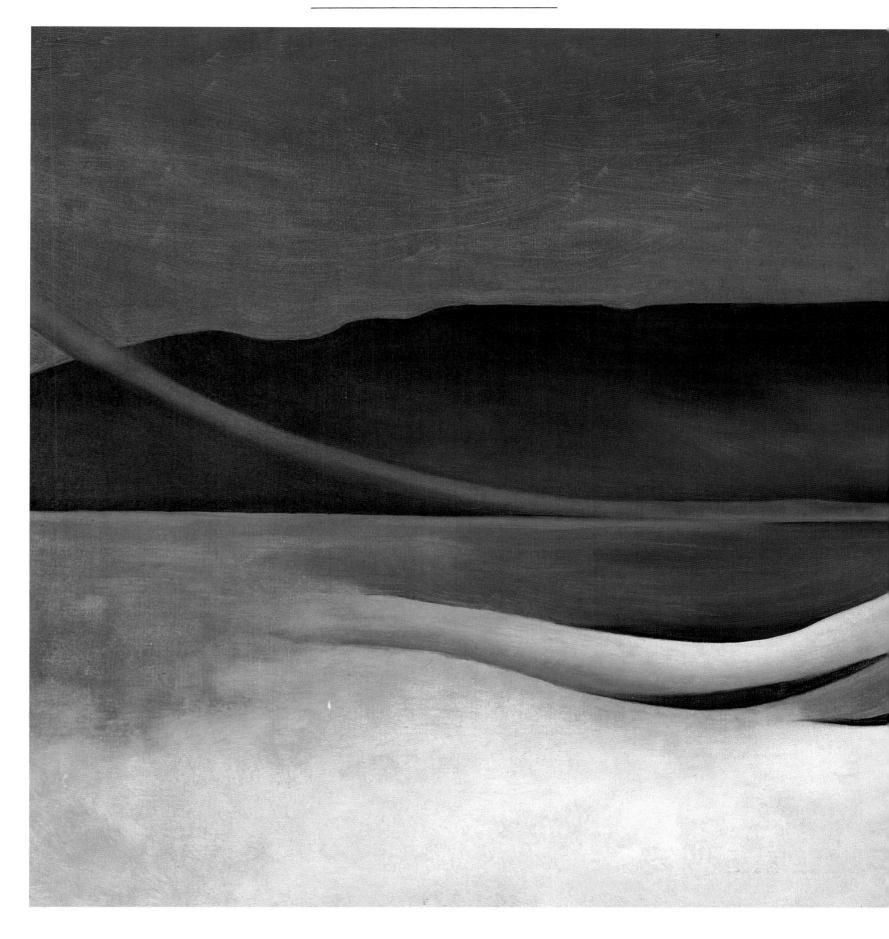

Lake George 1924
Oil on canvas, 18×35 inches
The Collection of James and Barbara Palmer

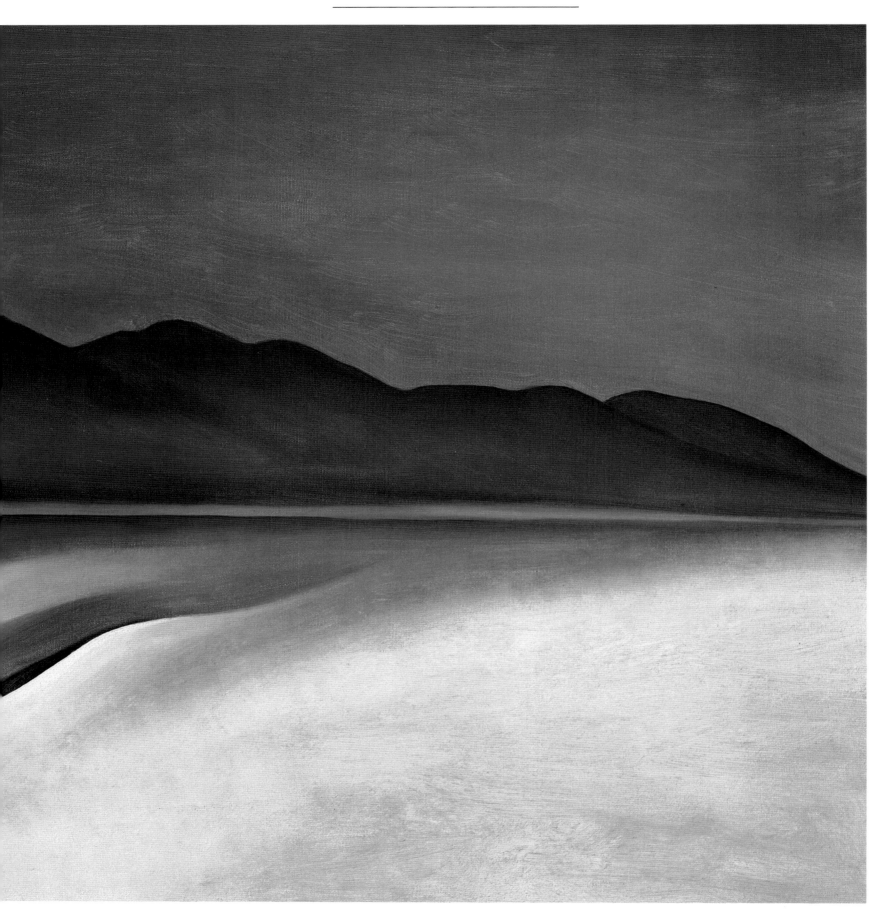

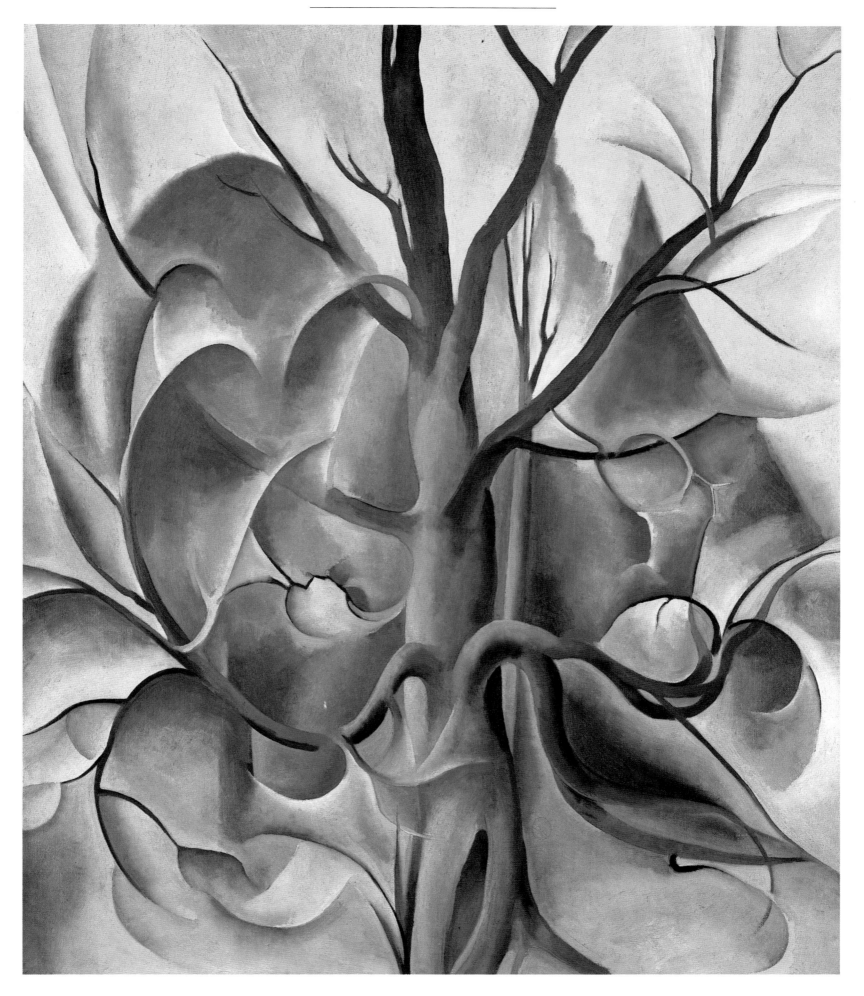

Above:
Gray Tree – Lake George 1925
Oil on canvas, 36×30 inches
Alfred Stieglitz Collection,
Bequest of Georgia O'Keeffe, 1986,
The Metropolitan Museum of Art, New York, NY (1987.377.2)

Right:
New York with Moon 1925
Oil on canvas, 48×30 inches
Fundacion Colección Thyssen-Bornemisza,
Madrid, Spain

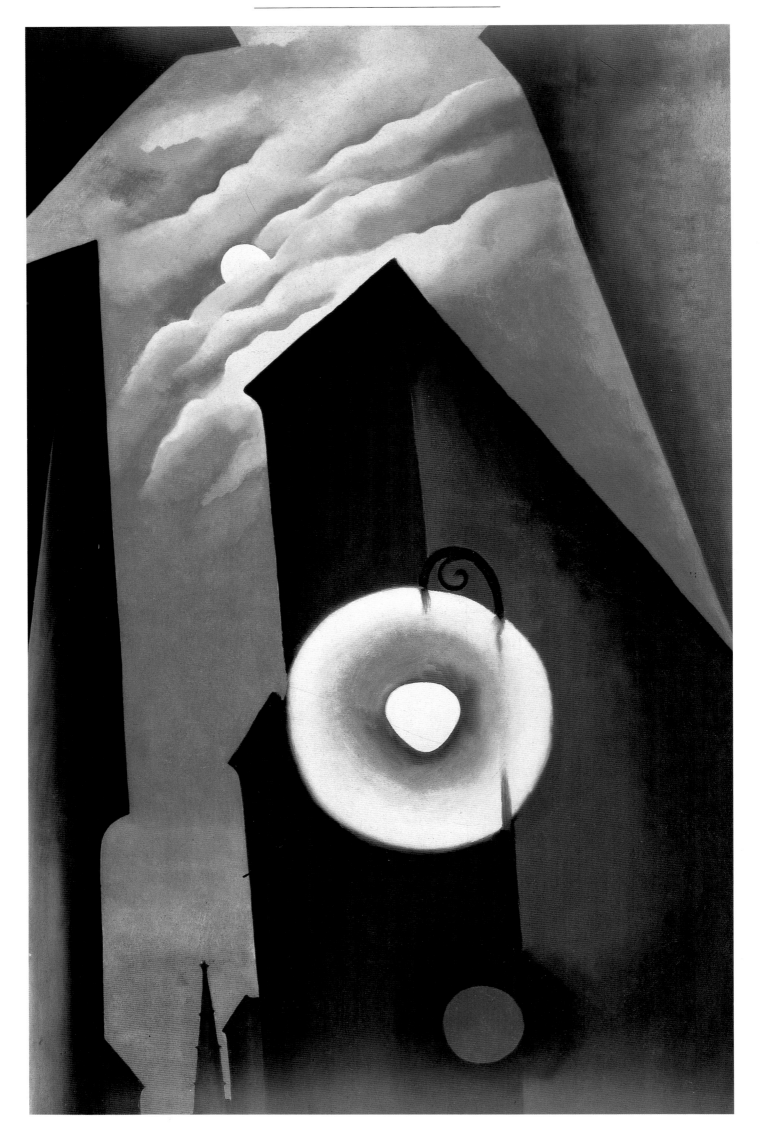

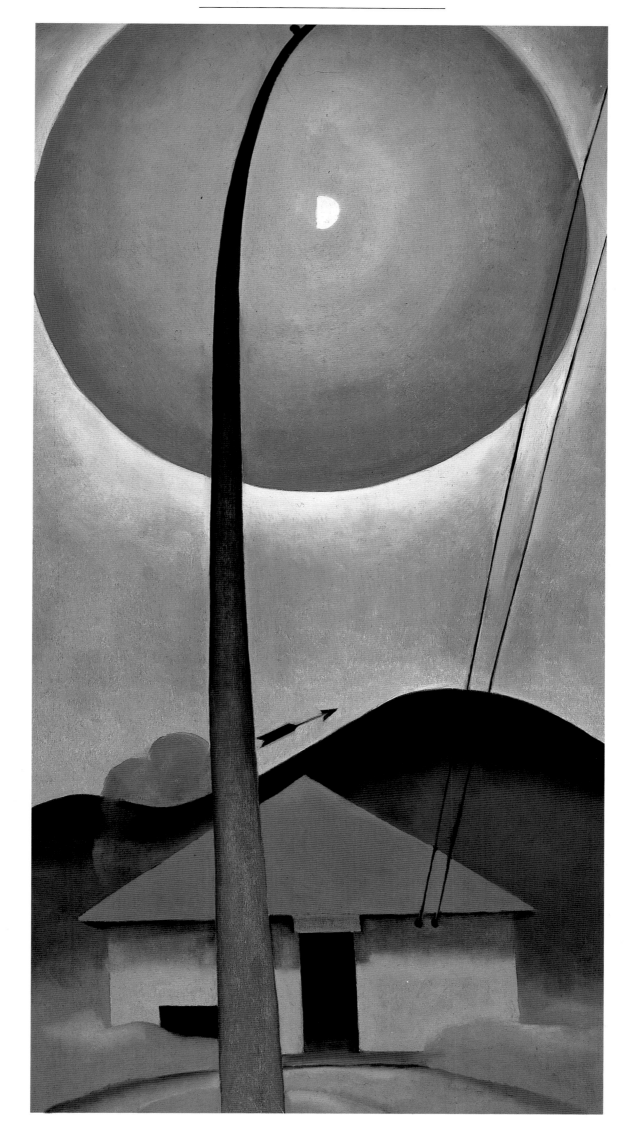

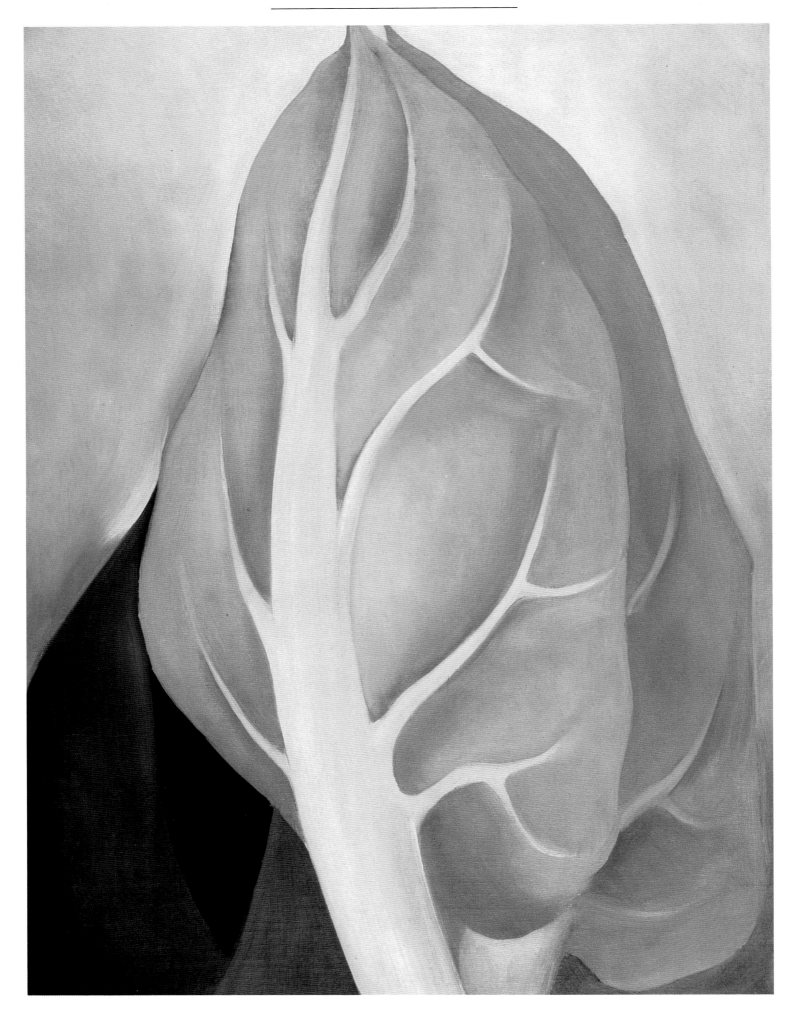

Above:
Cos Cob 1926
Oil on canvas, 22½×18½ inches
Collection of Fred Jones, Jr.
Museum of Art, The University of Oklahoma,
State Department Collection, Norman, OK

Left:
Little House with Flagpole 1925
Oil on canvas, 35½×17½ inches
The Gerald Peters Gallery, Santa Fe, NM

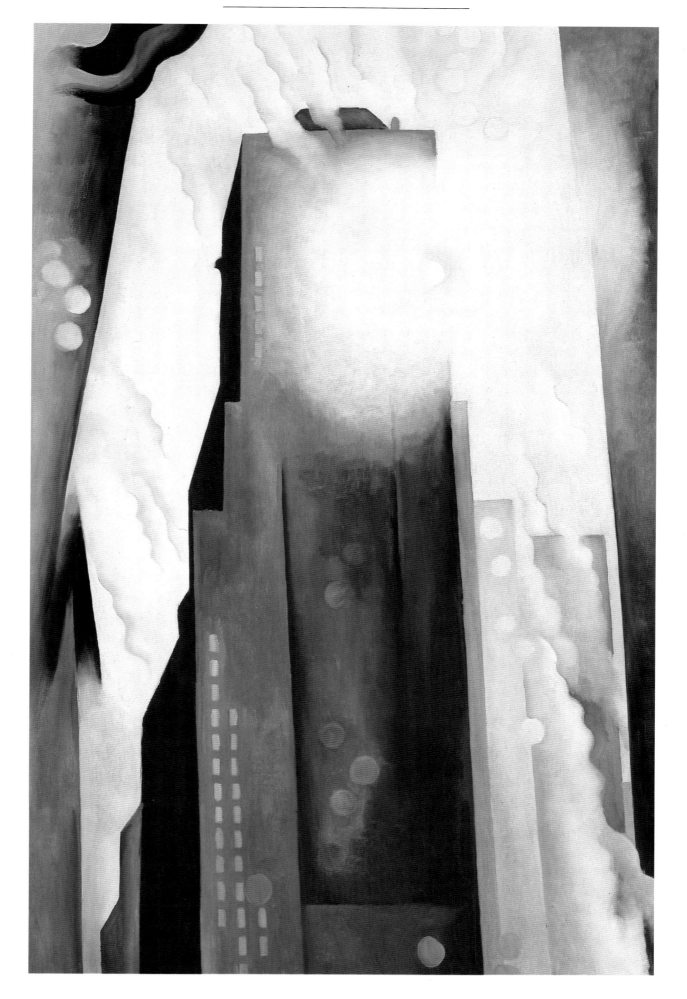

Above:
The Shelton with Sunspots 1926
Oil on canvas, 48½×30¼ inches
Gift of Leigh B. Block,
Photograph courtesy of The Art Institute of Chicago, Chicago, IL
(1985.206)

Right:
Shelton Hotel, New York I 1926
Oil on canvas, 32×17 inches
The Regis Collection, Minneapolis, MN

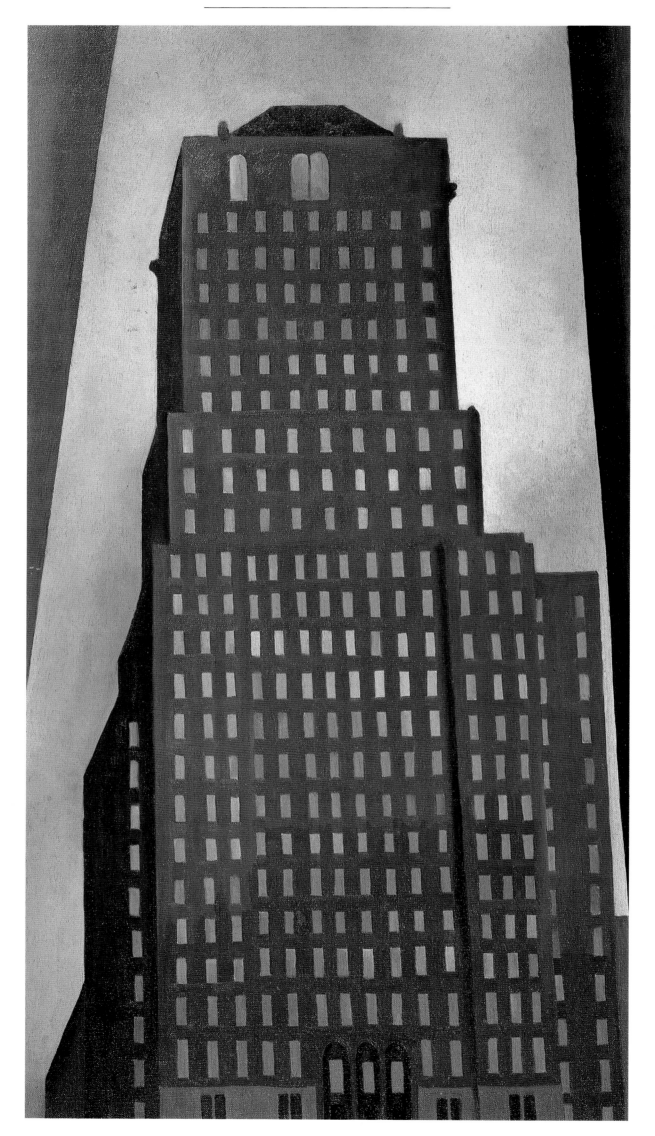

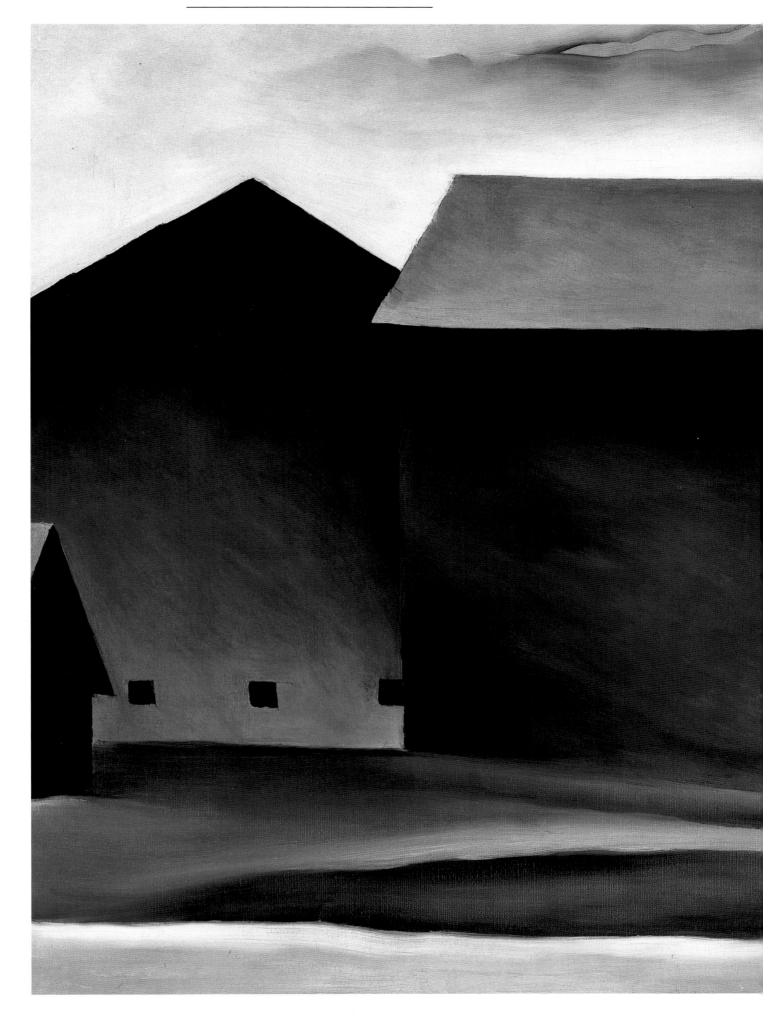

Lake George Barns 1926
Oil on canvas, 21¼×32 inches
Gift of The T. B. Walker Foundation, 1954,
Collection Walker Art Center, Minneapolis, MN

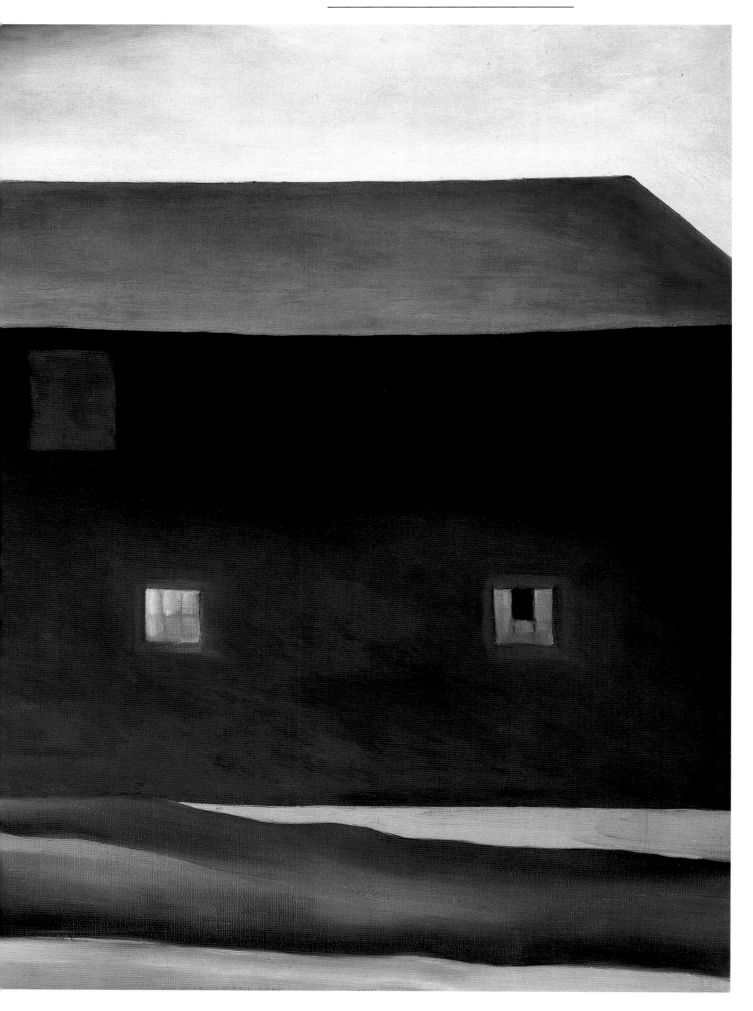

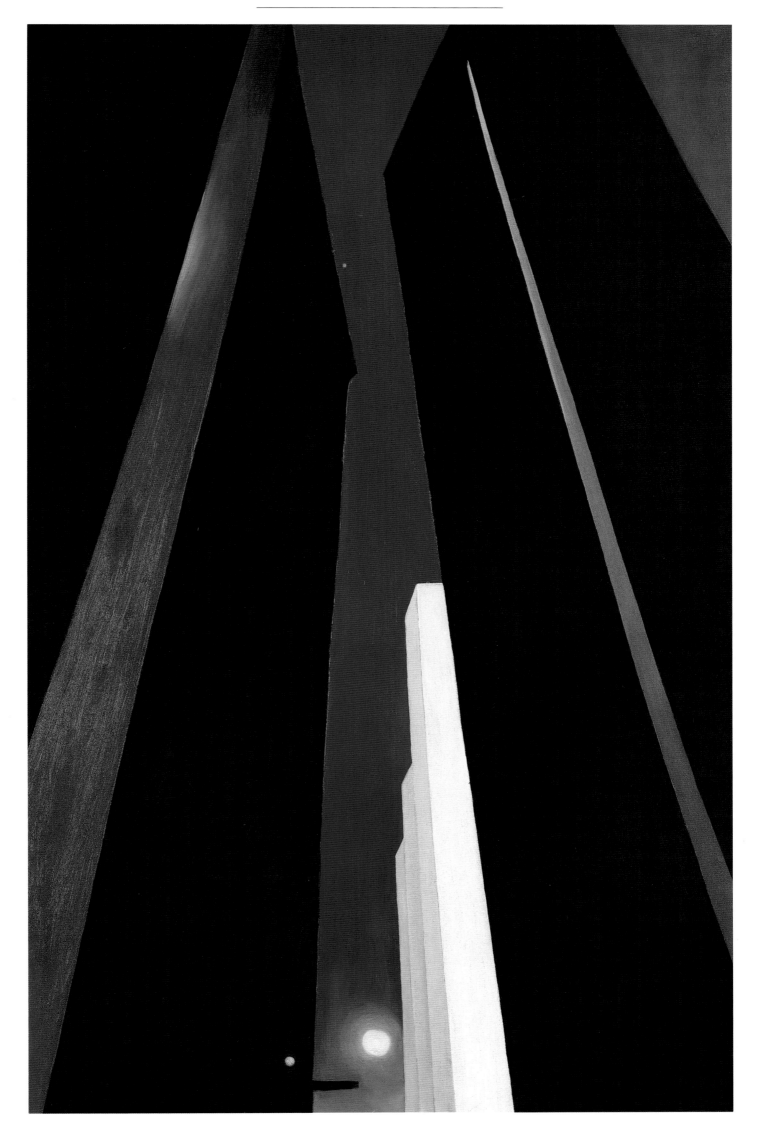

Left:
City Night 1926
Oil on canvas, 48×30 inches
Gift of The Regis Corporation, W. John Driscoll, and The Beim
Foundation; The Larsen Fund; and by public subscription,
The Minneapolis Institute of Arts, Minneapolis, MN

Above:
Lake George, New York c.1924
Oil on canvas, 8¾×15¾ inches
Gift of The Rebecca Salsbury James Collection, 1968,
Collection of The Museum of Fine Arts, Museum of New Mexico,
Santa Fe, NM (22.87.23P)

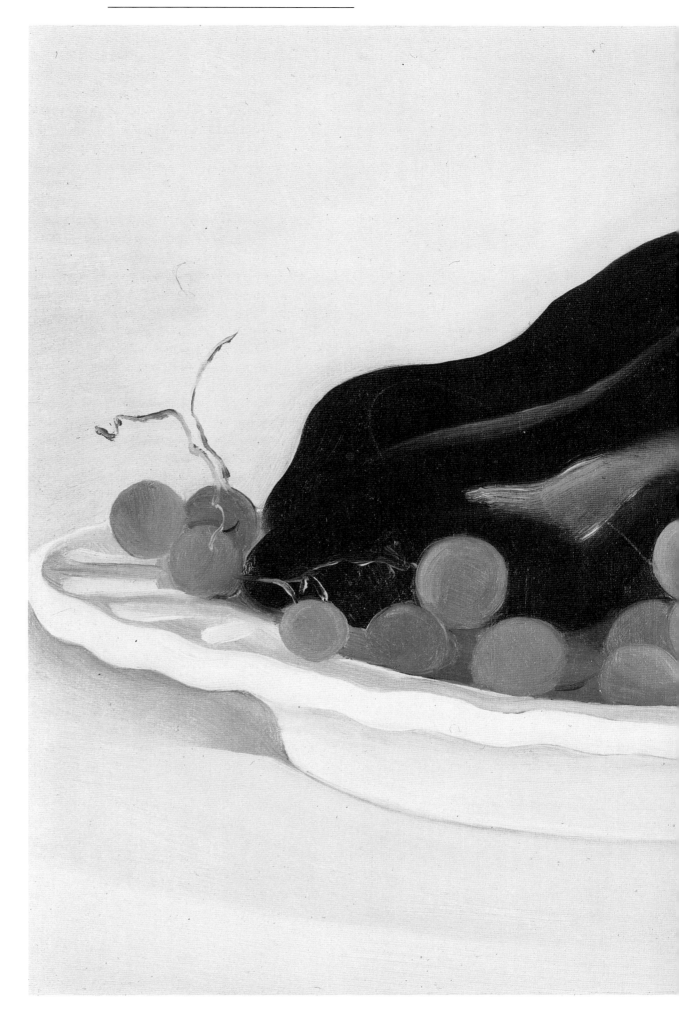

Red Pepper, Green Grapes 1928
Oil on canvas, 8¼×11¼ inches
Private collection,
Compliments of Parkerson Gallery, Houston, TX

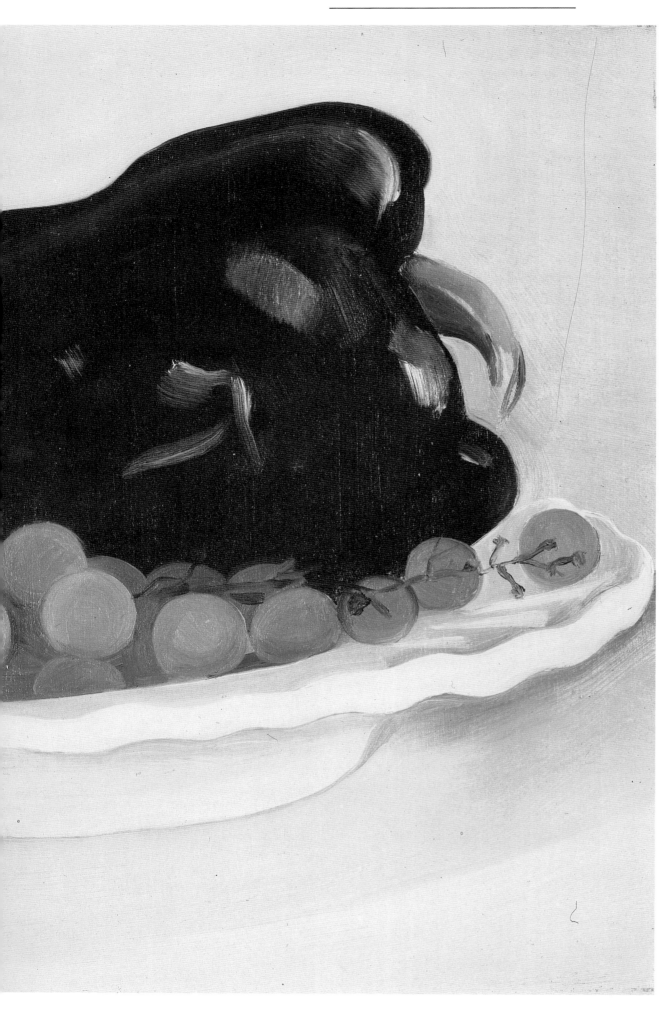

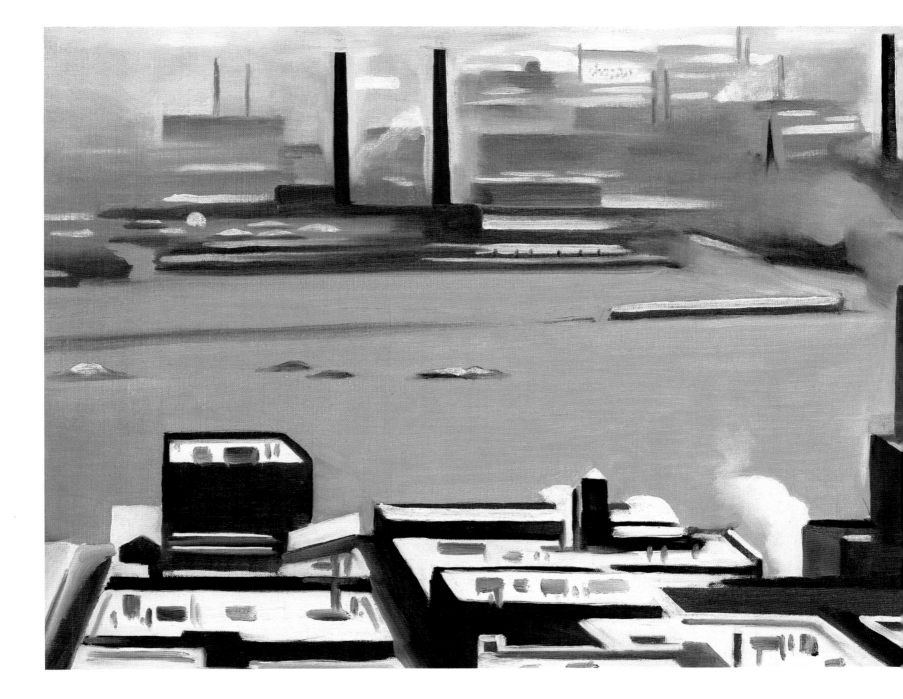

New York East River 1928
Oil on canvas, 12×32 inches
Alfred Stieglitz Collection,
Bequest of Georgia O'Keeffe, 1986,
The Metropolitan Museum of Art, New York, NY (1987.377.3)

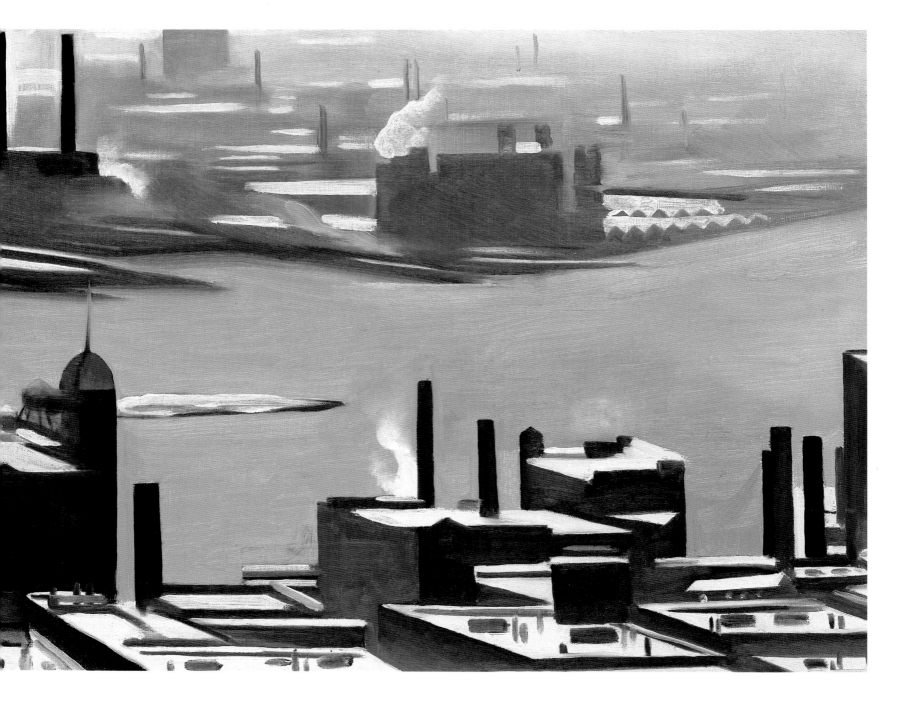

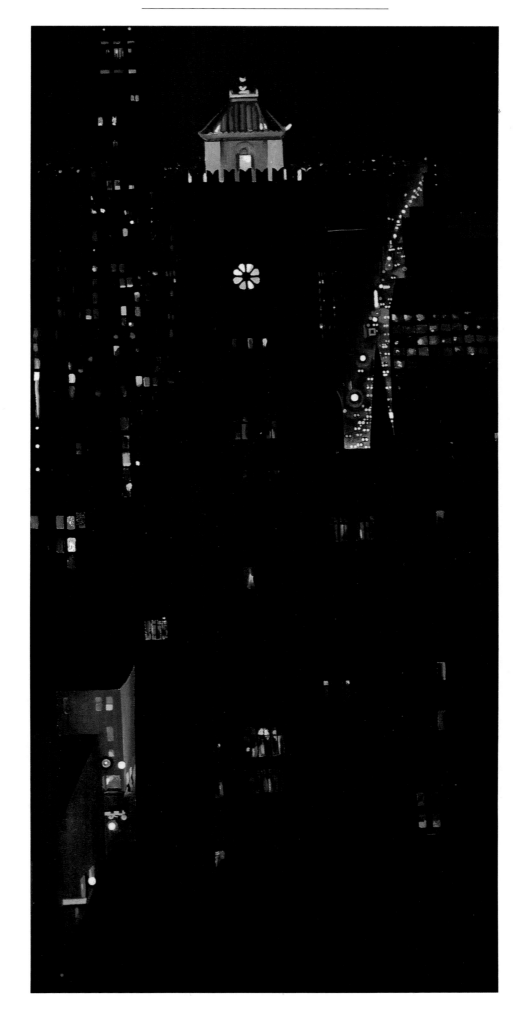

New York, Night 1928-29
Oil on canvas, 40⅛×19⅛ inches
N.A.A.-Thomas C. Woods Memorial Collection, 1958,
Sheldon Memorial Art Gallery, University of Nebraska, Lincoln, NE
(1958.N-107)

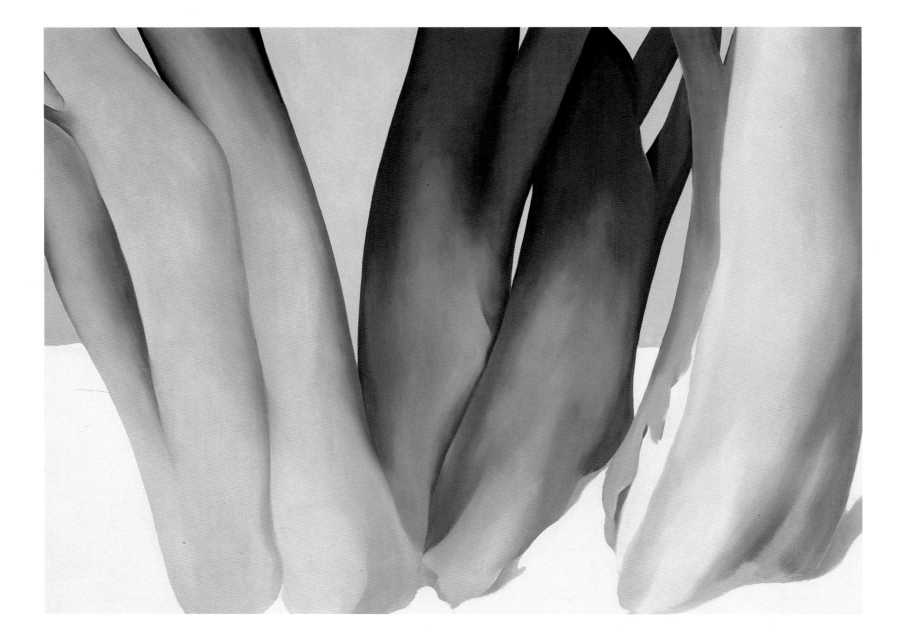

Bare Tree Trunks with Snow 1946
Oil on canvas, 29½×39½ inches
Dallas Art Association Purchase,
Dallas Museum of Art, Dallas, TX (1953.1)

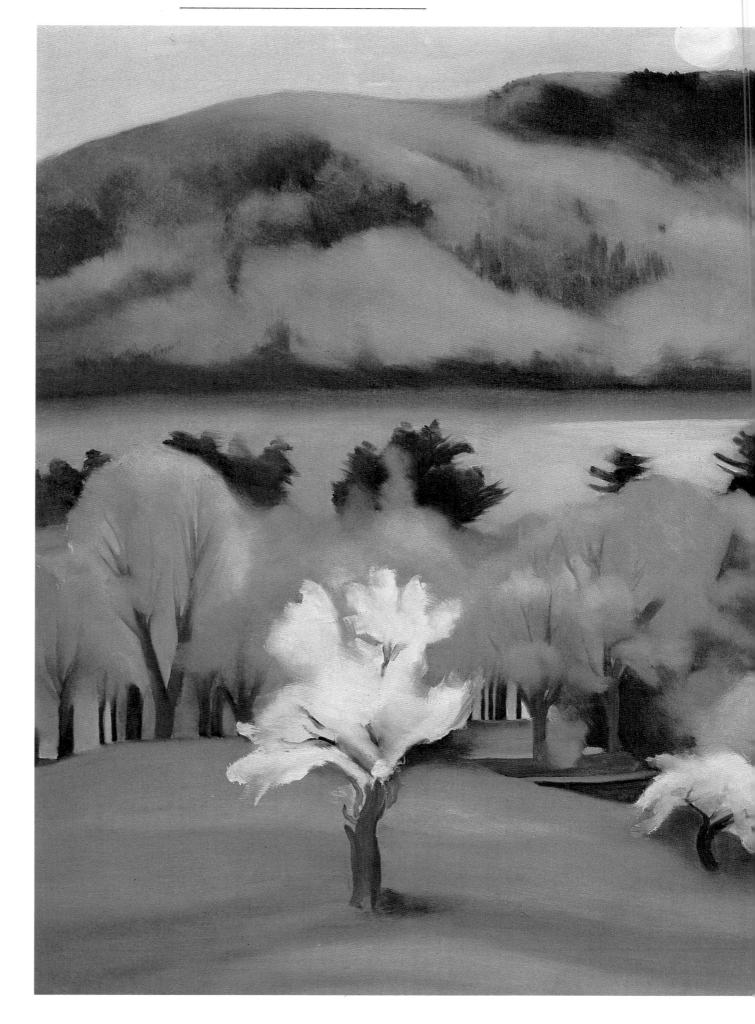

Lake George by Early Moonrise 1930
Oil and gouache on canvas, 24×36 inches
Gift of Roy R. Neuberger,
Collection Neuberger Museum of Art,
State University of New York at Purchase

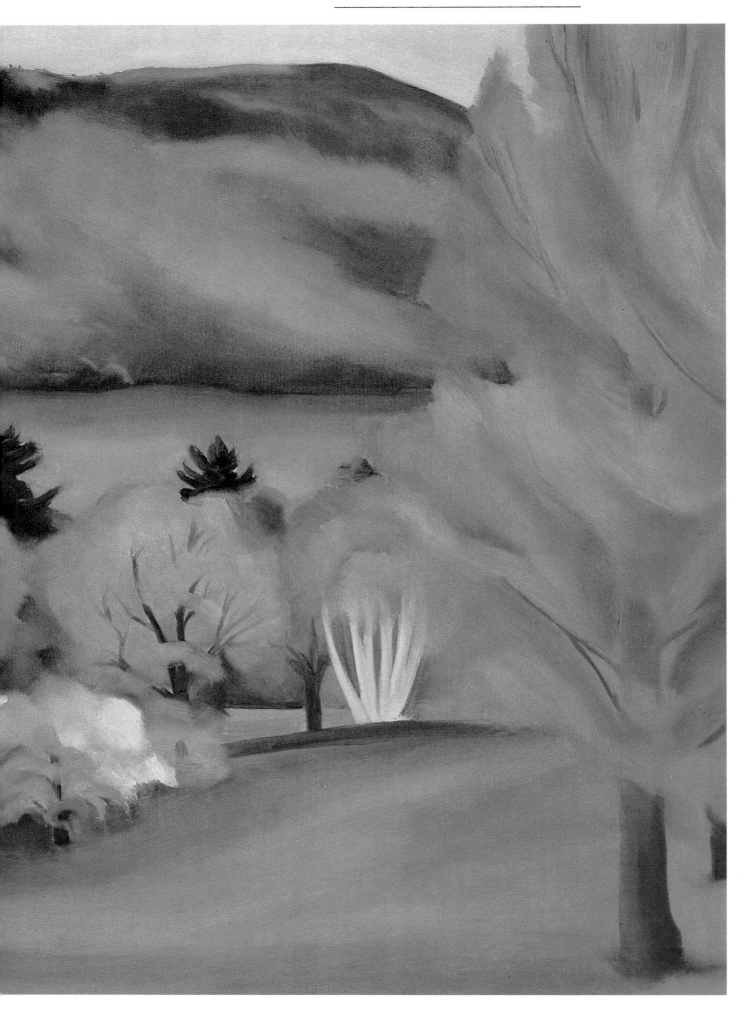

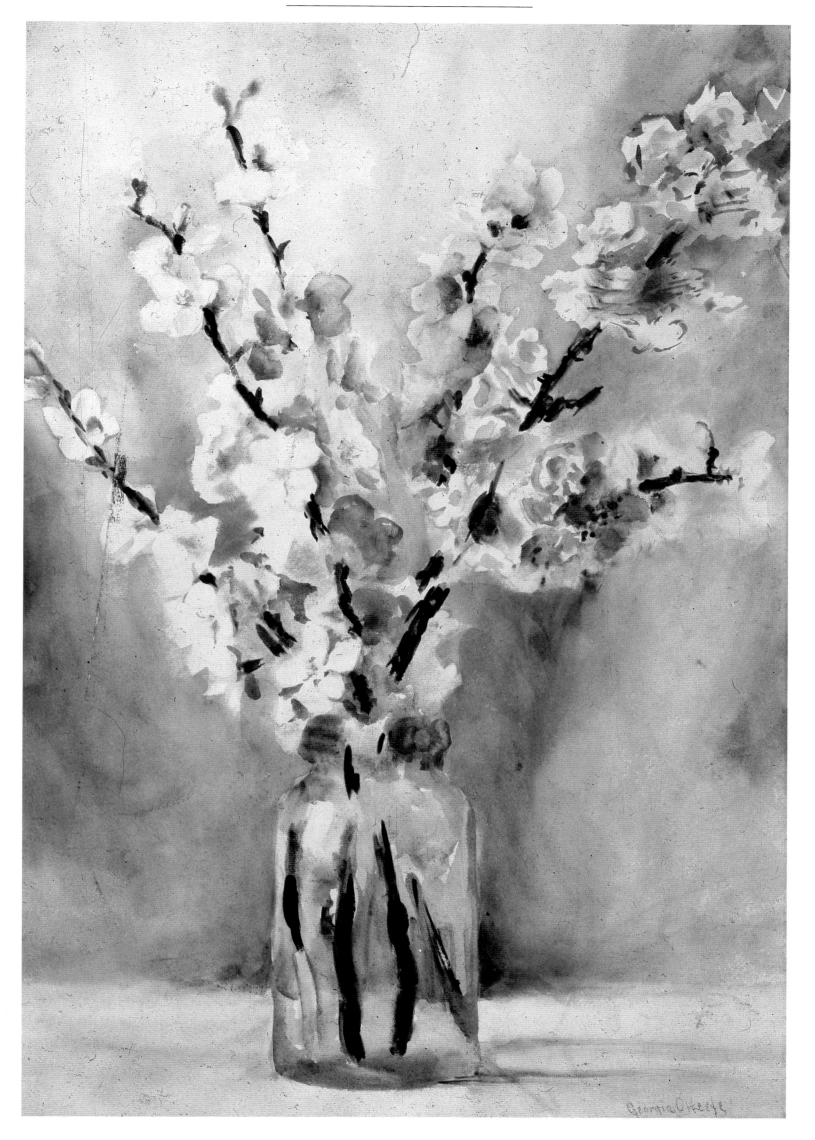

FLOWERS

O'Keeffe had painted flowers ever since her childhood painting lessons in Wisconsin, and they were to become a recurring motif in her work. During the winter months when she was living in New York, she would often return to flower themes, and later recalled: "When you take a flower in your hands and really look at it, it's your world for the moment. I want to give that world to someone else." O'Keeffe often told the story of how she stopped in a museum and saw a small still life of a teacup, saucer and spoon by the French painter Fantin-Latour; in the cup he had painted a tiny flower. O'Keeffe remembered that she had then felt the urge to paint a flower like that for herself, but hesitated: "If I could paint the flower exactly as I see it, no one would see what I see, because I would paint it small like the flower is small," she wrote in her An American Place exhibition catalog statement in 1939. O'Keeffe decided to paint flowers so big that viewers would be forced to stand and take notice of them. In her later old age she also said that she painted flowers because she did not paint people, claiming that the flowers were cheaper than hiring models and did not move as much!

O'Keeffe was familiar with the close-ups of flowers in photographs by Edward Steichen as well, and there were also a number in the oriental prints that she had seen and admired as a student. She had a great passion for the colors of blooms: once, at Lake George, she painted a bed of purple petunias in order to study the colors more closely. She later tried to explain why she had also painted a large white flower: "The large white flower with the golden heart is something I have to say about white – quite different from what white has been meaning to me. Whether the flower or the color is the focus I don't know. I do know that the flower is painted large to convey to you my experience of the flower."

O'Keeffe's first large flower painting was completed in 1924 on a large canvas, about 36 by 30 inches. Prior to this time her flowers were painted in close-up, but on small canvases. When Stieglitz first saw the large flower painting he is reputed to have said: "Well Georgia, I don't know how you're going to get away with anything like that – you aren't planning to show it, are you?" In fact, that was O'Keeffe's intention, and indeed the

large flowers were shown at the Seven Americans show in 1925, where they received rave reviews from the critics.

O'Keeffe's flowers were often painted frontally, rather like butterflies pinned down for scrutiny: lilies, petunias, jack-in-the-pulpits, poppies and irises were only a few of the specimens which O'Keeffe worked on in over 200 flower paintings. In addition to a penchant for poppies – an early painting from 1927 measures just 7 by 9 inches, while later works like *Oriental Poppies* (1928) and the single bloom of *Poppy* (1927) are over three feet wide – O'Keeffe had a liking for the unusual deep purple to near-black blooms of pansies, petunias and irises. Representative of O'Keeffe's large-scale early work depicting a single flower is *Black Iris III* (1926), the final and most detailed frontal version of the three compositions in the series. The composition is, in fact, a modification of the first large-scale flower paintings of 1924, such as *Red Canna*; the early works use a "V"-shaped arrangement (which first appeared in O'Keeffe's work in 1919), where diagonal lines fan upward and outward toward the top of the canvas. In *Black Iris III* the "V" is inverted, and the result is that the composition is weighted at the bottom by the dark color of the lower petals.

Throughout O'Keeffe's career, critics and the public alike often focused on what they perceived as sexual imagery in the flower compositions. One of the first articles of this type, published in 1920, was written by Marsden Hartley, who encouraged readers to see O'Keeffe's work in Freudian terms. O'Keeffe was outraged, and even five years later was upset when her flower paintings, despite her intention to paint in a realistic manner, were still reminding people of genitalia. Why should her paintings be interpreted this way? Why, when male artists like Hartley himself, or Demuth, painted flowers, were they not interpreted erotically? O'Keeffe surmised that it was simply because the public still refused to see her as an artist, only as a *woman* artist. She claimed that any sexual iconography was only to be found in the heads of the viewers of her paintings, and that such psychological interpretations trivialized her work. Nevertheless, such interpretations remain popular (even after her death), and during her lifetime O'Keeffe was acutely sensitive about the subject.

O'Keeffe's reputation as a painter was boosted in 1928 when she sold a series of six small calla-lily panels painted in 1923 to an anonymous collector in France, for the unprecedented sum of $25,000. O'Keeffe said that she painted the lily because she liked the tight flower formation and lack of leaves. The sale was the talk of New York: people were impressed by the large sum of

Still Life: Flowering Branches in a Mason Jar before 1915
Watercolor on paper, mounted on wood pulp board,
20¼ × 14⅛ inches
Gift of Hermine Sauthoff Davidson,
Elvehjem Museum of Art, University of Wisconsin, Madison, WI
(1981.129)

money involved, and were surprised that someone in France, the artistic capital of the world, would pay so much for work by an American artist, particularly a woman. The publicity surrounding the sale marked the beginning of real public interest in O'Keeffe, both as an artist and as a personality.

As a result of becoming so widely known, in the late 1930s O'Keeffe was approached by a number of commercial firms, such as the Steuben Glass Company, which commissioned O'Keeffe to produce a lily design to be etched on a vase. In 1936 the cosmetics magnate Elizabeth Arden commissioned a large O'Keeffe painting of four white blossoms with green leaves for the Arden Exercise Salon in New York, and in the summer of 1938 the advertising agency N. W. Ayers approached O'Keeffe on behalf of their client, asking her to be one in a series of artists who were visiting Hawaii. In exchange, O'Keeffe would present the Dole Pineapple Company with two paintings that could be used in their advertising. Accepting Dole's offer, O'Keeffe set out for Hawaii in 1939 and set about painting the islands' rare and exclusive flowers: yellow hibiscuses, white birds-of-paradise, golden plumeria, red ginger flowers, and green papaya trees. The one plant or flower which she did not paint, however, was the pineapple! On her return to New York, O'Keeffe decided to present Dole with two paintings: a red ginger flower and a green papaya tree. Dole was delighted with the first, but not with the second, and claimed that the papaya would be advertising a rival canning company's products. Honolulu was called, and a large, budding pineapple plant was shipped to O'Keeffe's apartment by air in under 36 hours. O'Keeffe claimed that had she known that she was required to paint a pineapple she would never have accepted Dole's invitation to visit Hawaii. However, she reluctantly agreed to fulfill the "contract" and began work, later admitting that she had, in fact, found the plant fascinating. In the end Dole used O'Keeffe's paintings to accompany its annual reports and some national magazine advertisements.

During the late 1920s, O'Keeffe began traveling on her own, and the most profound and lasting experience was her visit to New Mexico in 1929. The landscape, with its wide range of colors, its unique qualities of light, and the unusual vegetation, were to provide O'Keeffe with a rich source of powerful themes. The time which she spent in relative isolation in New Mexico in the 1930s and 1940s would without doubt prove to be the most fertile of her career.

One of the earliest canvases produced during her first trip in 1929 was *Black Hollyhock, Blue Larkspur*. Although painted in Taos, the subject and interpretation are typical of the New York flower paintings. In fact, in terms of composition, this painting is based on *White Rose with Larkspur III*, painted two years earlier. O'Keeffe increasingly began to combine themes in her paintings: in 1932, in *Cow's Skull with Calico Roses*, alongside the floral theme she introduced the bleached animal skulls and bones that she had found during her walks in New Mexico. The dual theme was developed further in works like *Ram's Skull with Brown Leaves* (1936). The initial combination of flowers and skulls occurred after the dry summer in New Mexico in 1930. In order to continue her work on the desert theme, O'Keeffe shipped a large container full of bones, skulls and locally made artificial flowers back to Lake George. According to the story, one day in mid-July 1931, O'Keeffe was toying with some of the fabric flowers when she was called to the door. Walking downstairs, she thought she would look silly greeting her guest with a fake flower in her hand, so she stuck it into the empty eye socket of a horse's skull that she had placed on the dining-room table for safekeeping. She later recalled: "On my return I was so struck by the wonderful effect . . . I knew that here was a painting that had to be done."

In some flower-and-bone paintings O'Keeffe introduced the third element of the landscape, but in every painting each element was worked upon as a separate entity which, when viewed in combination, led to startling visual effects: the skulls and flowers are often seen frontally and in meticulous detail; these float freely over the landscapes, which are seen from distant aerial perspectives.

Although skulls and bones became the dominant images in O'Keeffe's work of the 1940s, they nevertheless represent a link with her earlier flower paintings, for it was her concern with the formal qualities of the objects before her – the contrast between the concave and convex surfaces of the objects, and the interplay of positive and negative spaces – that O'Keeffe constantly explored.

Canna Lily 1919
Watercolor on paper, 23×12⅞ inches
Museum Purchase: Derby Fund,
Columbus Museum of Art, Columbus, OH (77.23)

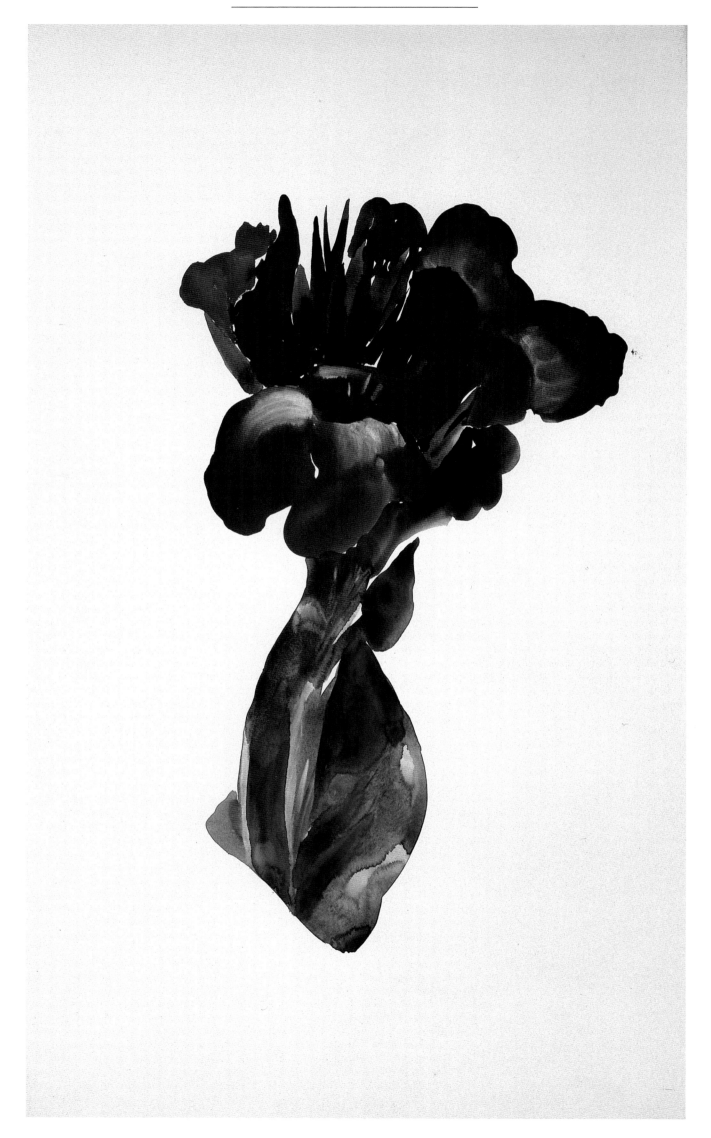

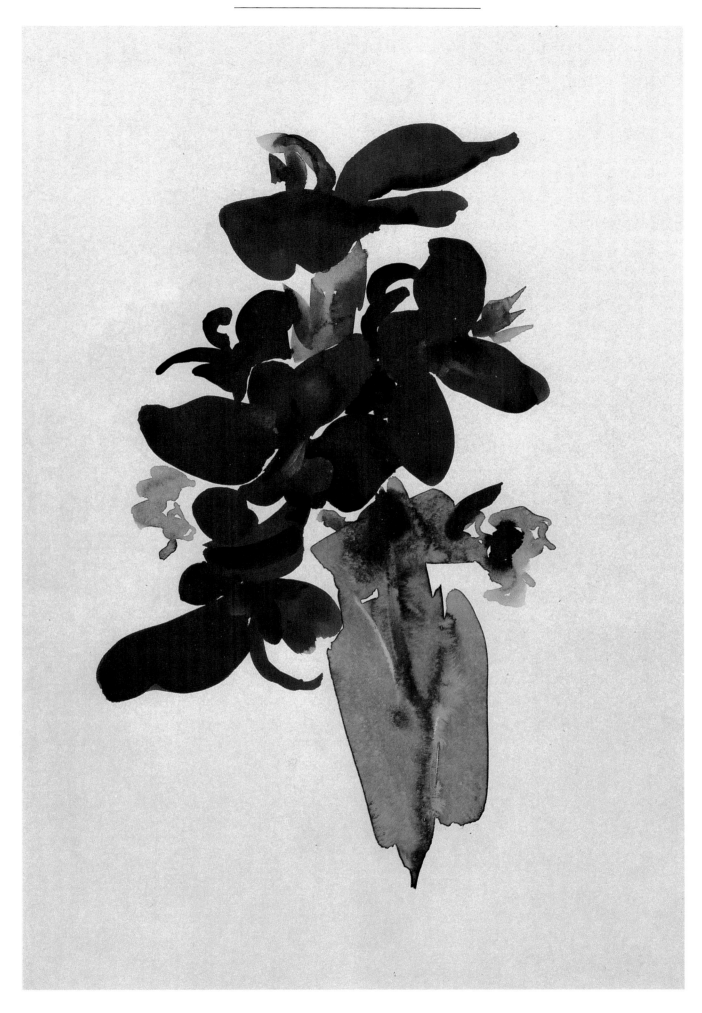

Red Canna c.1920
Watercolor on paper, 19⅜×13 inches
Gift of George Hooper Fitch, B.A. 1932, and Mrs. Fitch,
Yale University Art Gallery, New Haven, CT

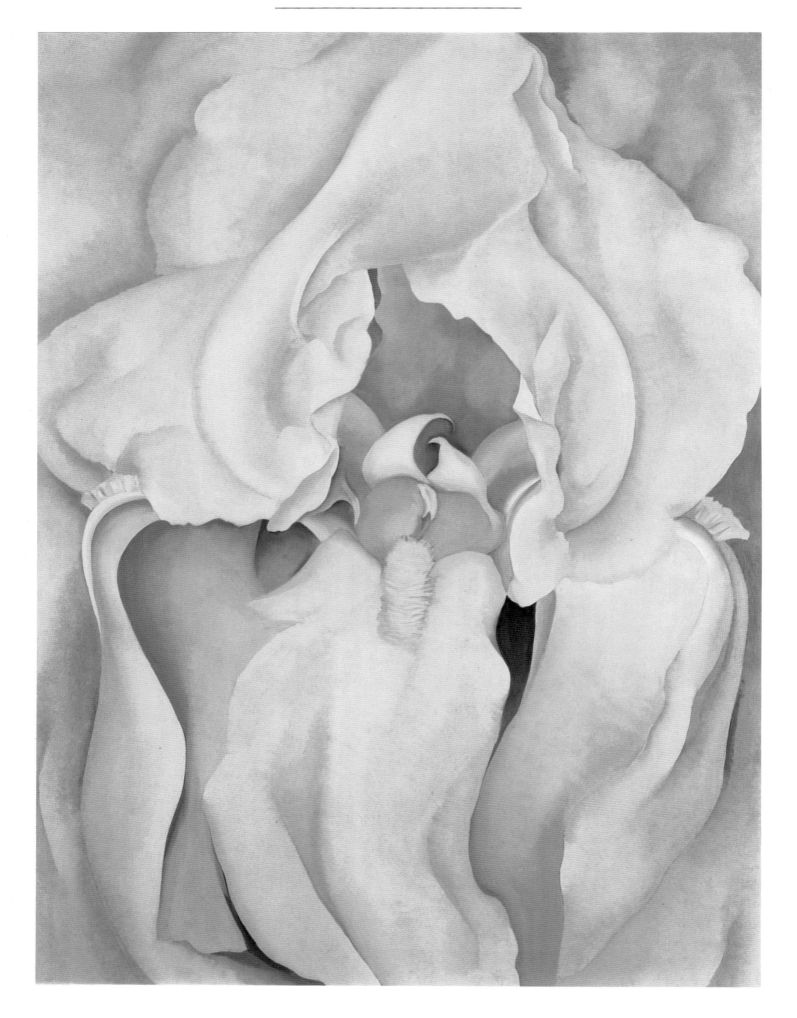

Light Iris 1924
Oil on canvas, 40×30 inches
Gift of Mr. and Mrs. Bruce C. Gottwald,
Virginia Museum of Fine Arts, Richmond, VA (85.1534)

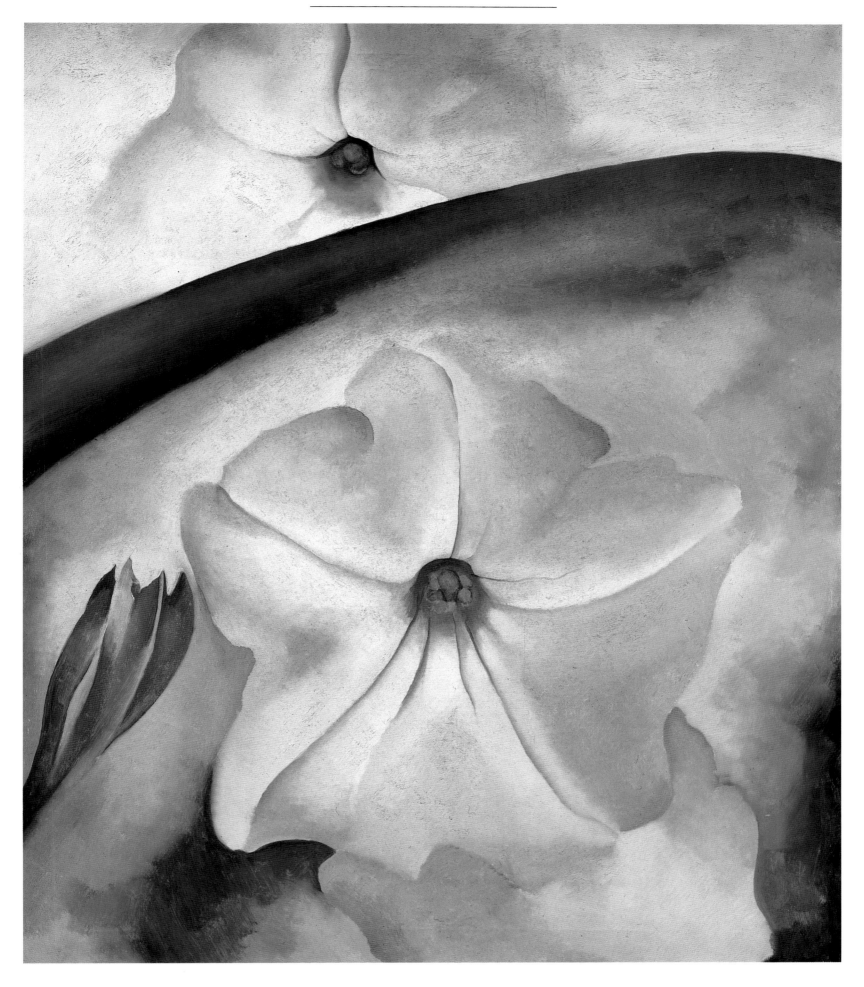

Petunia No. 2 1924
Oil on canvas, 36×30 inches
Collection of Mr. and Mrs. Gerald P. Peters, Santa Fe, NM

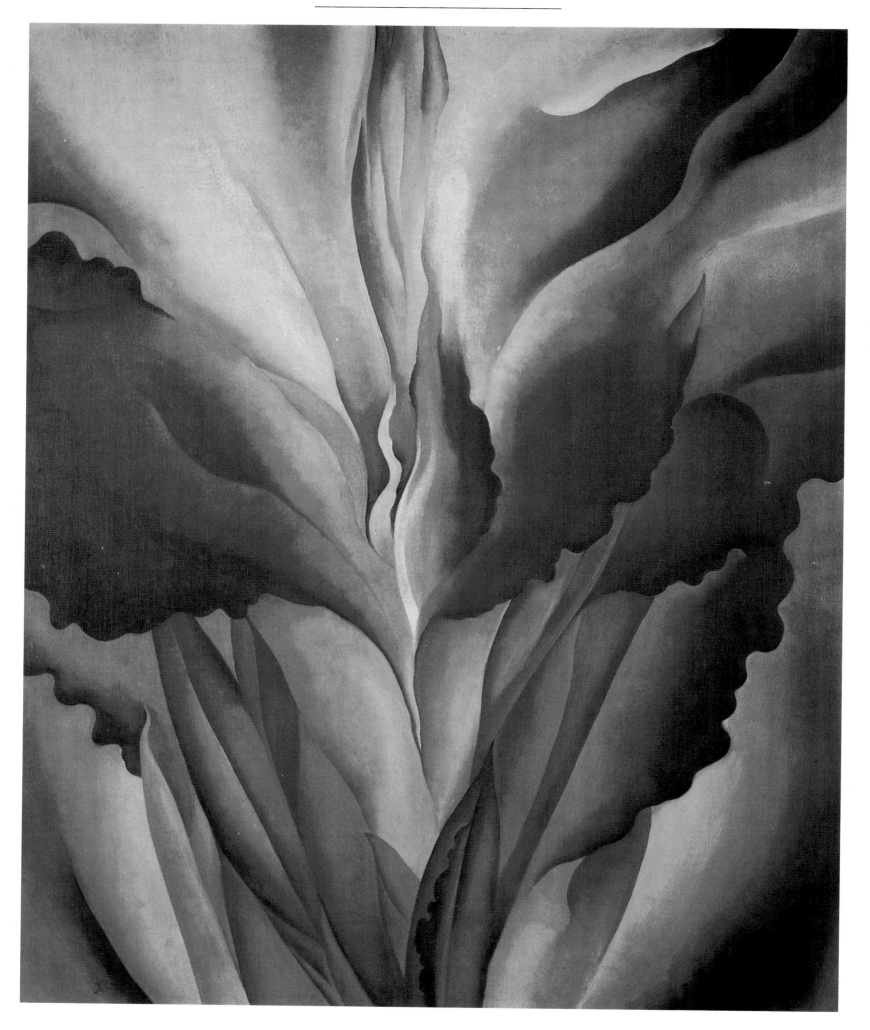

Red Canna c.1924
Oil on canvas mounted on masonite, 36×29⅞ inches
*Gift of Oliver James, University of Arizona Museum of Art,
Tucson, AZ*

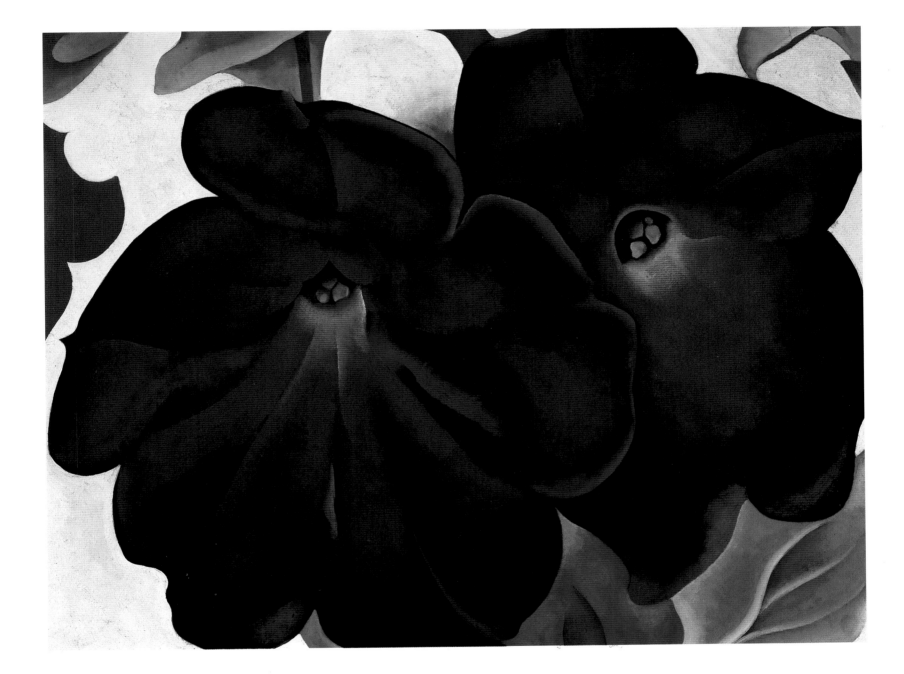

Black and Purple Petunias 1925
Oil on board, 20×25 inches
Photo courtesy of The Gerald Peters Gallery, Santa Fe, NM

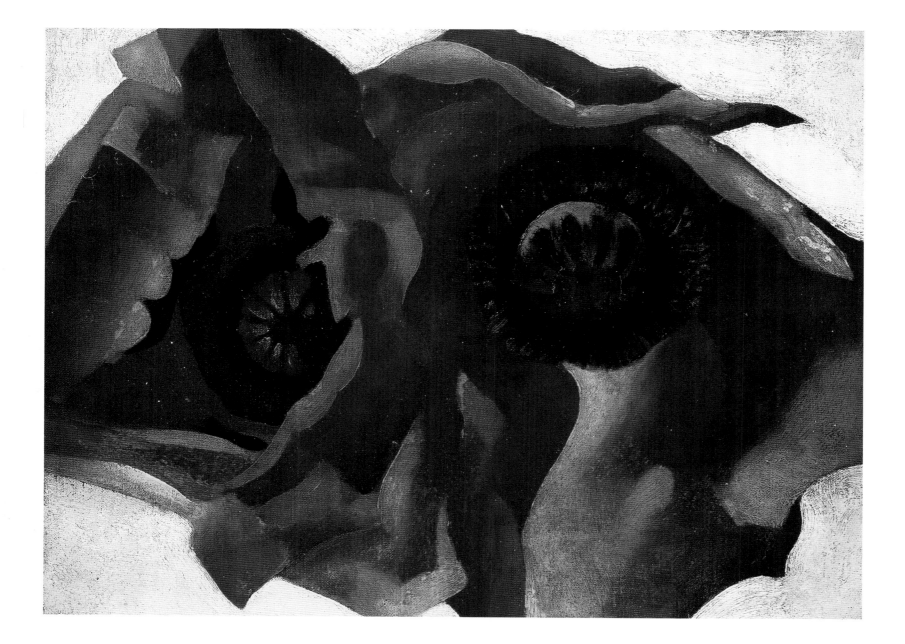

Poppies and Lake George, New York 1926
(On verso – double-sided painting)
Oil on canvas, 6×8 inches
The Regis Collection, Minneapolis, MN

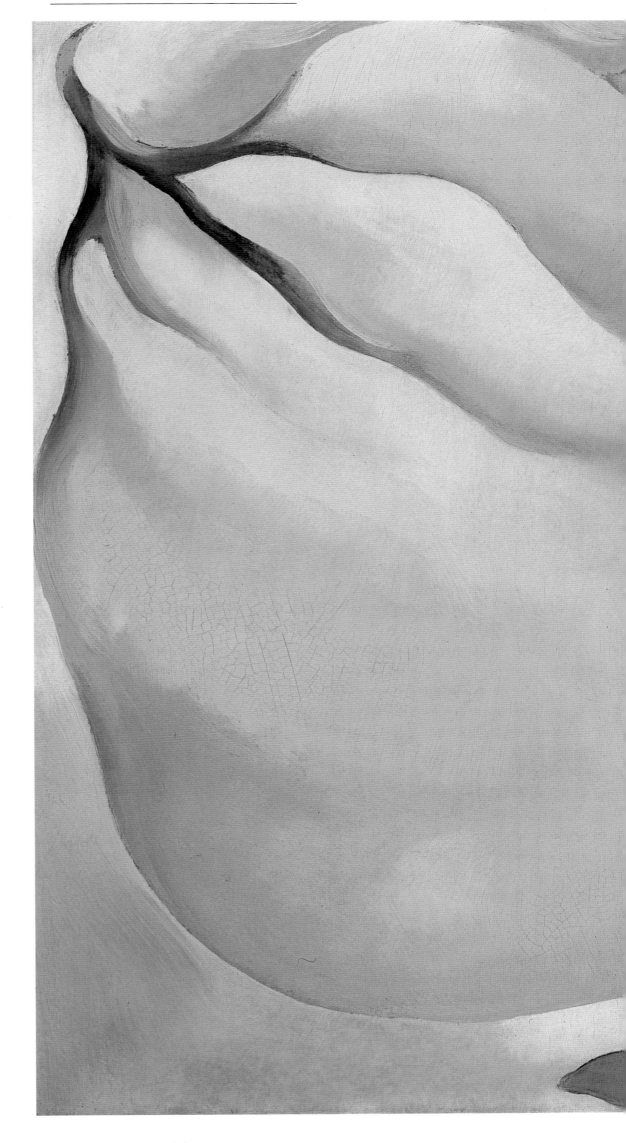

Yellow Calla 1926
Oil on fiberboard, 9⅜×12¾ inches
Gift of the Woodward Foundation,
National Museum of American Art,
Smithsonian Institution, Washington,
D.C./Art Resource, New York, NY
(1978.34)

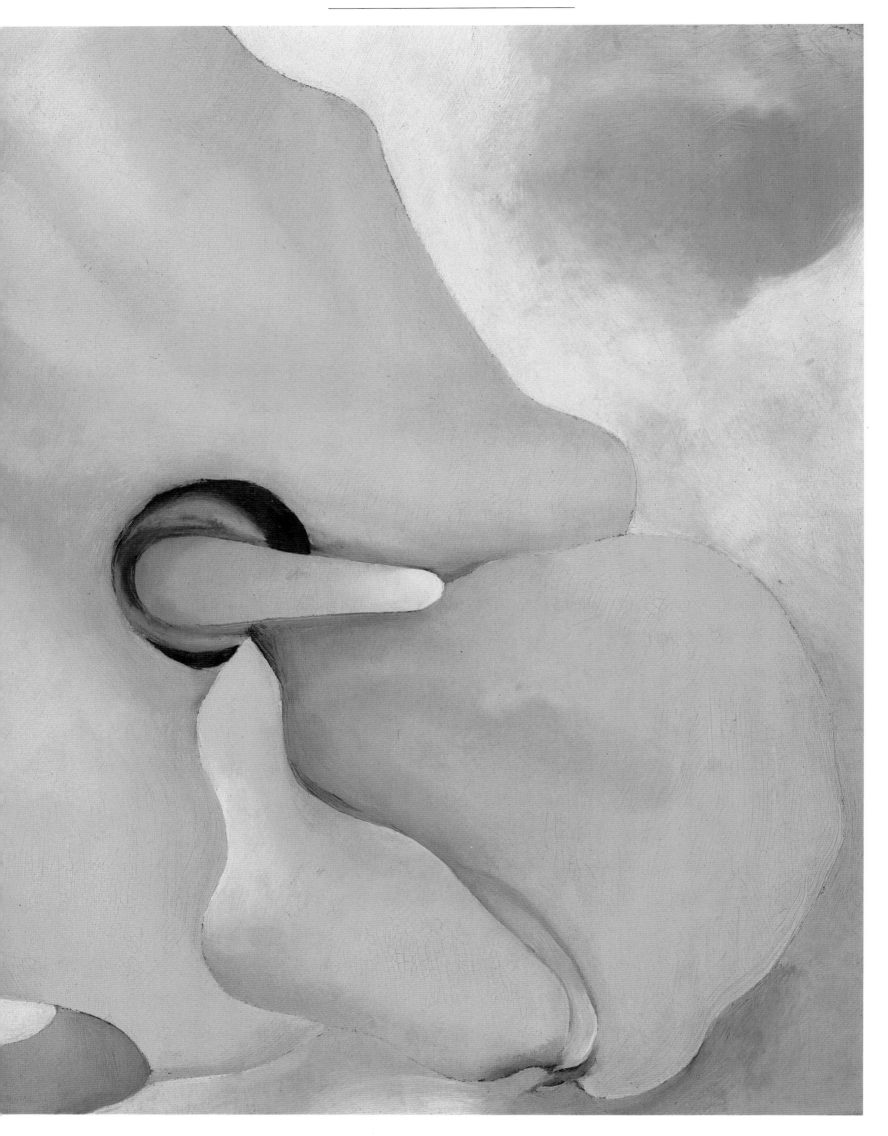

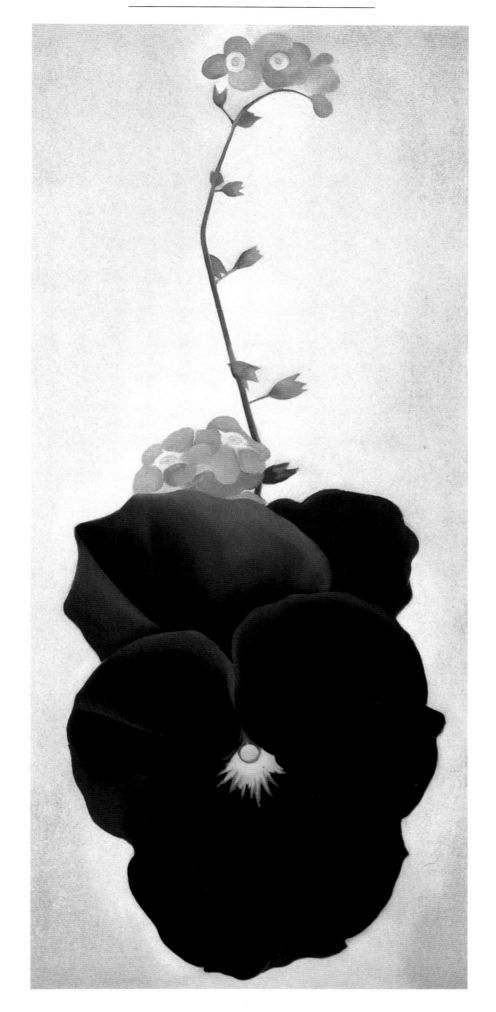

Pansy 1926
Oil on canvas, 26¹⁵⁄₁₆×12¹⁄₁₆ inches
Gift of Mrs. Alfred S. Rossin,
The Brooklyn Museum, Brooklyn, NY (28.521)

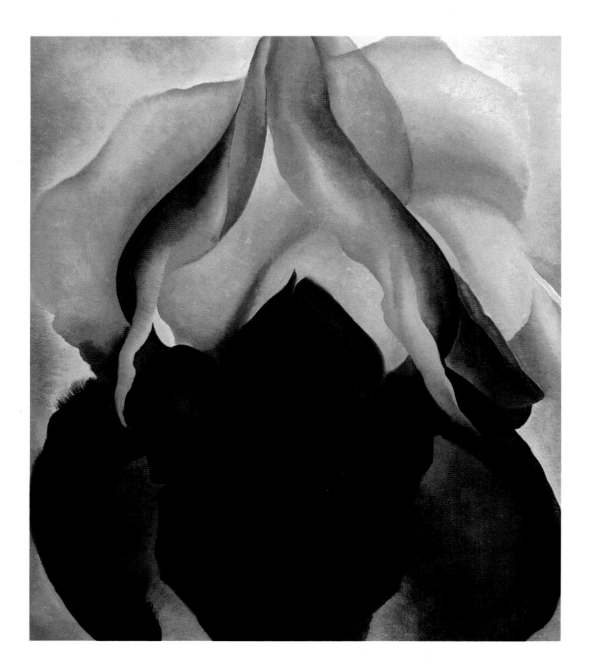

Black Iris III 1926
Oil on canvas, 36×29⅞ inches
Alfred Stieglitz Collection, 1969,
The Metropolitan Museum of Art, New York, NY (69.278.1)

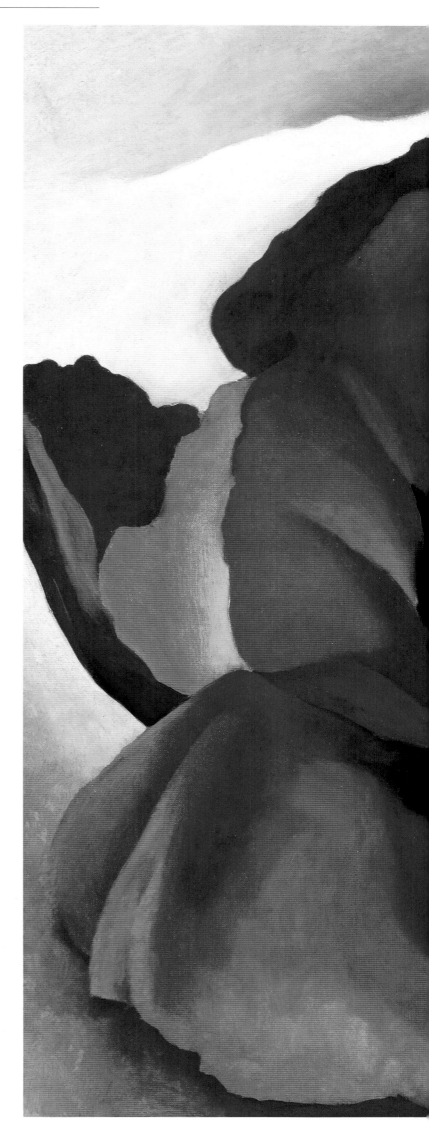

Poppy 1927
Oil on canvas, 30×36 inches
*Gift of Charles C. and Margaret Stevenson Henderson in memory of
Hunt Henderson, Museum of Fine Arts, St. Petersburg, FL*

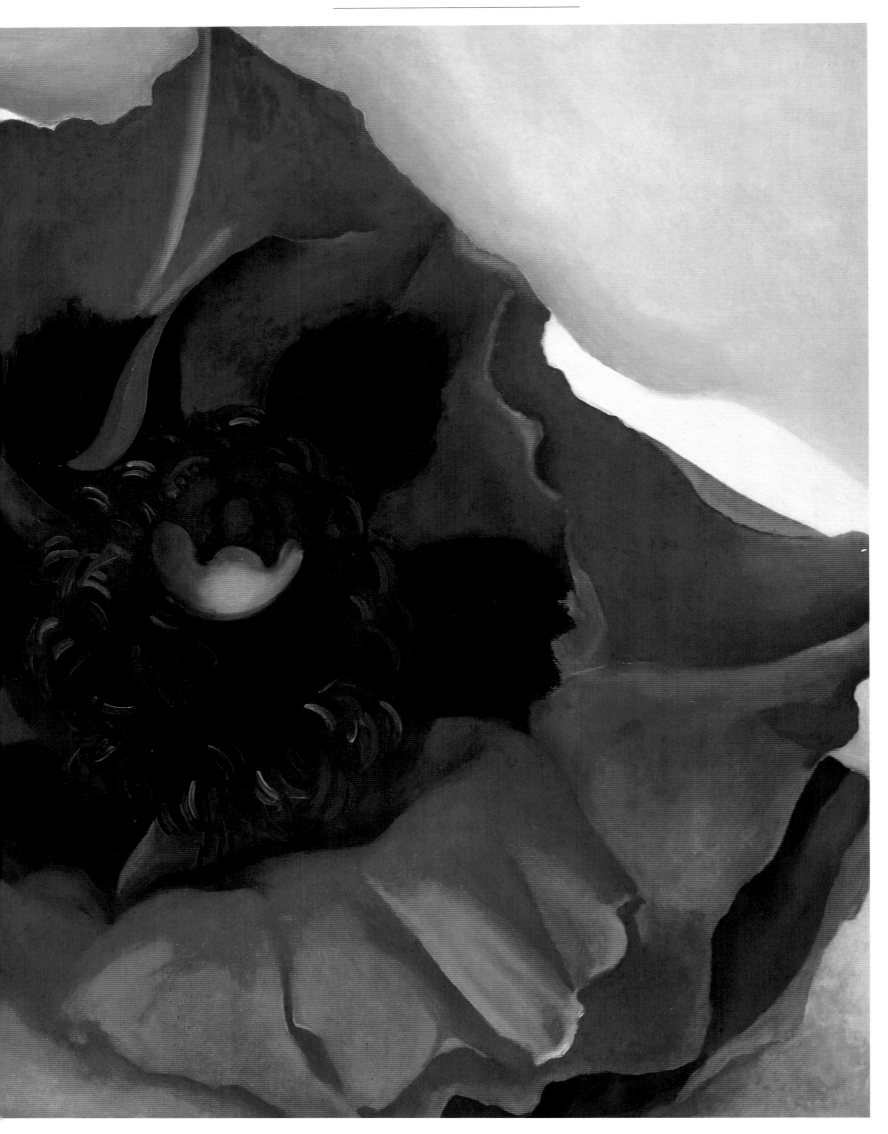

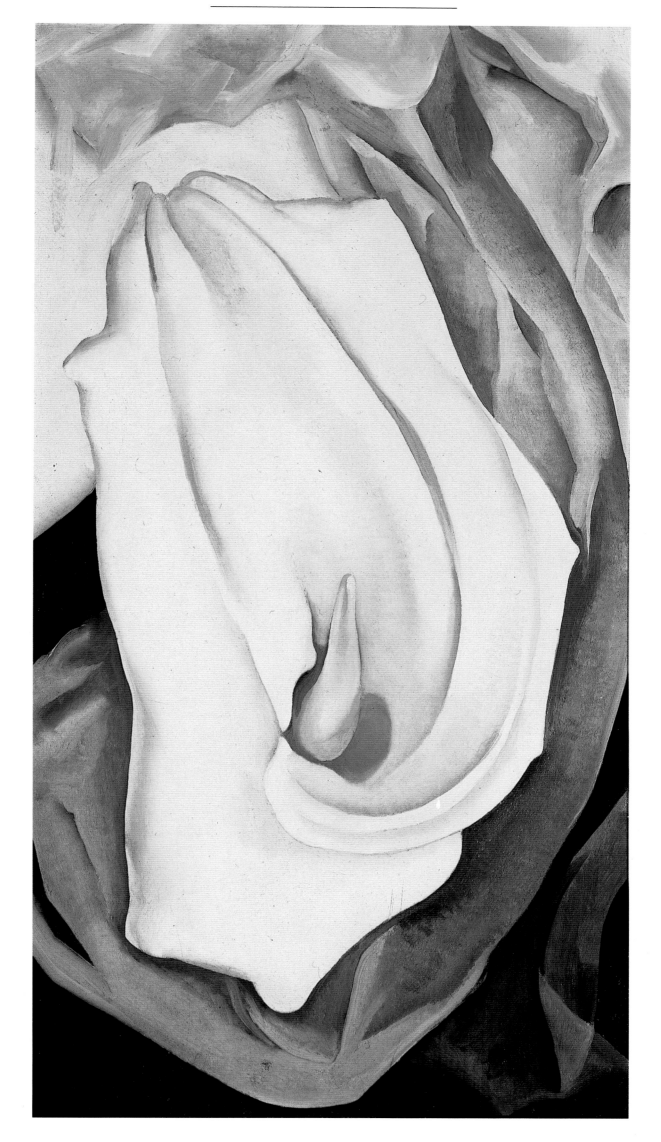

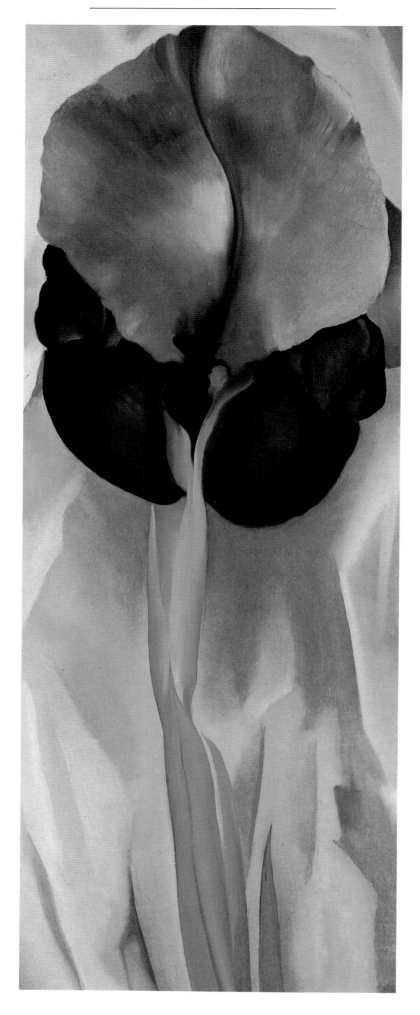

Left:
White Calla Lily 1927
Oil on canvas, 32×17 inches
The Gerald Peters Gallery, Santa Fe, NM

Above:
Iris 1929
Oil on canvas, 32×12 inches
Anonymous Gift, Colorado Springs Fine Arts Center,
Colorado Springs, CO

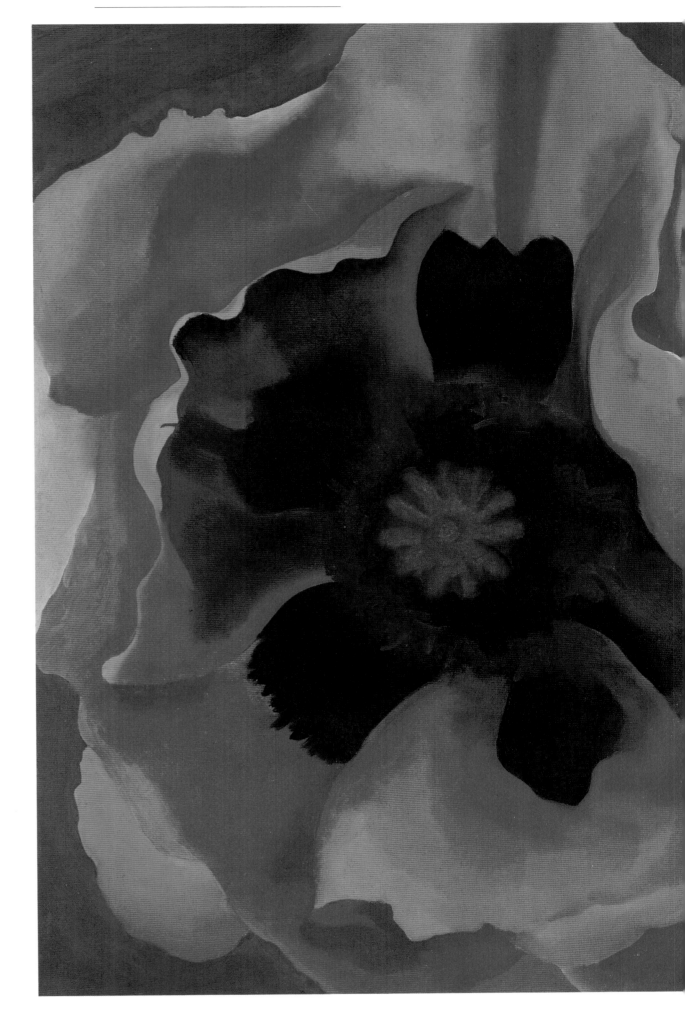

Oriental Poppies 1928
Oil on canvas, 30×40⅛ inches
Purchase, The Frederick R. Weisman Art Museum at the University of
Minnesota, Minneapolis, MN

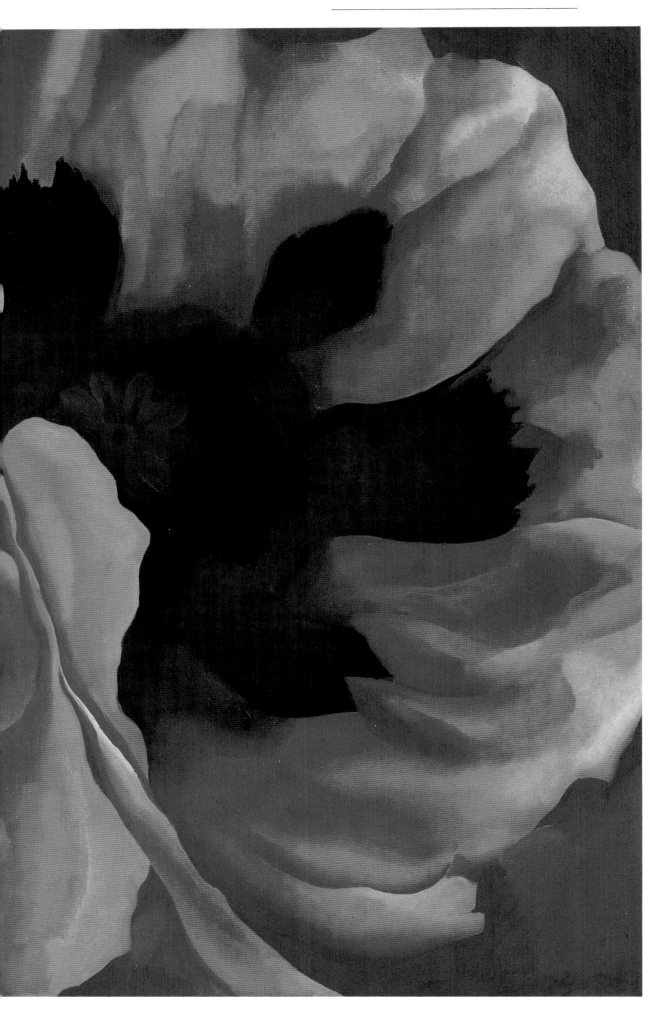

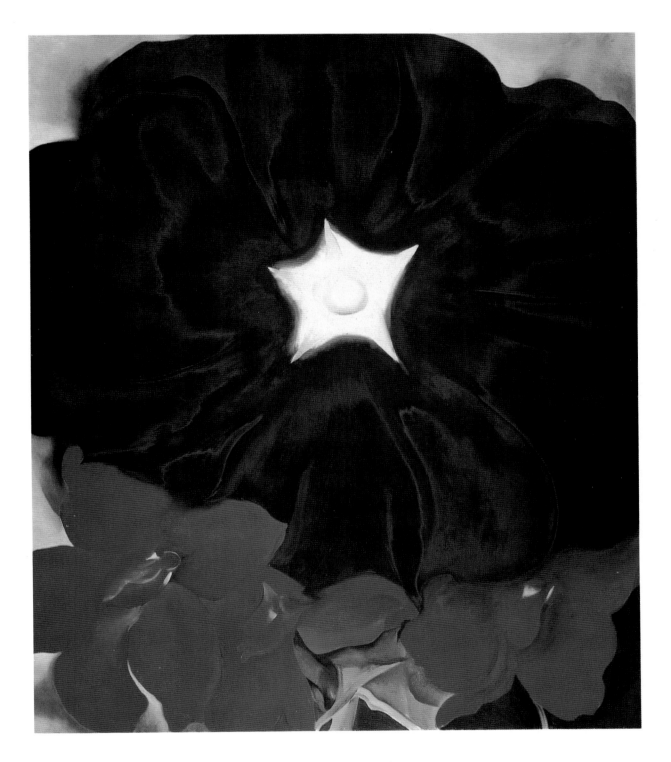

Black Hollyhock, Blue Larkspur 1929
Oil on canvas, 36×30 inches
George A. Hearn Fund, 1934,
The Metropolitan Museum of Art, New York, NY (34.51)

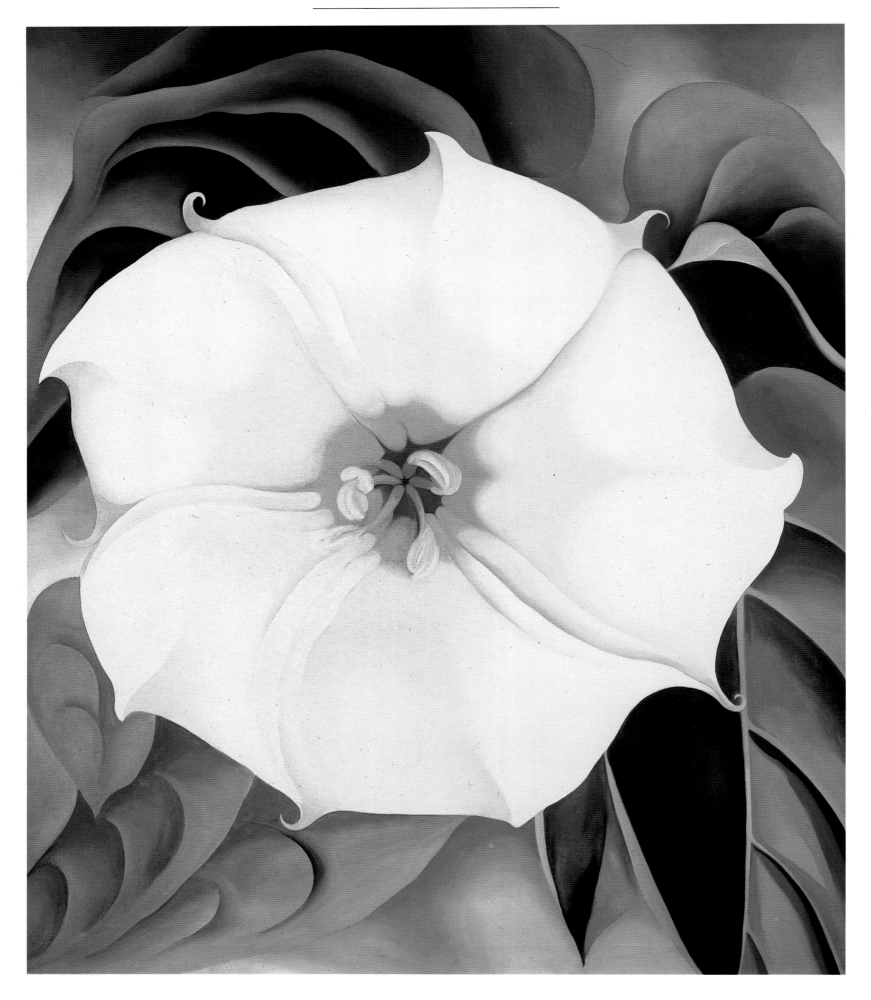

Jimson Weed 1932
Oil on canvas, 48×40 inches
Collection of Mr. and Mrs. Gerald P. Peters, Santa Fe, NM

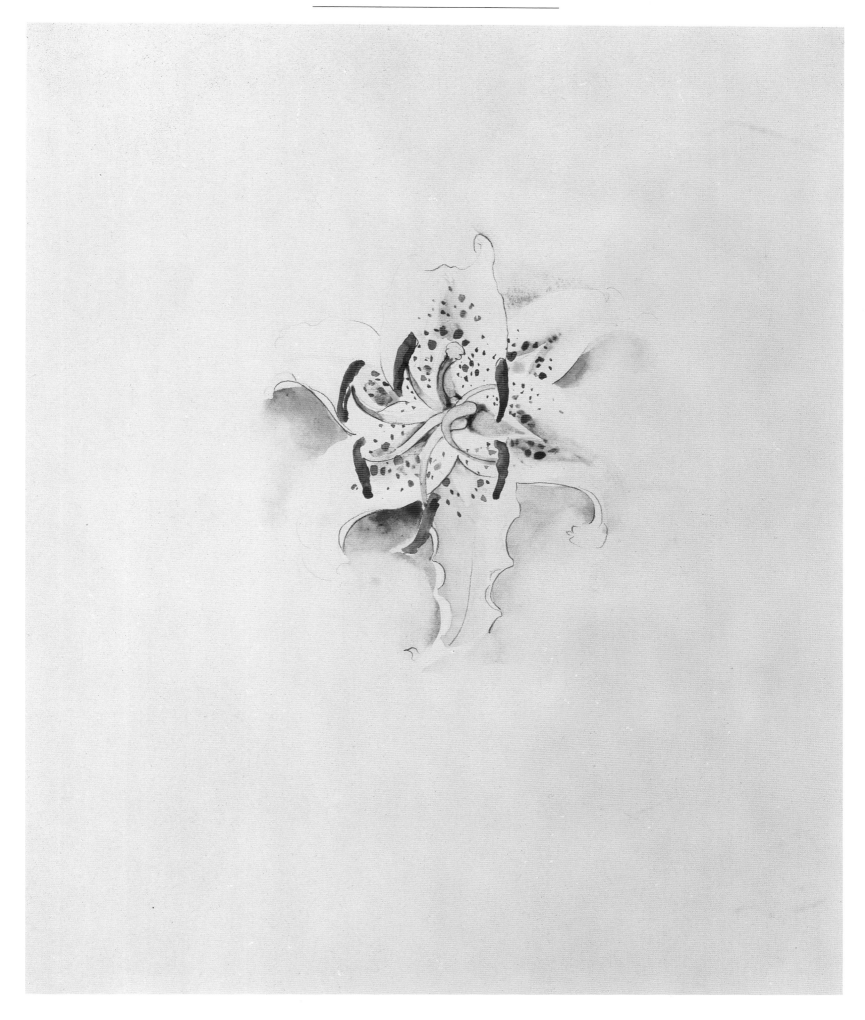

Spotted Lily *c.*1935
Watercolor, 15¾×12½ inches
Photo courtesy of The Gerald Peters Gallery, Santa Fe, NM

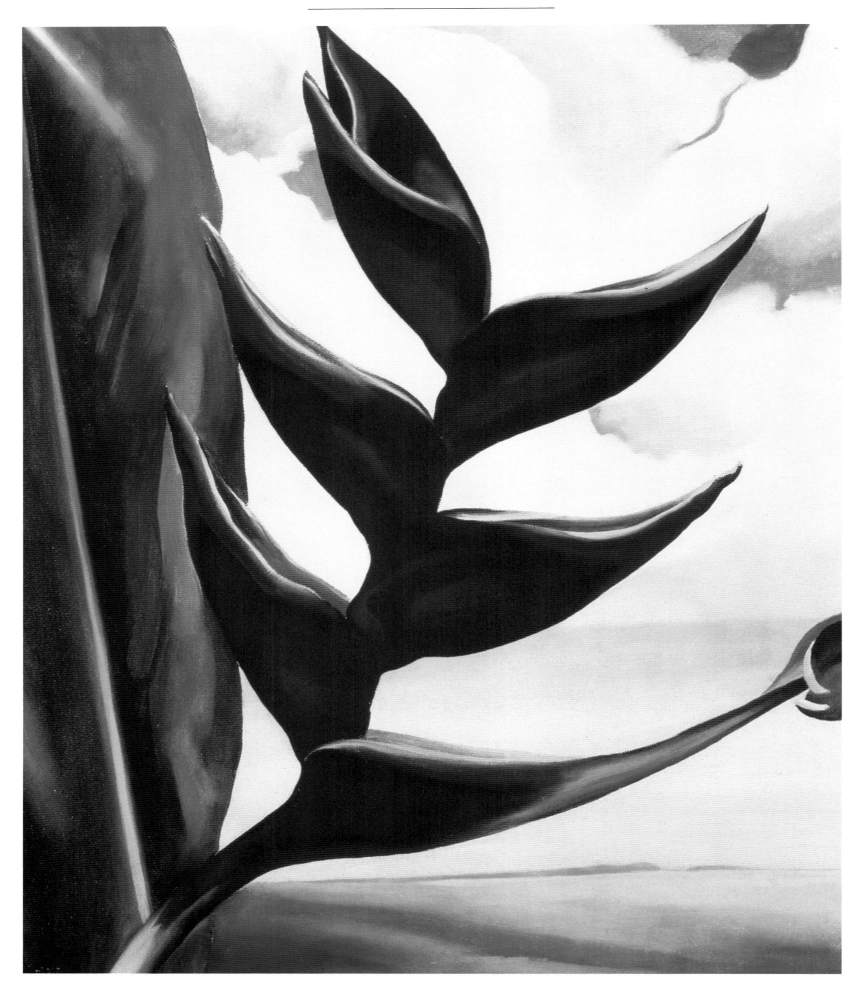

Haleconia: Crab's Claw Ginger 1939
Oil on canvas, 19×16 inches
Laila and Thurston Twigg-Smith Collection

Right:
Narcissa's Last Orchid 1941
Pastel, 21⅜×27⅛ inches
Gift of David H. McAlpin, The Art Museum,
Princeton University, Princeton, NJ

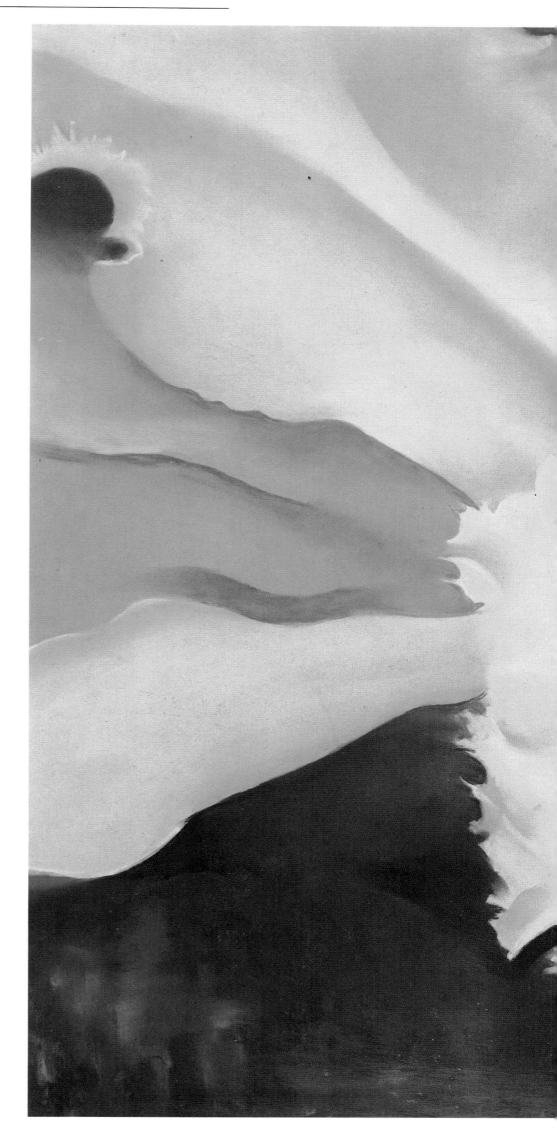

Overleaf:
Pink and Yellow Hollyhocks 1952
Oil on canvas, 24×40 inches
Bequest of Helen Miller Jones, Marion Koogler
McNay Art Museum, San Antonio, TX (1989.37)

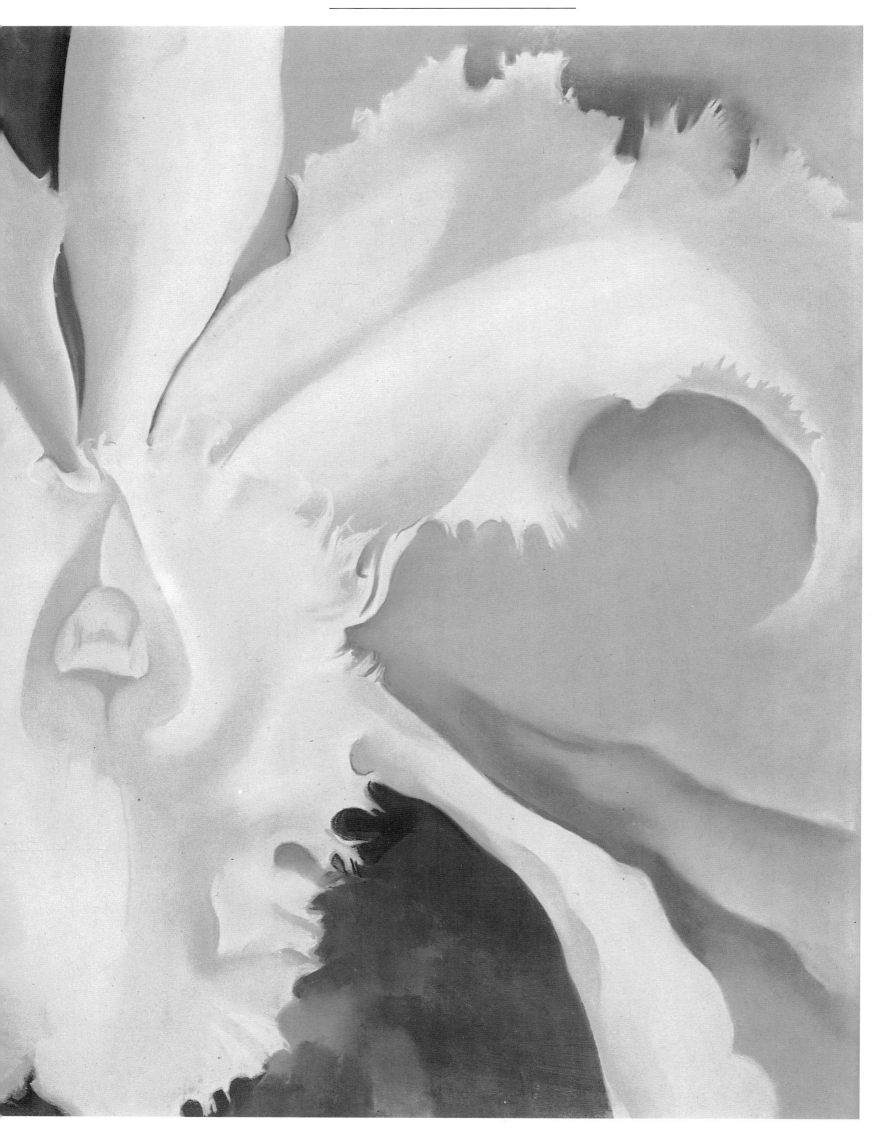

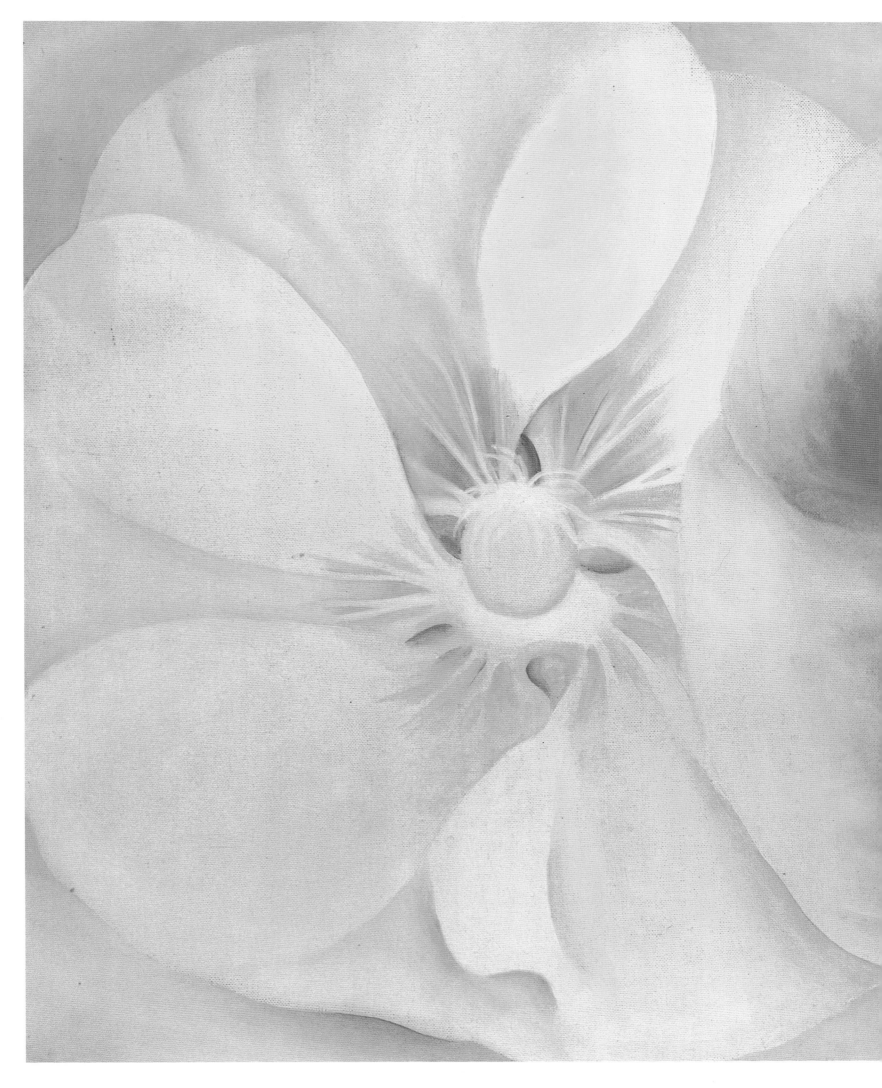

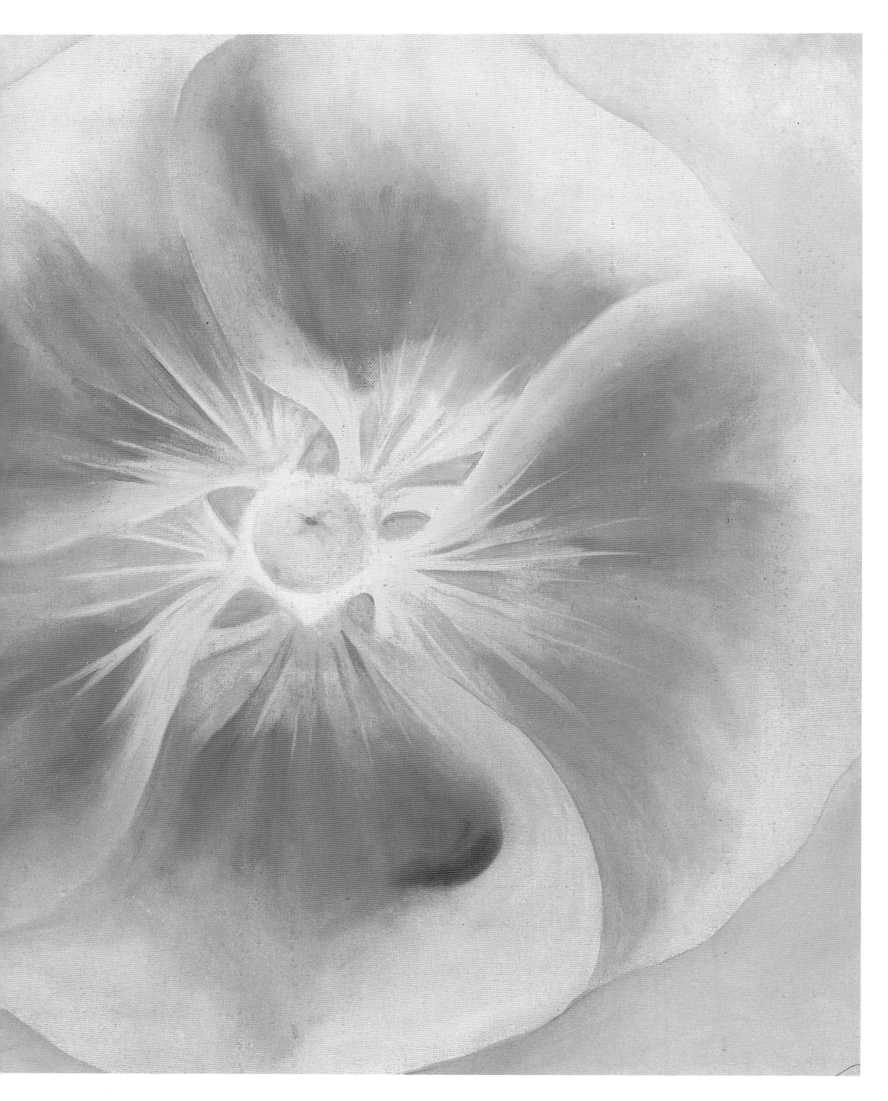

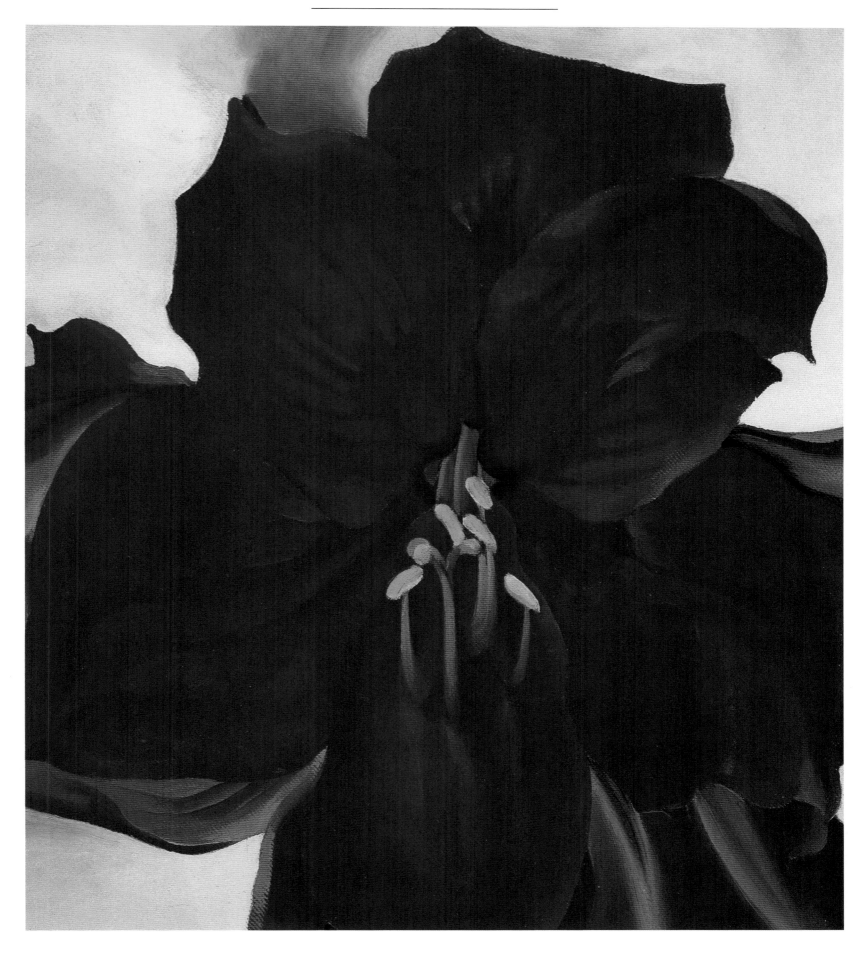

Above:
Red Amaryllis undated
Oil on canvas, 11⅞×10 inches
Gift of Mrs. Henrietta Roig,
Terra Museum of American Art, Chicago, IL

Right:
Black Hollyhock with Larkspur undated
Oil on canvas, 30×40 inches
Photograph courtesy of The Gerald Peters Gallery, Santa Fe, NM

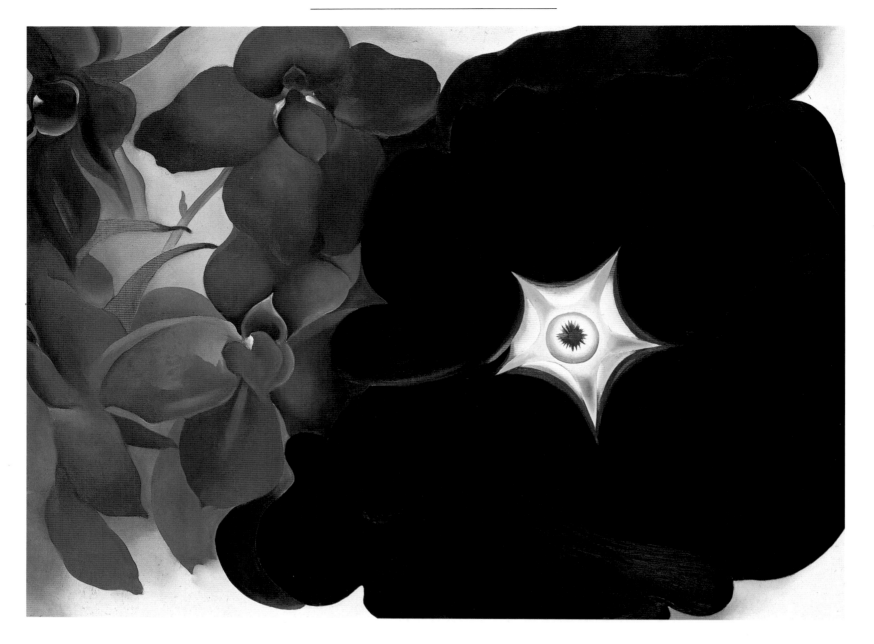

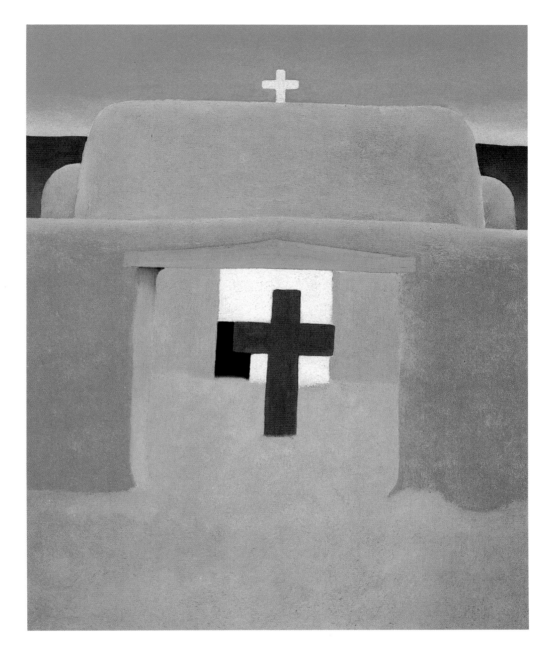

Above:
Gate of Adobe Church 1929
Oil on canvas, 20¹⁄₁₆×16 inches
Museum Purchase: Gift in Memory of Elisabeth Mellon Sellers from
her Friends, The Carnegie Museum of Art, Pittsburgh, PA (74.17)

Right:
Ranchos Church 1929
Oil on canvas, 24×36 inches
Alfred Stieglitz Collection, 1961,
The Metropolitan Museum of Art, New York, NY (61.258)

THE WEST

More than any other landscape, the deserts, hills, buttes and mountains of New Mexico inspired O'Keeffe's art. It was in 1917 that O'Keeffe first visited Santa Fe on her way back from a hiking vacation in Colorado with her sister Claudia, but it would be 12 years before she would return "home." For the 11 intervening summers she vacationed with Stieglitz at Lake George, and was beginning to feel that she had explored and painted everything that was available to her there. Urged to revisit the Southwest by Dorothy Brett and Mabel Dodge Luhan, who lived in Taos, O'Keeffe persuaded Beck Strand, the wife of the photographer Paul Strand, to accompany her. Thus on 1 May 1929, O'Keeffe and Beck left New York for New Mexico. O'Keeffe was lodged in the Pink House, a guest cottage on Mabel Luhan's property, which looked out across a green meadow to the Taos mountains in the distance. Although she enjoyed the company that gathered at Mabel's ranch, O'Keeffe, in her desire for freedom to explore the desert and mountains more thoroughly, bought a Model A Ford, which

she used as a sort of mobile studio. Now her trips took her as far afield as the cliff ruins of Mesa Verde in southern Colorado, Canyon de Chelly, and the Grand Canyon. O'Keeffe committed each experience to canvas, including the time when she had experimented with bootleg whiskey in *After the Las Vegas Rodeo*.

During her travels in New Mexico, O'Keeffe occasionally came across large, mysterious black crosses planted in the arid landscape. While some locals said that the crosses marked the spots where Catholics had died, or where the pallbearers had stopped to pray on the way to the cemetery, others believed that they were the work of the Penitente, a secret society which had originated in medieval Spain that practiced flagellation and staged reconstructions of the Crucifixion. O'Keeffe painted three versions of the black crosses in the New Mexican landscape, paintings which startled the New York critics when they were first exhibited. The cross theme was one to which O'Keeffe would later return during her trip in 1932 to the Gaspé

Peninsula in Canada, where she saw the numerous mariners' crosses that had been erected in memory of those who had been lost at sea.

In New Mexico O'Keeffe also began a series of paintings based on the eighteenth-century mission church at Ranchos de Taos. Already a popular subject for artists in the area, O'Keeffe depicted the St. Francis of Assisi mission church in her own unique way. Two groups of paintings done in 1929, and later on her second visit to the region in 1930, demonstrate the changes in O'Keeffe's work during this period. O'Keeffe painted about eight pictures of the large adobe church and, with one exception, which shows the front façade with its bell towers and crosses, all the paintings are views of the rear of the building. The first paintings, done in 1929, emphasize the church's sculptural masses which, at the rear, are enhanced by unusual, large supporting buttresses, and, as in *Ranchos Church I*, O'Keeffe emphasizes the way the man-made building uneasily inhabits the natural landscape, by use of the clear definitions of the land, the church and the sky. The paintings of the Ranchos church from 1930 mark O'Keeffe's change in perception of the relationship of the building to its environment. In the paintings of the later series, dark outlines are eliminated, and the elements of land, church and sky are painted in much more closely related colors and tones.

In addition to architectural studies and floral compositions, O'Keeffe also painted some purely landscape subjects during her first visit to New Mexico in 1929. The landscapes were treated in a very similar way to her flower motifs: a single form enlarged to fill the entire picture space. It was not until her second visit in 1930, however, that O'Keeffe's landscapes would display a new, important influence: the panoramic scene became the subject of works which emphasized the three-dimensional forms of the landscape. The clear, crisp quality of light that O'Keeffe enjoyed in the Southwest enabled her to see for great distances, and many of her paintings show the New Mexican landscape as a series of receding layers. It was the mountains of the region that would be the inspiration for many of O'Keeffe's paintings, such as *The Mountain, New Mexico* (1931), *The Red Hills Beyond Abiquiu* (1930), and *Red Hills, Gray Sky* (1935).

Equally important was the recurring subject of bones, with which O'Keeffe began working in 1930. During her summers in New Mexico, she collected the dry, sun-bleached bones which she found scattered across the desert floor, and shipped them back to Lake George. Her 1932 exhibition provided yet another shock to the art establishment, when O'Keeffe's skull-and-flower paintings were shown. Some critics described them as surreal, others decided that they exhibited a morbid death fantasy and were perverse. O'Keeffe did not see them that way, and explained in her autobiography: "I have used these things to say what . . . is to me the wideness and the wonder of the world I live in."

Cow's Skull: Red, White and Blue (1931), which was most likely painted not in New Mexico but in Lake George, is one of O'Keeffe's most famous paintings, and is also one of her earliest studies of a single bone isolated from its natural environment. For O'Keeffe it was the shape and texture of the bones, with their interplay of positive and negative, convex and concave spaces, that inspired her to paint them over and over again. Of *Cow's Skull: Red, White and Blue*, O'Keeffe also said: "I am quite excited about our country," and the painting's patriotic colors distinguish the work as a truly American painting.

As soon as one theme was worked to its ultimate conclusion, O'Keeffe would introduce another to her paintings. Having introduced the floral element in *Cow's Skull with Calico Roses* in 1932, she developed the skull-and-flower theme further, eventually introducing a third element: the landscape.

O'Keeffe painted some of her best-known works during her first years at Ghost Ranch: *Blue River* (1935) and *Red Hills with the Pedernal* (1936) reflect her deep admiration for the landscape of the Southwest of America. *From the Faraway Nearby* (1937) demonstrates a later development in the landscape-and-skull theme. This picture was painted in the summer of 1937, when O'Keeffe was living at Ranchos de los Burros, a house on the Ghost Ranch property near Abiquiu. In this painting the animal skull is no longer suspended in midair, but rests on the narrow strip of landscape at the bottom of the canvas and, as in the second series of paintings of the Ranchos church, the colors of the elements are more unified. Instead of the frontally positioned skull, the elk's skull is shown here in a three-quarters profile, a view which emphasizes its three-dimensionality. But like many of O'Keeffe's skull-and-landscape paintings, the familiar sense of ambiguous space remains. Because her landscape paintings often lack a middle distance, objects in them appear either very near or very far off.

The natural connection between the bones and the desert landscape in which they were preserved and found by O'Keeffe, was developed further in the *Pelvis* series, painted between 1943 and 1945. The series consists of about a dozen paintings, which show the bone both in its entirety, and in close-up fragments. Although the bone is explored from different angles – front, profile, rear – its position on the canvas remains central. The earliest paintings of the series, like *Pelvis with Moon* from 1943, show the complete pelvic bone. In later works O'Keeffe became aware of the compositional qualities offered by the openings in the bone, such as in *Pelvis with the Distance*. In a subsequent group of paintings, executed between 1944 and 1945, O'Keeffe concentrated on the openings themselves, to the exclusion of all landscape details, thereby focusing the spectator's attention wholly on the three elements of bone, opening and sky. During the next 13 years O'Keeffe sometimes returned to the theme of the pelvic bone or openings, adapting some 1944 compositions by replacing the naturalistic colors with brighter, some would say, more garish ones.

O'Keeffe's bone paintings were probably the most startling images she produced during the 1930s and 1940s, but they were not the only themes she explored. The summer that she moved into Ranchos de los Burros, she painted a view of her house

which she entitled *The House I Live In*, and she also painted the Pedernal, the flat-topped mesa about 10 miles away from Abiquiu. Long after she had worked off the skeletal themes, the New Mexican landscape would endure in her work.

In the summer of 1940 O'Keeffe painted *Red and Yellow Cliffs*, a view of the cliffs situated to the rear of Ghost Ranch. From the roof of Ranchos de los Burros O'Keeffe could see the magnificent colors and formations of the land around her, including, to the east, the Canyon National Forest. Near the village of Abiquiu were the gray-white formations of ancient lava ash, which, beginning in 1940, O'Keeffe painted many times, calling the area the "White Place."

Some of O'Keeffe's most dramatic landscape paintings of New Mexico are her free and selective views of a place she nicknamed the "Black Place," a stretch of gray hills 150 miles to the northwest. Between 1940 and 1943 O'Keeffe painted around seven canvases of views of the Black Place. While the hills in these paintings always appear in distant perspective, in some paintings she concentrated on their shape and mass, while in others she focused on their textural qualities. In all of the *Black Place* paintings O'Keeffe worked with a deliberately restricted palette (of grays and blacks), set of shapes (rectangles) and of lines (diagonal), thereby removing all extraneous details of the landscape. Furthermore, she returned to the "V"-shaped compositions that she had used earlier in her flower paintings, to suggest both dynamic movement and balance. In 1945, when O'Keeffe bought a second home in Abiquiu overlooking the Chama River Valley, she found plenty of subjects for her paintings: nature, as depicted in *Spring Tree I*, and her home, details of which she painted a number of times in works such as *In the Patio II* (1948).

The work which followed on from O'Keeffe's *Black Place* series roughly falls into two categories. Firstly, there are the abstract representations of nature where the subject is still recognizable (such as the waterfall paintings done in the 1950s, or the Grand Canyon paintings from the 1960s). The second category consists of more severe abstractions, where the imagery may have been derived from nature, but where this cannot be specifically identified. This category includes O'Keeffe's work from the 1950s: geometrical color abstractions; aerial pictures like *It Was Blue and Green*; and those of clouds, skies and landscapes from above, which she had seen during her airplane trips.

Front of Ranchos Church 1930
Oil on canvas, 20×36 inches
The Gerald Peters Gallery, Santa Fe, NM

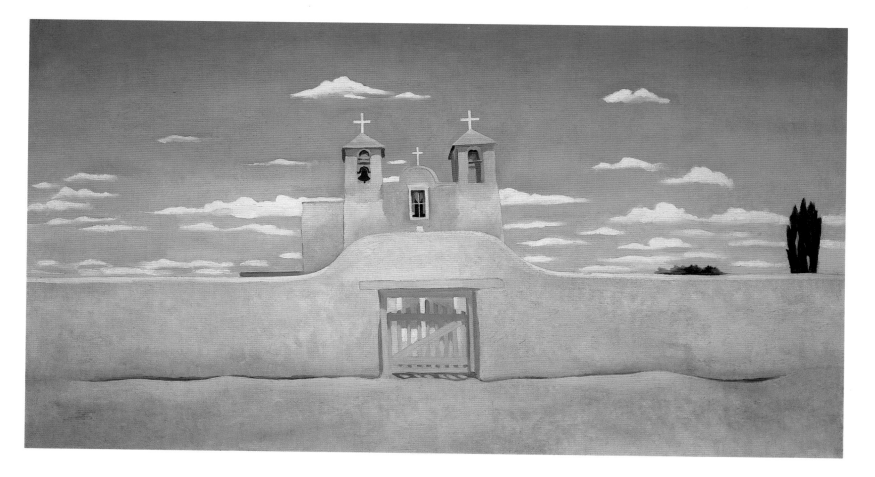

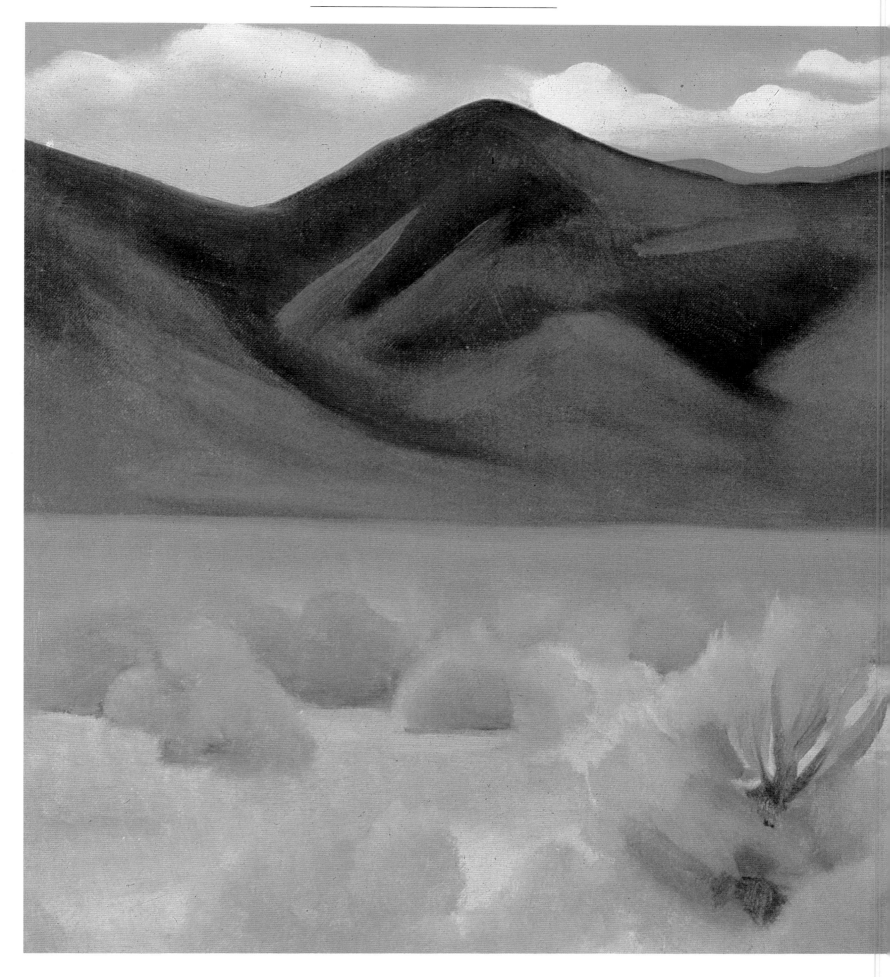

Hills Before Taos 1930
Oil on canvas, 16×30 inches
The Blount Collection,
Collection of The Montgomery Museum of Fine Arts, Montgomery, AL

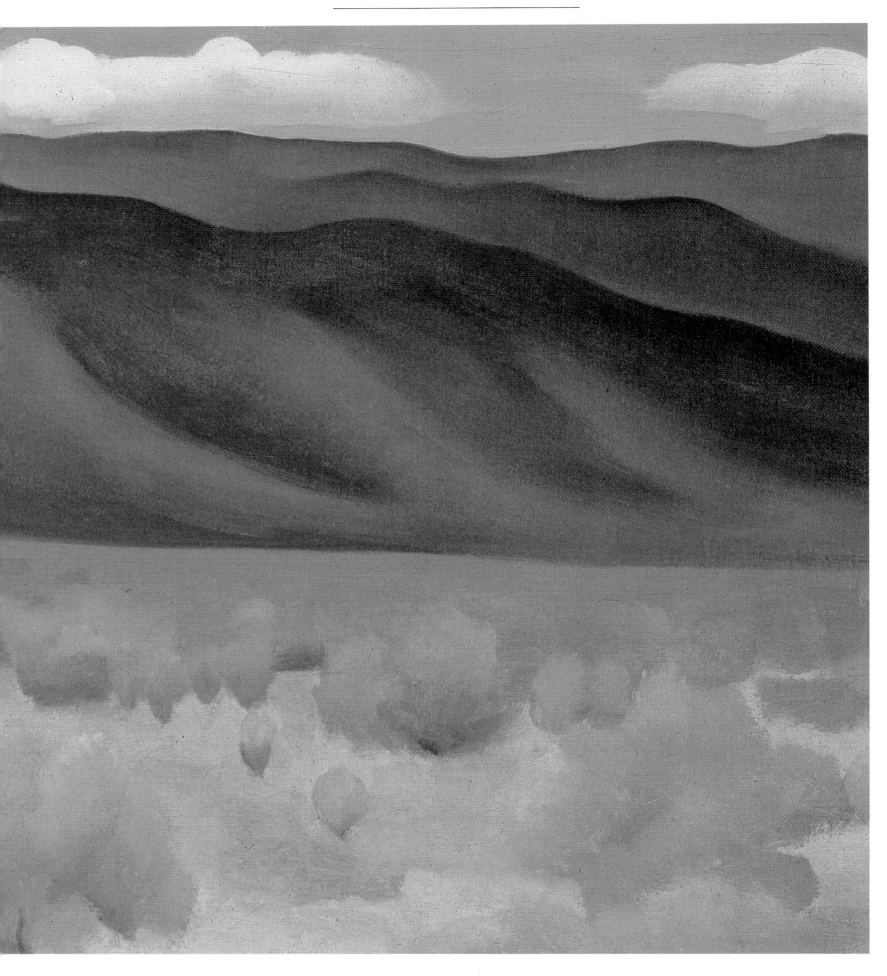

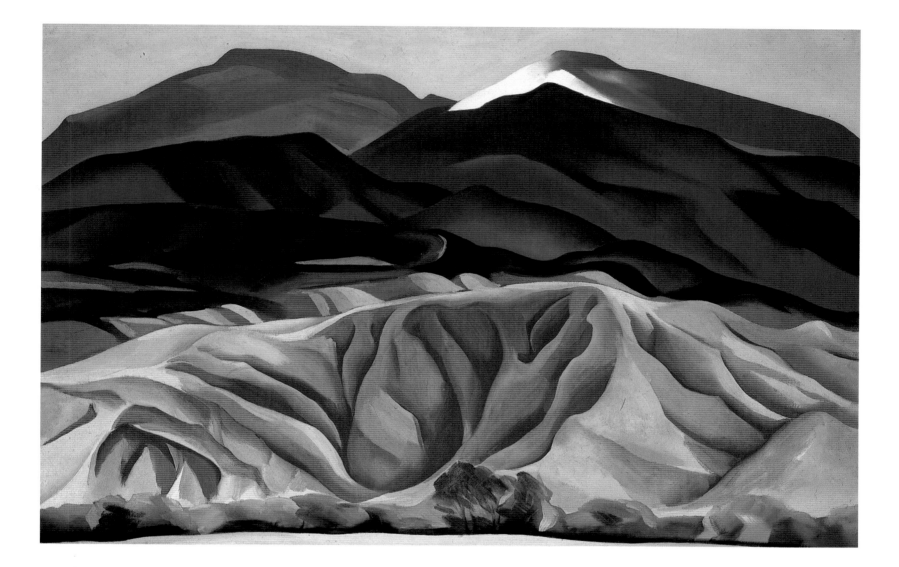

Black Mesa, New Mexico undated
Oil on canvas, 24¼×36¼ inches
*Private collection, photo courtesy of The Gerald Peters Gallery,
Santa Fe, NM*

The Red Hills Beyond Abiquiu 1930
Oil on canvas, 30×36 inches
*Eiteljorg Museum of American Indian and Western Art,
Indianapolis, IN*

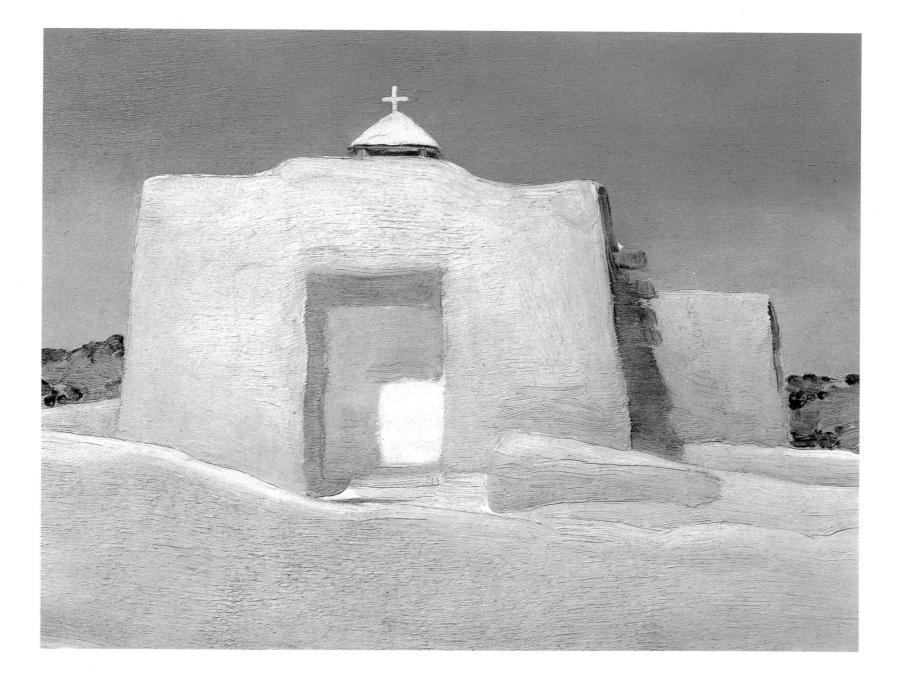

Above:
Near Alcade, New Mexico undated
Oil on panel, 7×8¾ inches
Bequest of Doris M. Brixey,
Yale University Art Gallery, New Haven, CT (1984.32.21)

Right:
Cow's Skull with Calico Roses 1932
Oil on canvas, 36×24 inches
Gift of Georgia O'Keeffe,
Photograph © 1993, The Art Institute of Chicago, Chicago, IL
(1947.712)

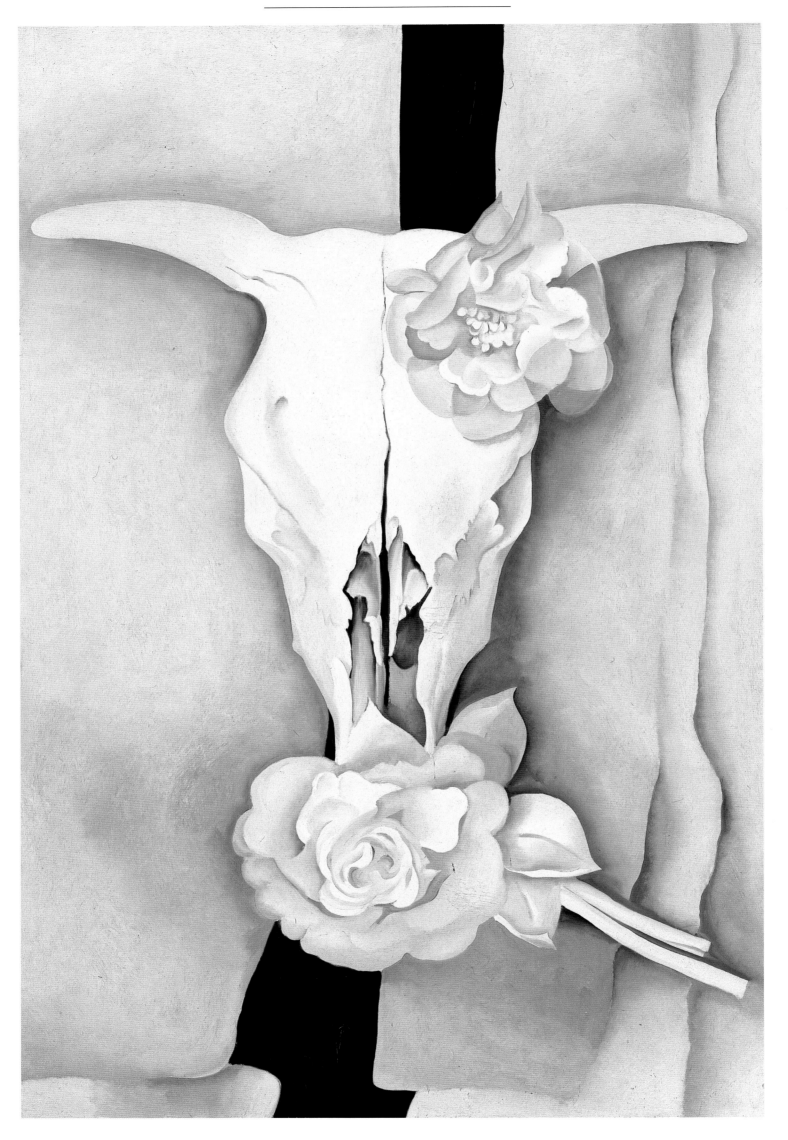

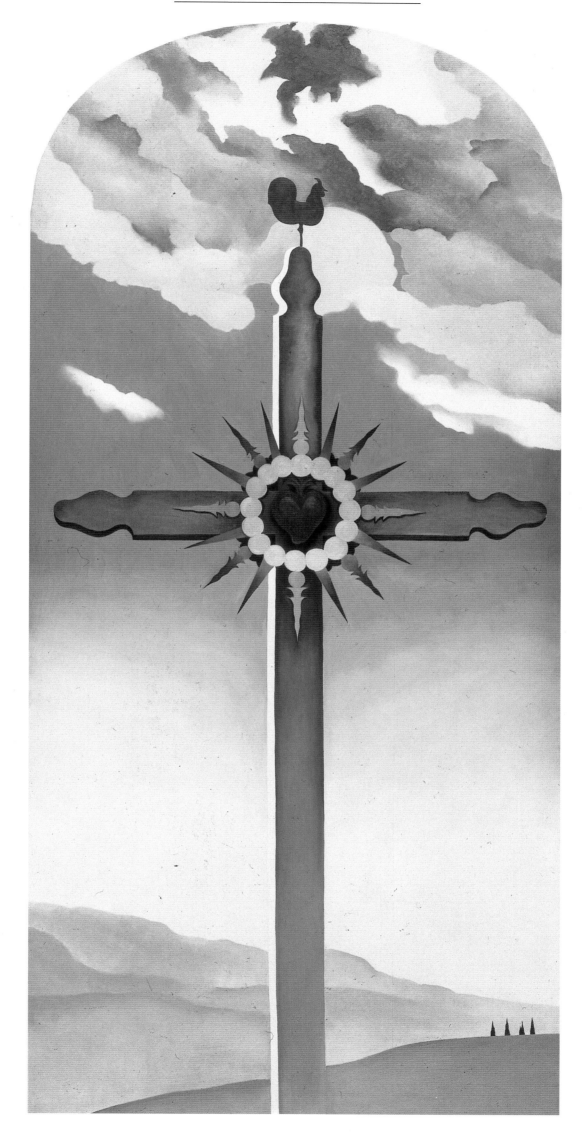

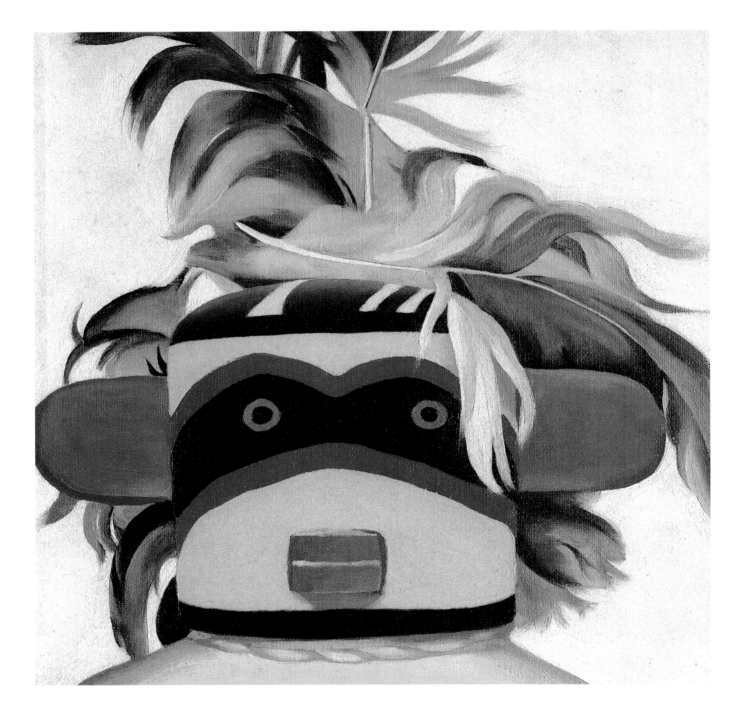

Left:
Cross with Red Heart 1932
Oil on canvas, 83¼×40½ inches (arched)
The Regis Collection, Minneapolis, MN

Above:
Katchina (detail) 1936
Oil on canvas, 7×7 inches
Gift of The Hamilton-Wells Collection,
San Francisco Museum of Modern Art, San Francisco, CA (76.188)

127

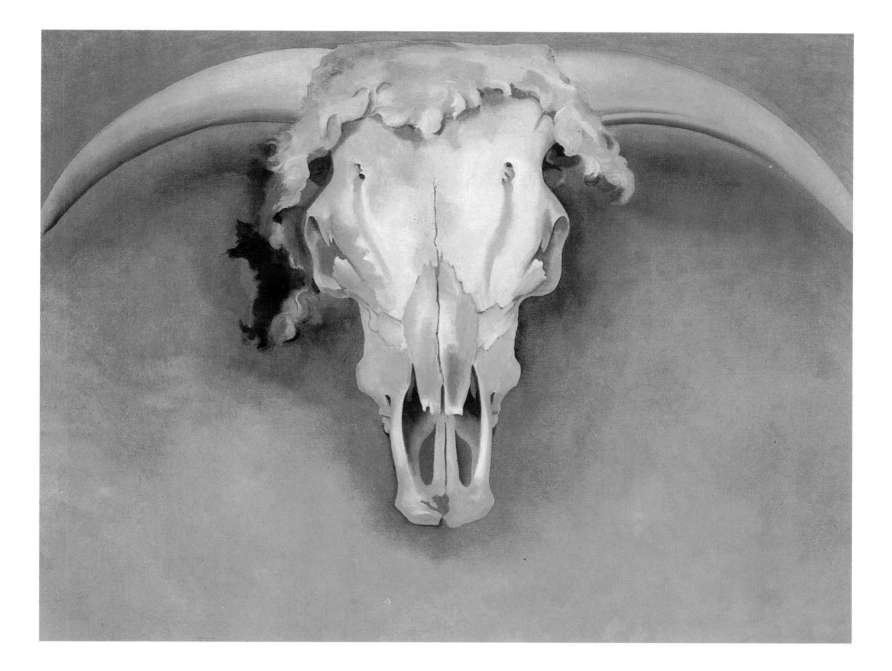

Bob's Steer Head 1936
Oil on canvas, 30×36 inches
Gift of Arthur Milliken, B.A. 1926,
Yale University Art Gallery, New Haven, CT (1965.52)

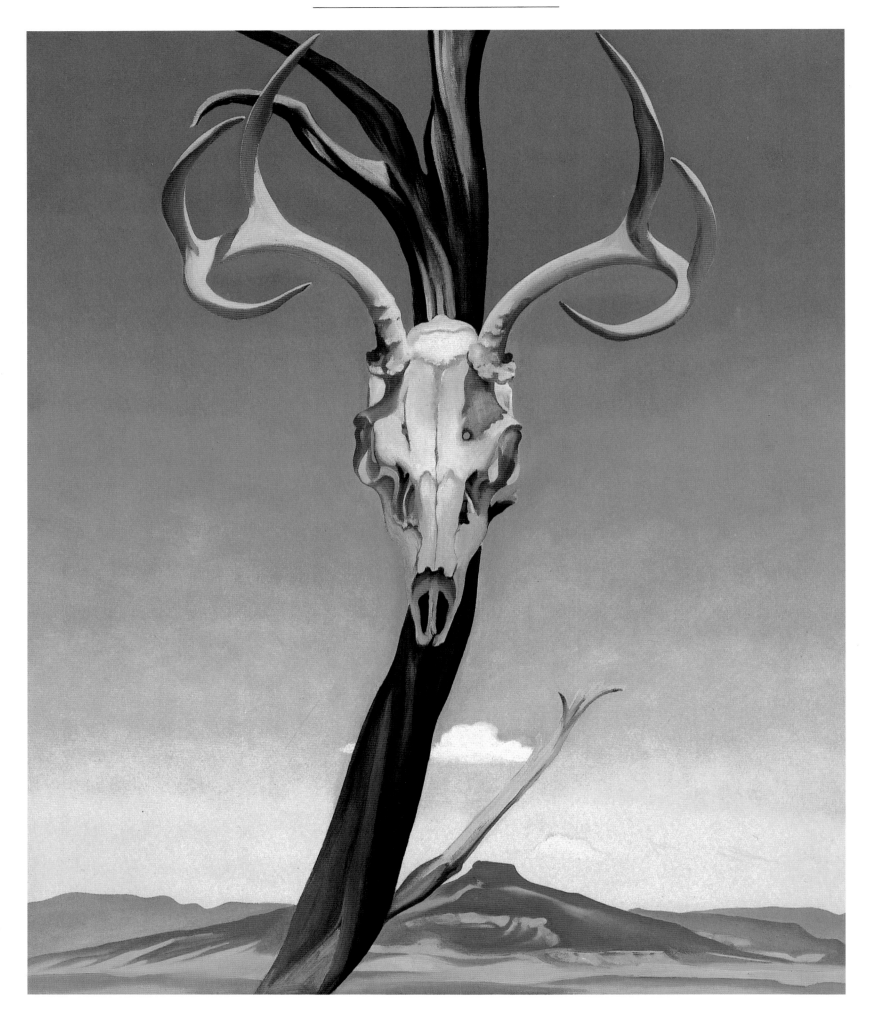

Deer's Skull with Pedernal 1936
Oil on canvas, 36×30 inches
Gift of The William H. Lane Foundation,
Courtesy of The Museum of Fine Arts, Boston, MA (1990.432)

From the Faraway Nearby 1937
Oil on canvas, 36×40⅛ inches
Alfred Stieglitz Collection, 1959,
The Metropolitan Museum of Art, New York, NY (59.204.2)

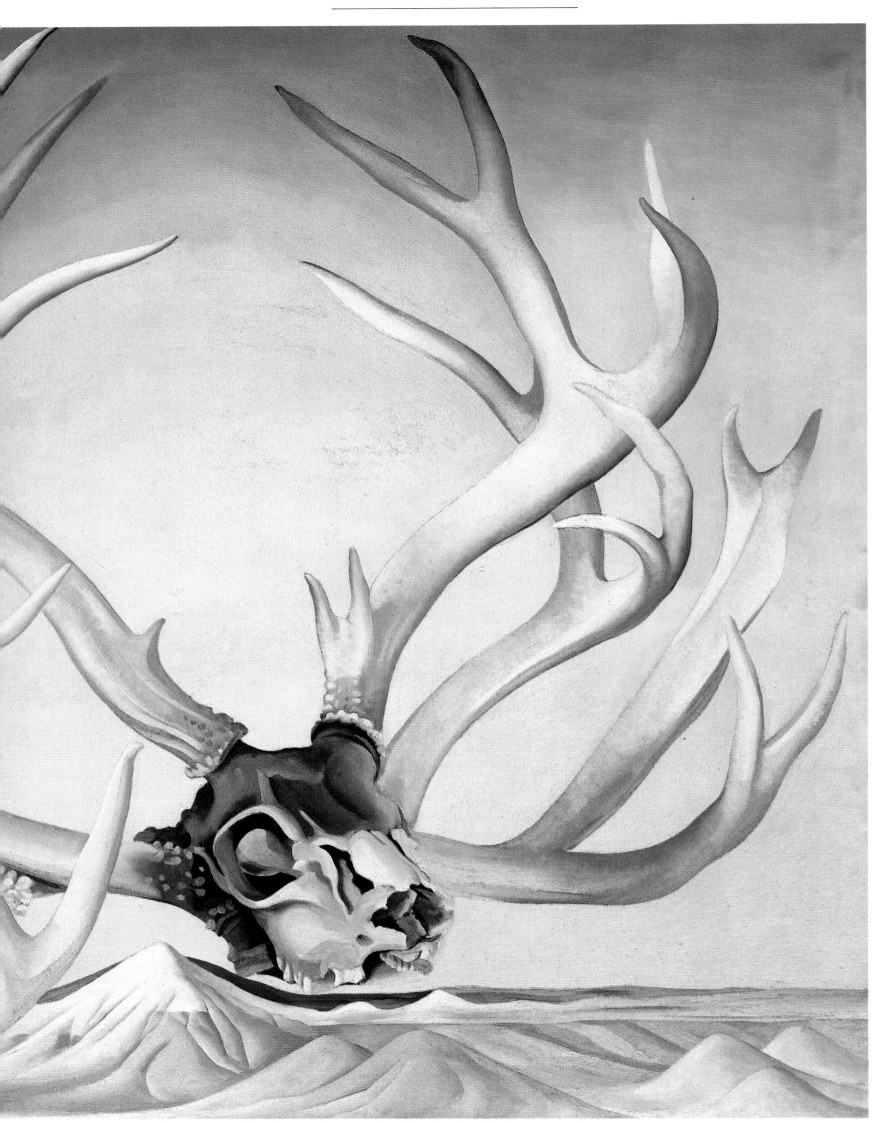

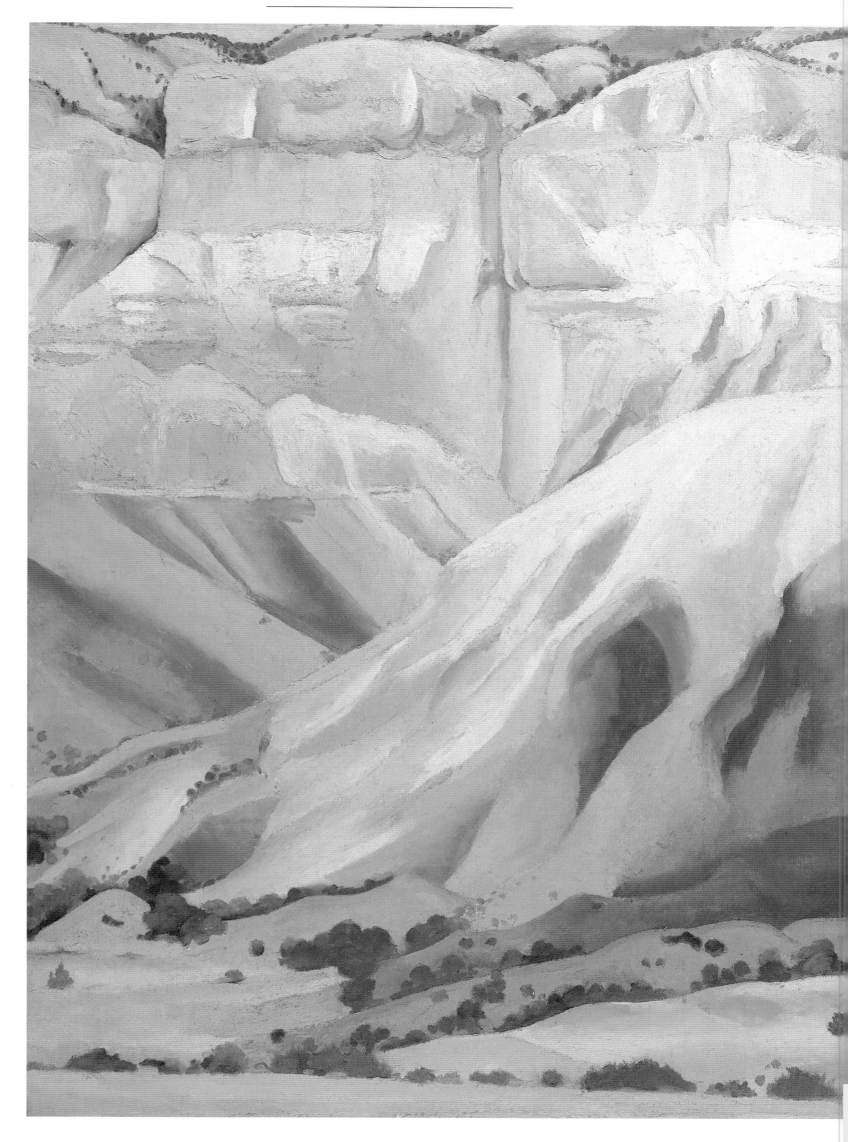

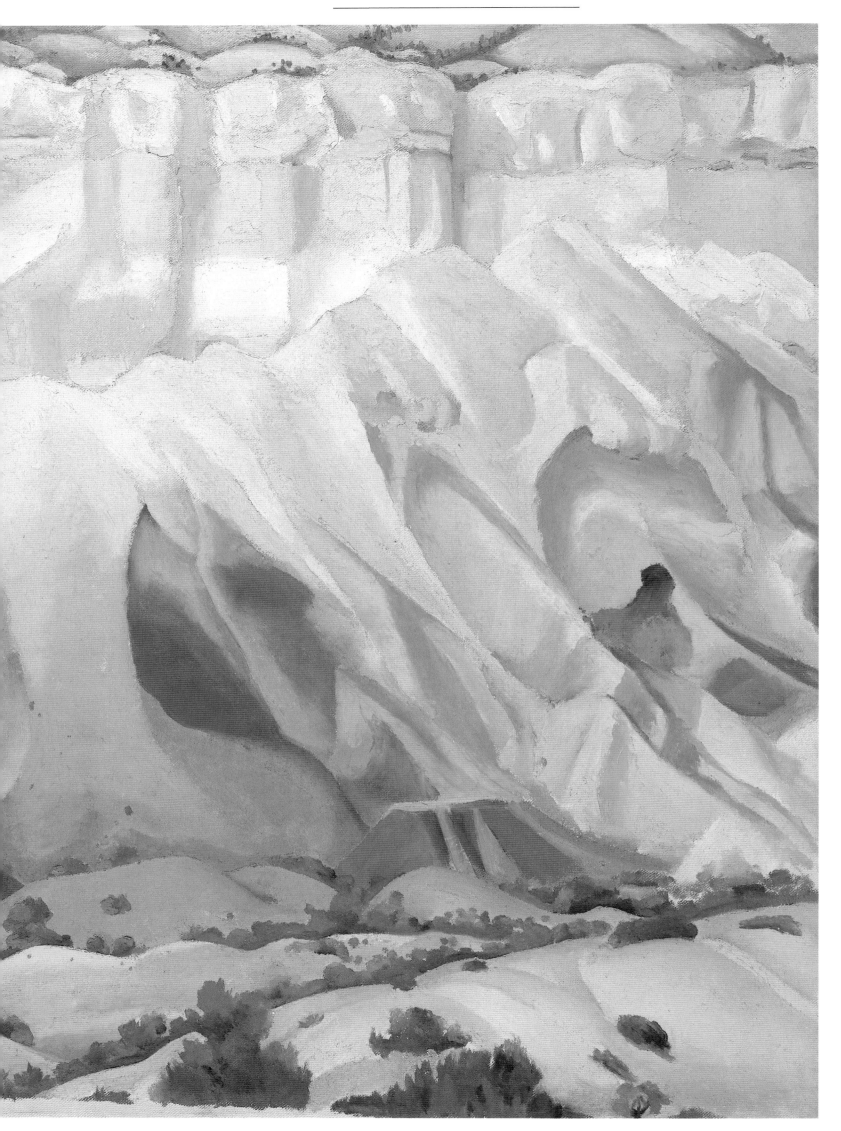

Preceding pages:
Red and Yellow Cliffs – Ghost Ranch
1940
Oil on canvas, 24×36 inches
Alfred Stieglitz Collection,
Bequest of Georgia O'Keeffe, 1986,
The Metropolitan Museum of Art, New York,
NY (1987.377.4)

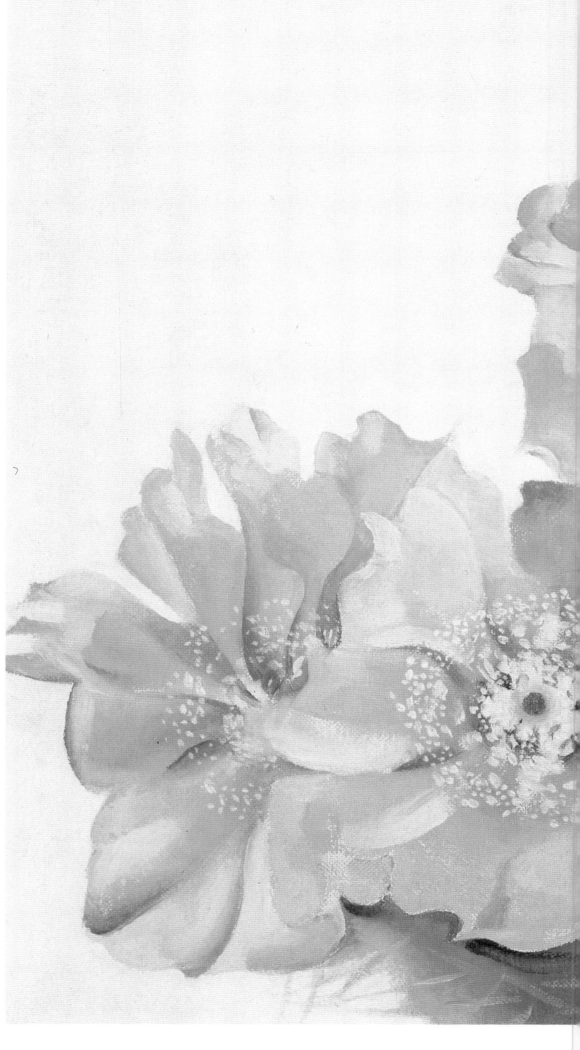

Right:
Yellow Cactus 1940
Oil on canvas, 12×16 inches
Louise Jordan Smith Fund, 1944,
Maier Museum of Art, Randolph-Macon
Women's College, Lynchburg, VA

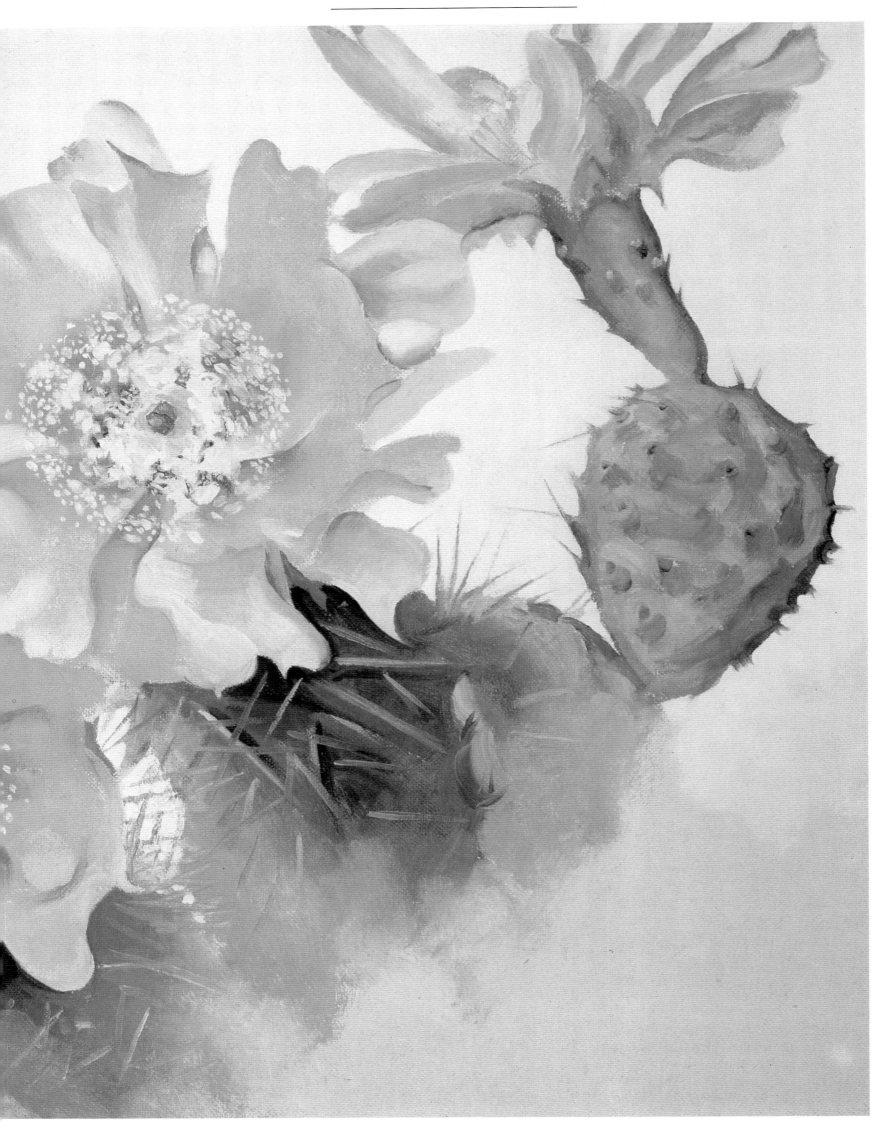

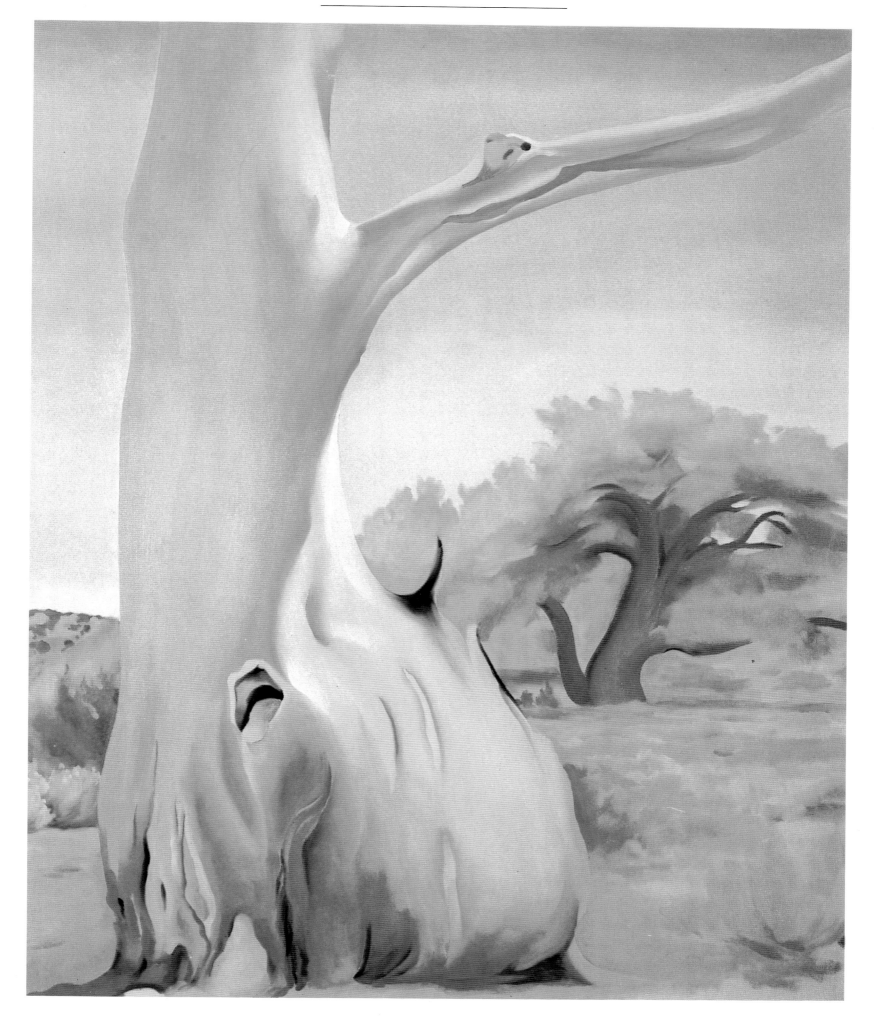

Dead Cottonwood Tree, Abiquiu, New Mexico 1943
Oil on canvas, 36×30 inches
Gift of Mrs. Gary Cooper,
Collection of The Santa Barbara Museum of Art, Santa Barbara, CA
(1951.6)

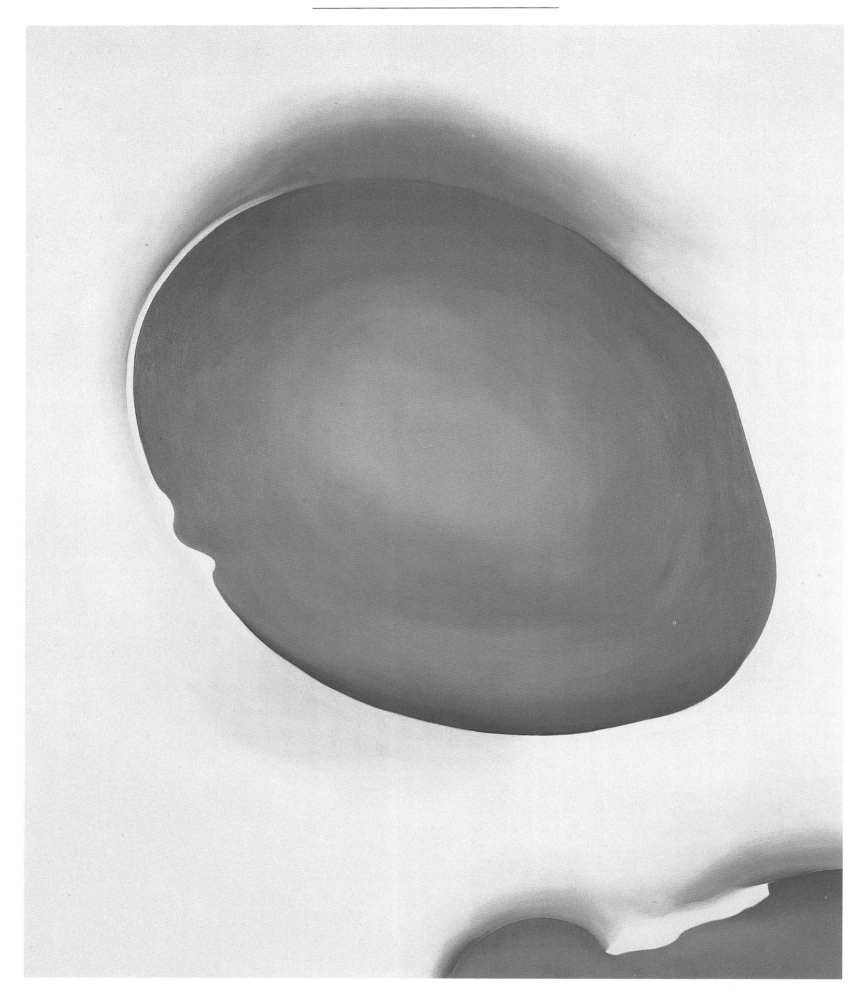

Pelvis with Blue (Pelvis I) 1944
Oil on canvas, 36×30 inches
Gift of Mrs. Harry Lynde Bradley,
Milwaukee Art Museum, Milwaukee, WI

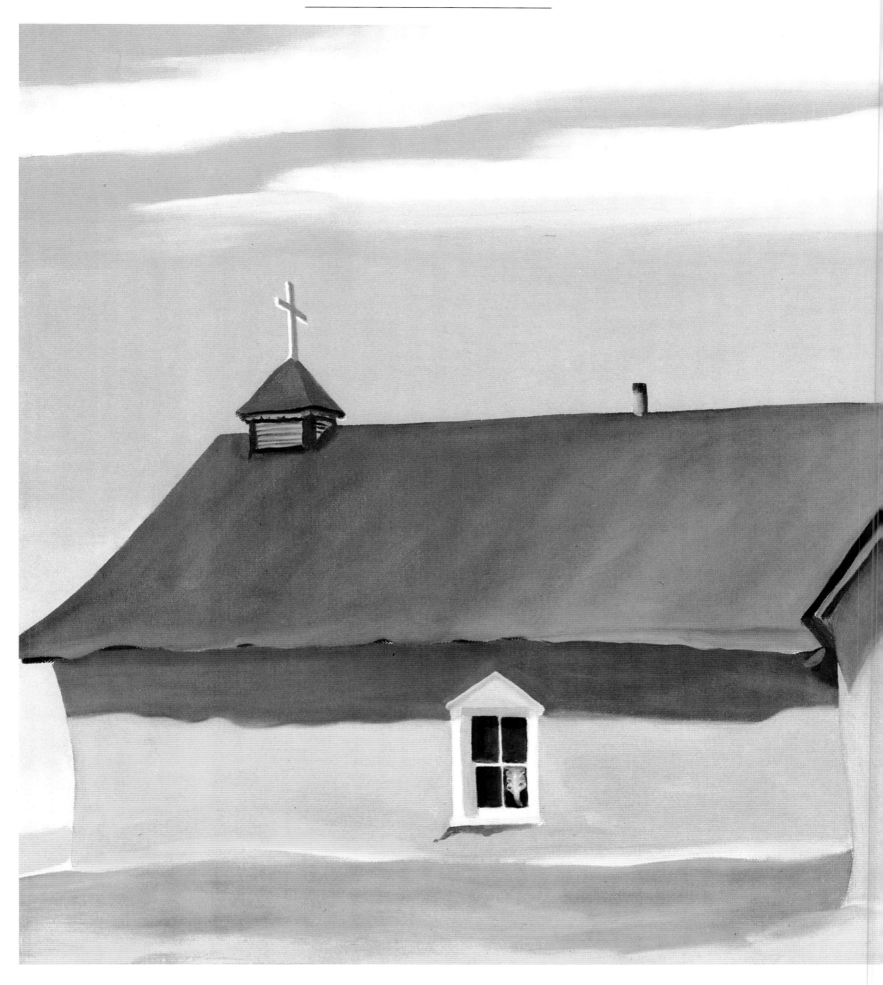

Cebolla Church 1945
Oil on canvas, 20×36⅛ inches
Bequest of Robert F. Phifer in honor of Dr. Joseph C. Sloane,
North Carolina Museum of Art, Raleigh, NC

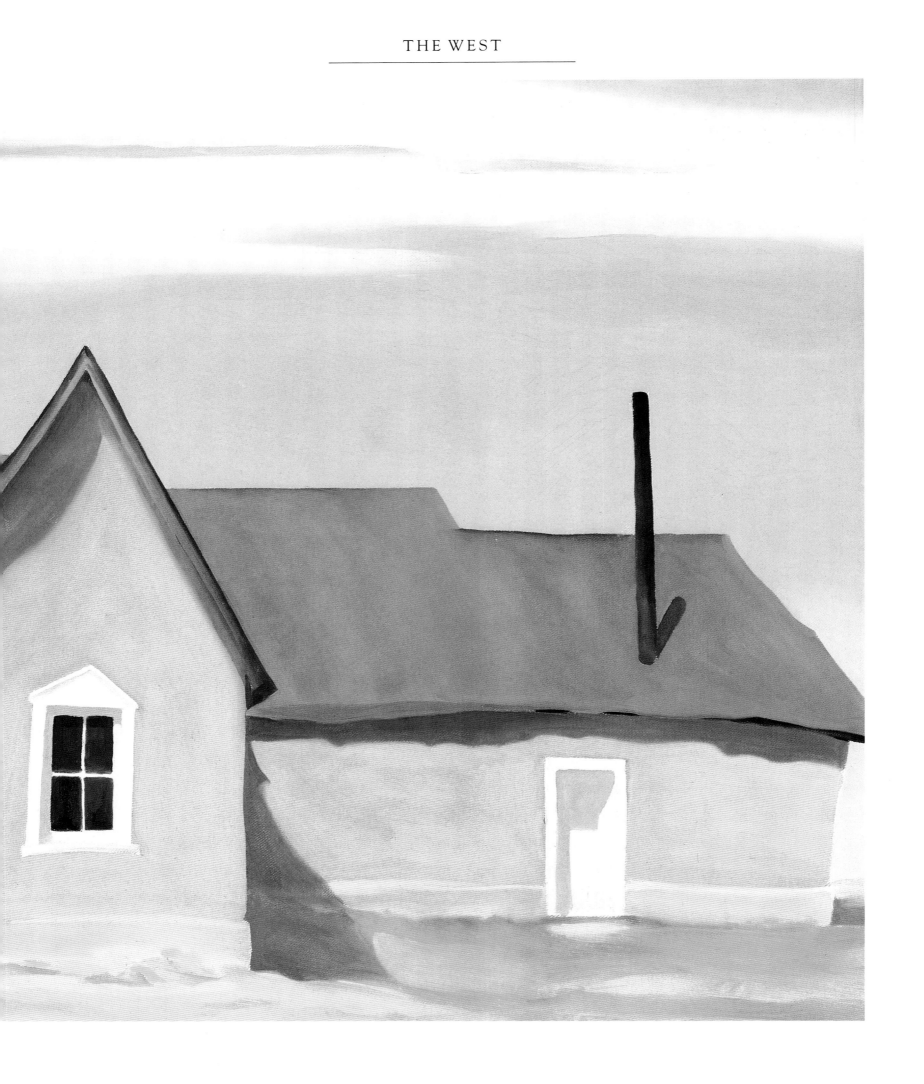

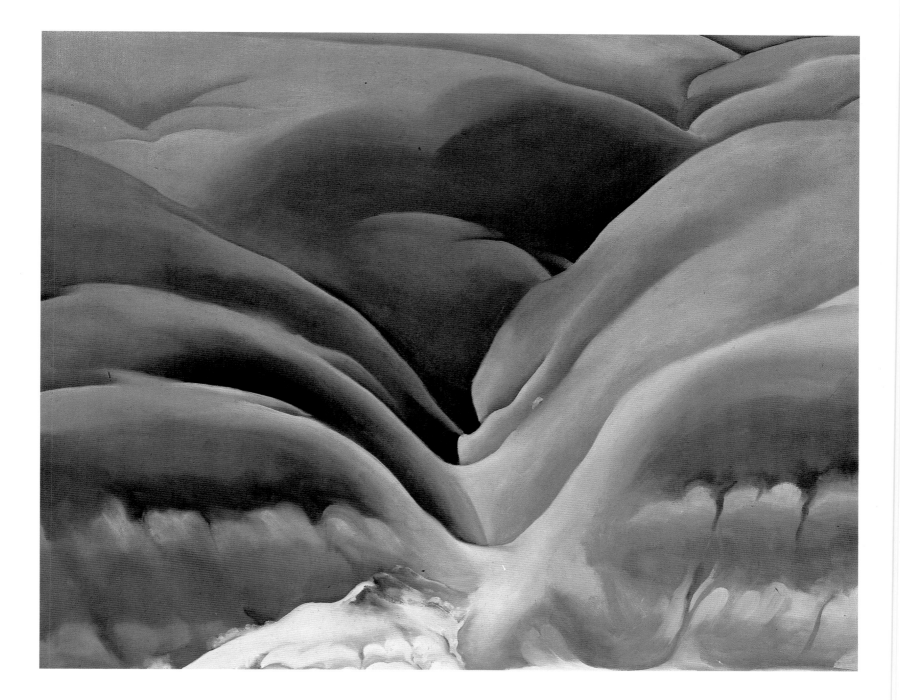

Black Place 1945
Oil on canvas, 24×30 inches
Photo courtesy of The Gerald Peters Gallery, Santa Fe, NM

In the Patio II 1948
Oil on linen, 18×30 inches
Bequest of Helen Miller Jones, 1986,
Collection of The Museum of Fine Arts,
Museum of New Mexico, Santa Fe, NM (86.137.19)

142

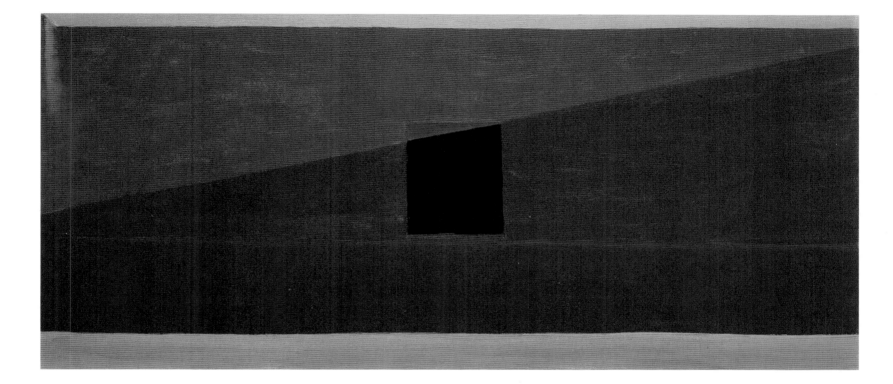

Patio Door — Green and Red 1951
Oil on canvas, 12×26 inches
Photo courtesy of The Gerald Peters Gallery, Santa Fe, NM

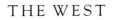

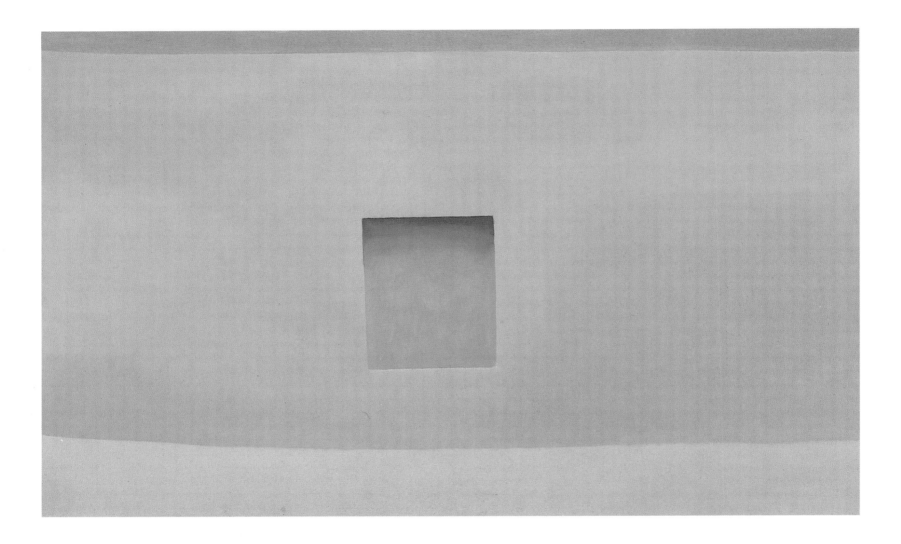

Wall with Green Door 1952
Oil on canvas, 30×47⅞ inches
Gift of The Woodward Foundation,
In the Collection of The Corcoran Gallery of Art,
Washington, D.C. (1977.8)

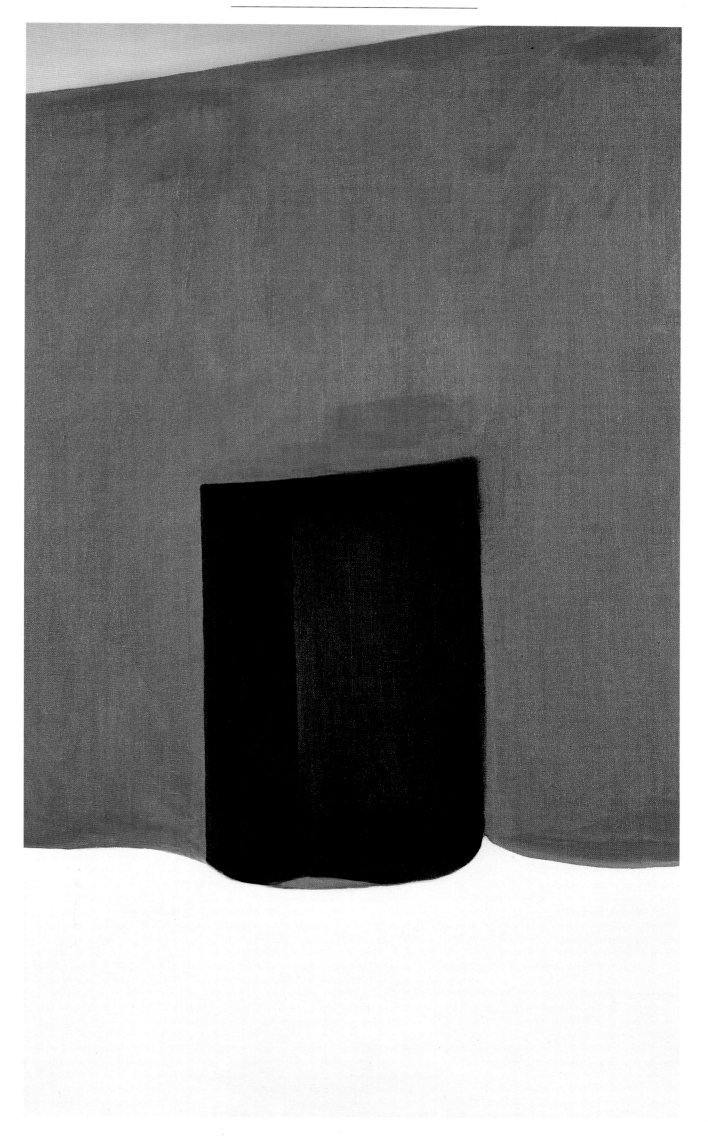

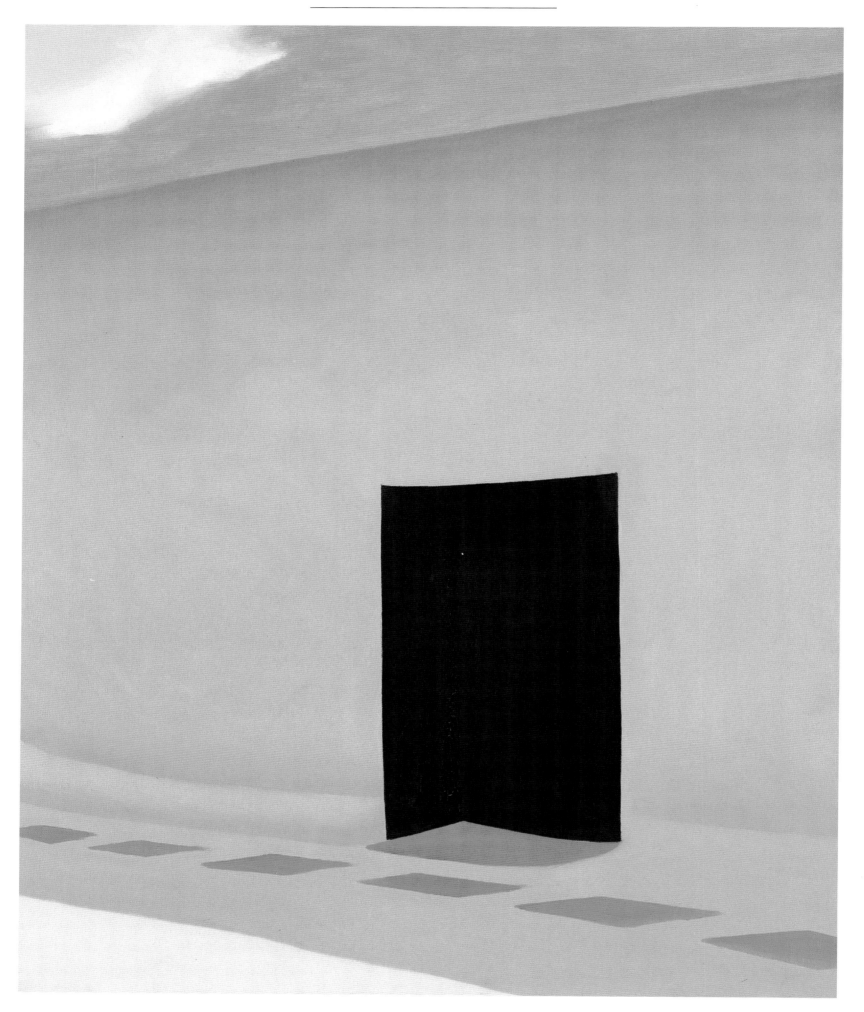

Left:
Black Door with Snow II 1955
Oil on canvas, 30×18 inches
Gift of Mrs. Harry Lynde Bradley,
Milwaukee Art Museum, Milwaukee, WI

Above:
Patio with Cloud 1956
Oil on canvas, 36×30 inches
Gift of Mrs. Edward R. Wehr,
Milwaukee Art Museum, Milwaukee, WI

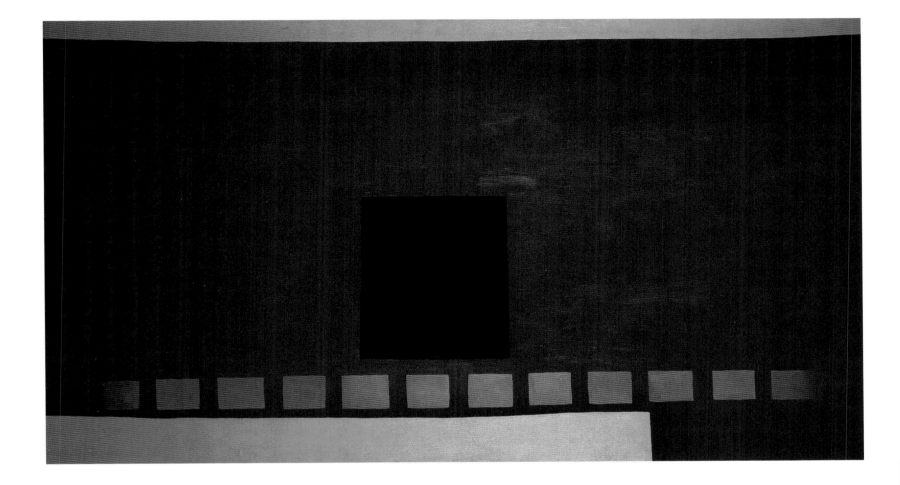

Black Door with Red 1955
Oil on canvas, 48×84 inches
Bequest of Walter P. Chrysler, Jr.,
The Chrysler Museum, Norfolk, VA
(89.63)

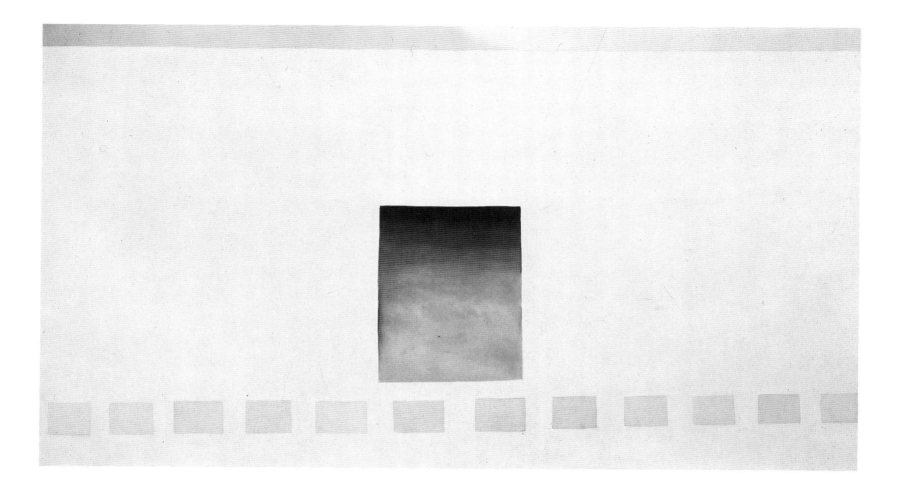

White Patio with Red Door 1960
Oil on canvas, 48×84 inches
The Regis Collection, Minneapolis, MN

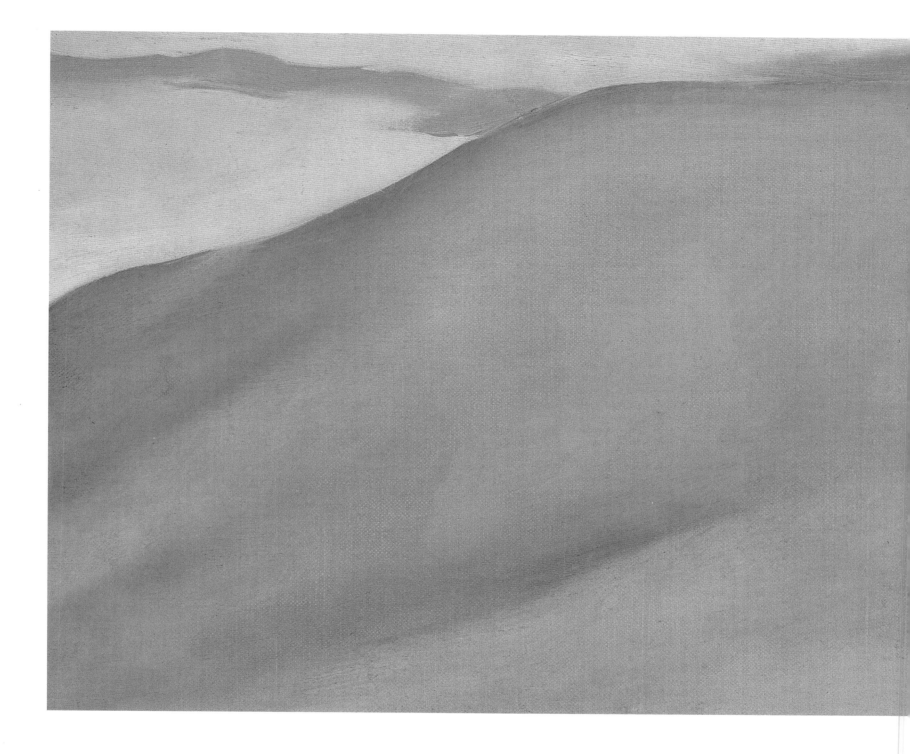

Small Hill Near Alcade undated
Oil on canvas, 10×24¼ inches
Collection of Auburn University, Auburn, AL

149

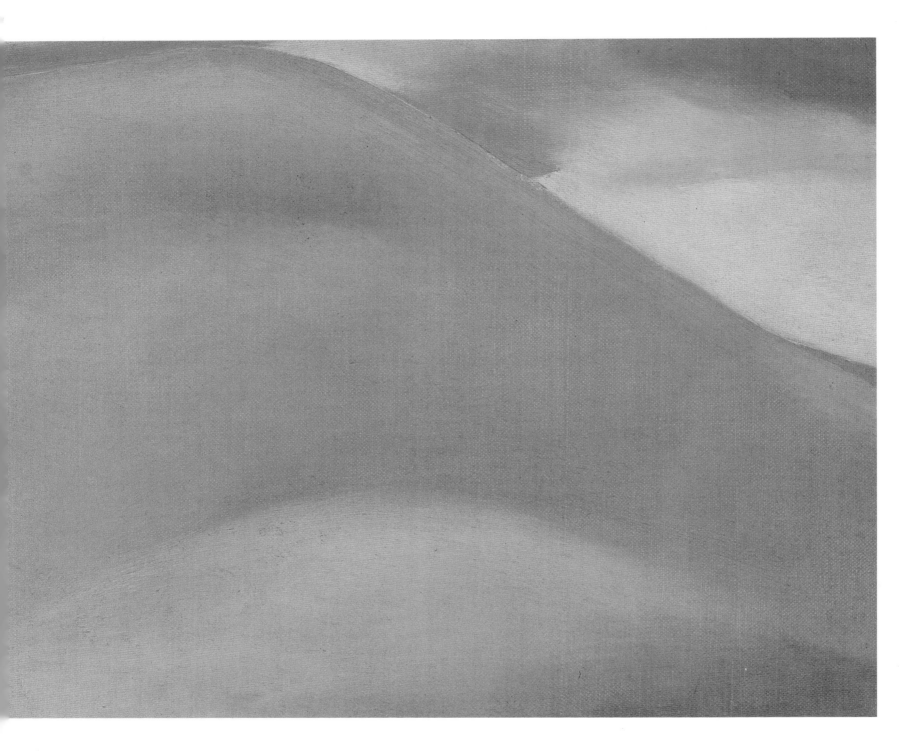

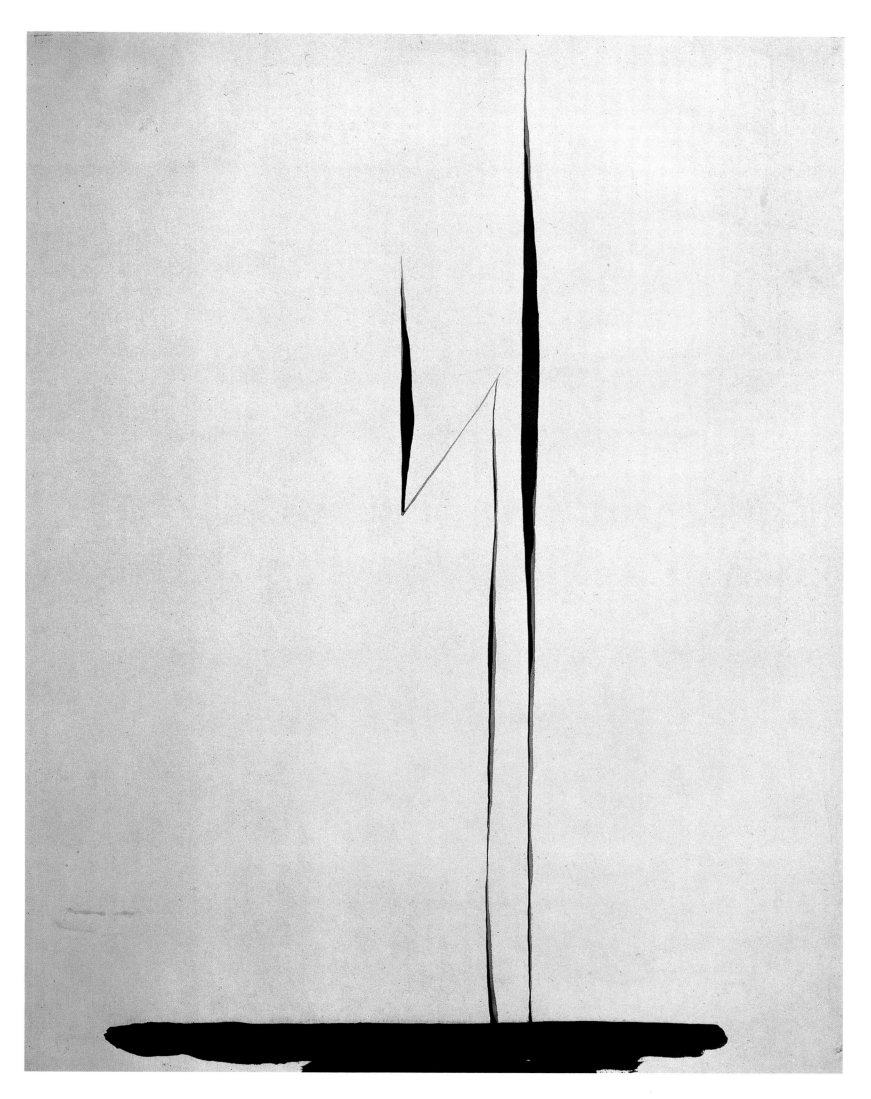

ABSTRACTIONS

The drawings that launched O'Keeffe as a professional artist were begun in South Carolina in 1915, and were produced exclusively in black charcoal applied to large sheets of white paper. To a great extent these drawings were heavily influenced by the shapes and patterns O'Keeffe found in Arthur Wesley Dow's book *Composition* (1914) and through his teaching at Teachers College. O'Keeffe's interest in abstract forms based on nature was also shared by many of the avant-garde American artists with whom she often exhibited: Dove, Marin, Hartley, Demuth and the photographer Paul Strand, as well as Stieglitz himself. Arthur Dove, one of America's early abstractionists, was to be of special importance to O'Keeffe. As a young student she had been impressed by his work, which had been reproduced in Jerome Eddy's book *Cubists and Post-Impressionism* (1914). Dove's work, in which subject was subordinate to line, color and shape, provided O'Keeffe with many motifs for her own work. Of particular influence was also Paul Strand, whose work O'Keeffe first saw reproduced in Stieglitz's magazine *Camera Work* in October 1916. Strand's studies of details of objects in extreme close-up or magnification so that they lose all pictorial reference and become abstractions of pat-

tern, shape and line predate O'Keeffe's own geometric abstractions by four years. O'Keeffe's huge flower studies of the 1920s also followed on from Strand's similar photographic studies and, furthermore, Strand had visited the Gaspé Peninsula in Canada, where he had photographed the weathered Canadian barns. Strand's subsequent visit to New Mexico in the late 1920s may also have encouraged O'Keeffe to visit the same places after him.

Drawing XIII (1915) is one example of O'Keeffe's efforts to evoke nature through purely abstract forms, and, in doing so, to capture her own personal experience of it. With the limited materials of charcoal and paper, O'Keeffe initially produced tonally and graphically complex compositions. Having mastered the concepts of abstraction, O'Keeffe then gradually began to reintroduce color into her work and, from June 1916, started to work exclusively in watercolors (such as in the *Blue* series), before then moving on to oils, which would later become her primary medium.

In late 1917 O'Keeffe returned to figurative subject matter, and completed a group of 16 watercolors which can be divided into two series: four highly abstracted paintings of the female

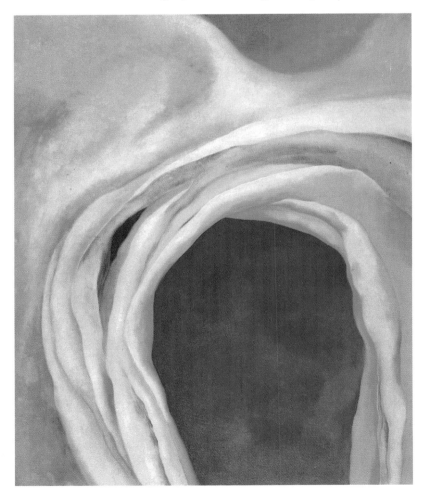

Left:
Blue Lines X 1916
Watercolor on paper, 25×19 inches
Alfred Stieglitz Collection, 1969,
The Metropolitan Museum of Art, New York, NY (69.278.3)

Right:
Music – Pink and Blue I 1919
Oil on canvas, 35×29 inches
From the Collection of Mr. and Mrs. Barney A. Ebsworth

figure in profile, and 12 of seated female nudes which show a more closely observed study of pose and anatomical structure. In both series O'Keeffe exploited the watercolor's fluidity and transparency, allowing the colors to bleed into each other to produce subtle tonal variations. A similar watercolor technique can be seen in the abstract landscape compositions of the *Evening Star* series of paintings from 1917. O'Keeffe would always be selective about the amount of detail she included in her paintings, constantly adjusting the subject to fit her compositions by eliminating, reworking or adding to its elements. Even when her paintings were representational, like the skyscraper paintings, they were nevertheless abstractions. One of the several abstractions which she painted in the 1920s, *Gray Line with Black, Blue and Yellow* (c.1923) is, in fact, compositionally related to her first abstract works of 1919 which were inspired by music: *Music – Pink and Blue I* or *Blue and Green Music*. The specific source for the *Gray Line* painting is unknown, although it is frequently associated with landscapes, with flowers, and even with female genitalia – an interpretation which O'Keeffe always emphatically denied.

A further example of O'Keeffe's selectivity is to be found in the series of *Corn Dark* paintings produced during the summer of 1924 at Lake George, of which there are three variations. O'Keeffe explained that these abstract paintings were, in fact, her particular view of the leaves of a corn plant. In *Corn Dark I*, the image is greatly enlarged, and is brought to the front of the picture plane. While at first the corn plant appears to have been seen frontally, it has actually been viewed from a high vantage point.

Between 1926 and 1930, O'Keeffe worked on a large number of abstract compositions which, although at first sight appear to be nonobjective, were in fact based on physical reality, and also on O'Keeffe's memories of actual experiences. In contrast to the 1919 abstractions, these later paintings emphasize line and two-dimensional space. *White Abstraction (Madison Avenue)* (1926) uses a point-and-line motif to represent the converging city streets, while in *Black Abstraction* (1927) – one of O'Keeffe's most abstract compositions – point and line appear to be almost the only compositional elements. According to O'Keeffe, *Black Abstraction* was inspired by her experience of being anesthetized before an operation in 1927. She remembered that while she tried to delay the effects of the anesthetic, she saw a bright, white light overhead, which appeared to be getting smaller. In *Black Abstraction* the canvas is filled by dark concentric rings, in front of which is a light "V" form, which O'Keeffe recalled was the shape of her own arms as she lay on the operating table. At the vertex of this "V" is a white spot – the diminishing overhead light in the operating theater.

As O'Keeffe's familiarity with a particular place or subject increased, she subsequently produced works which were less representational and more interpretive, as she explored her emotional responses to the various aspects of her environment. For example, she produced seven increasingly abstract paintings based on the subject of the jack-in-the-pulpit flower that grew around Lake George, where she worked for part of each year from 1918 to the 1930s. In the 1920s, O'Keeffe had visited and worked in the secluded area around York Beach in Maine, and the shells she collected on the beach there became the subject of a number of paintings and drawings, such as the *Shell and Shingle* series. Later, O'Keeffe's adobe house in Abiquiu, New Mexico, in which she lived after 1948, inspired her largest series of architectural paintings, the 24 *Patio* pictures of the 1950s, which are also among some of her most abstract and minimalist works.

In the 1950s O'Keeffe began traveling extensively, and in 1953, at the age of 66, she made her first trip to Europe. It appears that much of the art of the great European masters which she saw in the museums there had little impact on her work. Far more influential was her experience of airplane travel and the views which she saw through the window while airborne. In 1959 O'Keeffe set off on a round-the-world trip, and recorded the aerial views of rivers, tributaries and deltas on small scraps of paper which she kept in her purse. When she returned home, O'Keeffe made large charcoal drawings that were reminiscent of her 1915 charcoals, before working them in oils of unusual colors. These ribbons of rivers flowing through flattened landscapes were given titles like *It was Yellow and Pink, It was Red and Pink* and *From the River, Light Blue*. Following her recent interest in river courses, it seemed natural for O'Keeffe to study them more closely, and in 1961 she joined a river-rafting trip down the upper part of the Colorado River as it meandered gently through southern Utah. Because there was no time to paint on this trip, O'Keeffe returned to the river more than half-a-dozen times to see the natural monuments of Music Temple, Mystery Canyon, and Hidden Passage Canyon. Back in her studio, she translated what she had seen and experienced onto canvas, the results being the *On the River* and *Canyon* series. O'Keeffe appears to have been uncertain of these paintings, for she never exhibited them publicly.

In 1963 O'Keeffe turned from the river theme to focus on the related theme of the road: "Rivers and roads lead people on" she remarked about the two subjects. *The Winter Road*, with its single calligraphic brush stroke, is O'Keeffe's interpretation of highway U.S. 48, the road which linked her home to the outside world. In one direction the highway led to Albuquerque airport, in the other, it led to Ghost Ranch, before reaching out toward Tierra Amarilla.

Abstraction 1917
Watercolor, 15¾×10¾ inches
Collection of Mr. and Mrs. Gerald P. Peters,
Santa Fe, NM

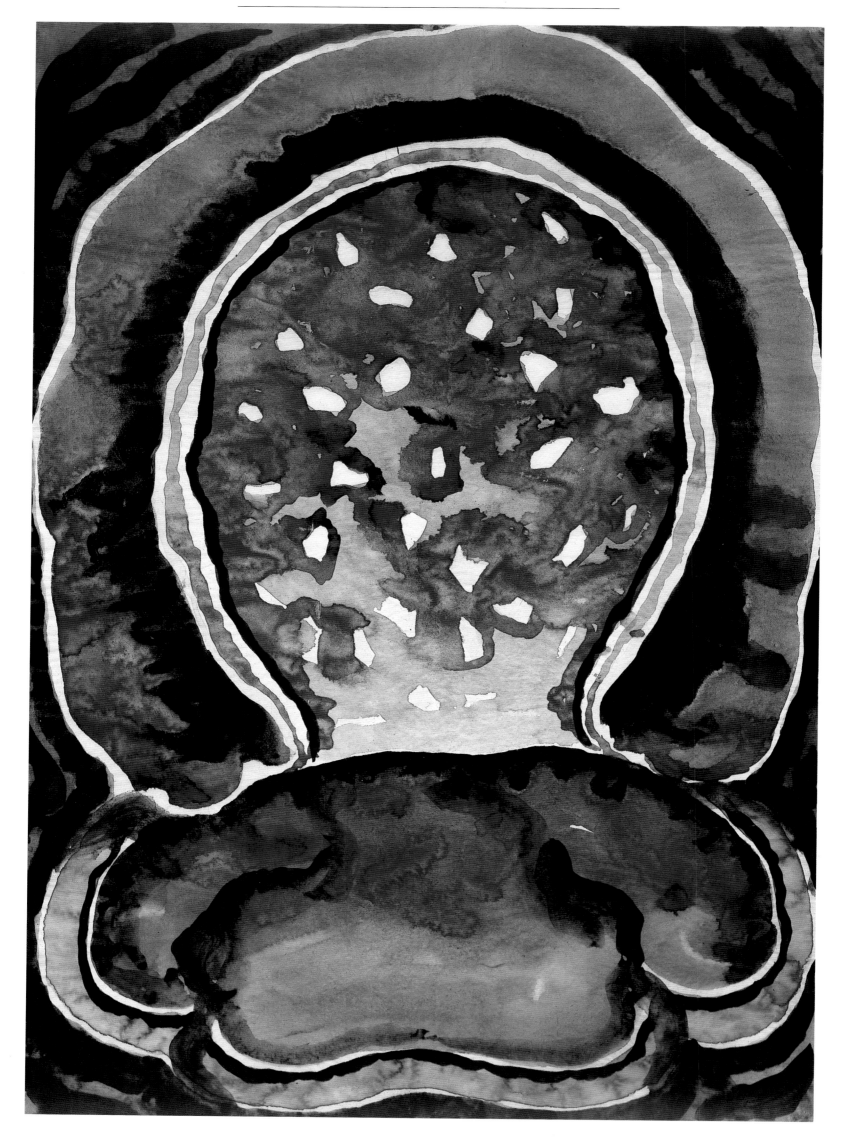

The sky had always been of importance to O'Keeffe. In an interview for *Life* magazine in 1968, she said: "I suppose I could live in jail as long as I had a little patch of blue sky to look at." In her early years in Texas, O'Keeffe had painted washes of the western sky, and even in New York it mattered to her. When she began to travel in airplanes, the liberating expanse of the sky once again became an apparent theme in her work. One of the first oils she painted depicted a solid mass of white clouds on the lower two-thirds of the canvas; in the upper part she painted the blue sky. As the series of cloud paintings continued, the cloud bank became increasingly fractured into small cloudlets, between which was the blue of infinite space. In 1965 O'Keeffe began work on the largest painting of her career, the 24 by 8 foot *Sky Above Clouds IV*. This was also O'Keeffe's last major work, since by 1971 she had lost most of her central vision and was able to see only peripherally, out of the corners of her eyes. Now in her old age, O'Keeffe was unable to bring into precise focus many of the objects that she had studied previously, and in despair she stopped painting.

It was not until 1976 that O'Keeffe began painting again, following encouragement by Juan Hamilton. The resulting series of oils, called *From a Day with Juan*, recall O'Keeffe's experience of seeing the Washington Monument against the blue sky. In 1977 she began working again in watercolors; a view of the orchard seen from her bathroom window called *Pink and Green Spring* displays the same strong shapes and colors that marked O'Keeffe's work from the very beginning. She also completed a series of blue watercolors – round balls and slashes – which remind the viewer of her 1916 watercolors. Indeed, in

recognition of this, O'Keeffe even called one of the paintings *Like an Early Abstraction*.

Hamilton had encouraged O'Keeffe to continue working, often reminding her that Henri Matisse, although bedridden, had carried on working by using colored paper cut into shapes. O'Keeffe would now have her housekeeper read her the names of colors on the tubes of paint, and also hired studio assistants to help her. She would direct her assistants to hold a piece of string against a canvas, so that she could visualize a form, then the assistant would draw in the shape in charcoal, mix the colors, and even complete some of the background painting. O'Keeffe, however, disliked the idea of admitting that she had had any help with her painting, although it is evident that her later works demonstrate far less subtle tonal gradations or color modulations than her earlier paintings. Even so, using this approach, O'Keeffe was able to continue working, and produced works like *Black Rock with Blue Sky and White* (1972). Enlarged and isolated, like a piece of sculpture on its plinth, the single rock is placed against the blue of the sky.

O'Keeffe's loss of much of her eyesight did, nevertheless, seriously limit the amount of paintings she could produce, and virtually cut her off from her main source of inspiration, the landscape around her. She produced few works in the last decade of her life, and those that she did produce were often either of images that she had retained in her memory, or reinterpretations of earlier works. One of O'Keeffe's last pieces was the 11-foot-high cast and painted aluminum spiral sculpture titled *Abstraction*, completed in 1982, a work which had its origins in a prototype white plaster piece made in 1945.

Gray Line with Black, Blue and Yellow c.1923
Oil on canvas, 49½×31½ inches
Museum Purchase with funds provided by The Agnes Cullen Arnold Endowment Fund, The Museum of Fine Arts, Houston, TX (77.331)

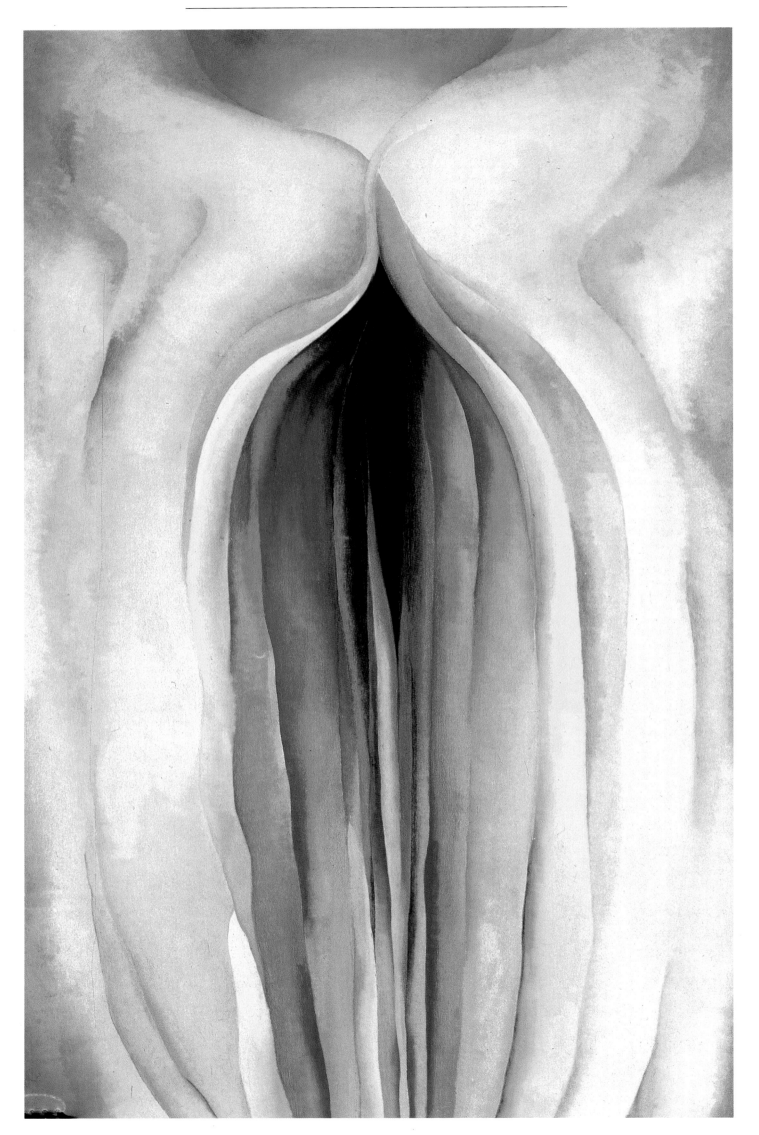

A Storm 1922
Pastel on off-white laid paper, mounted on
illustration board, 18×24⅛ inches
Anonymous Gift, 1981,
The Metropolitan Museum of Art, New York, NY
(1981.35)

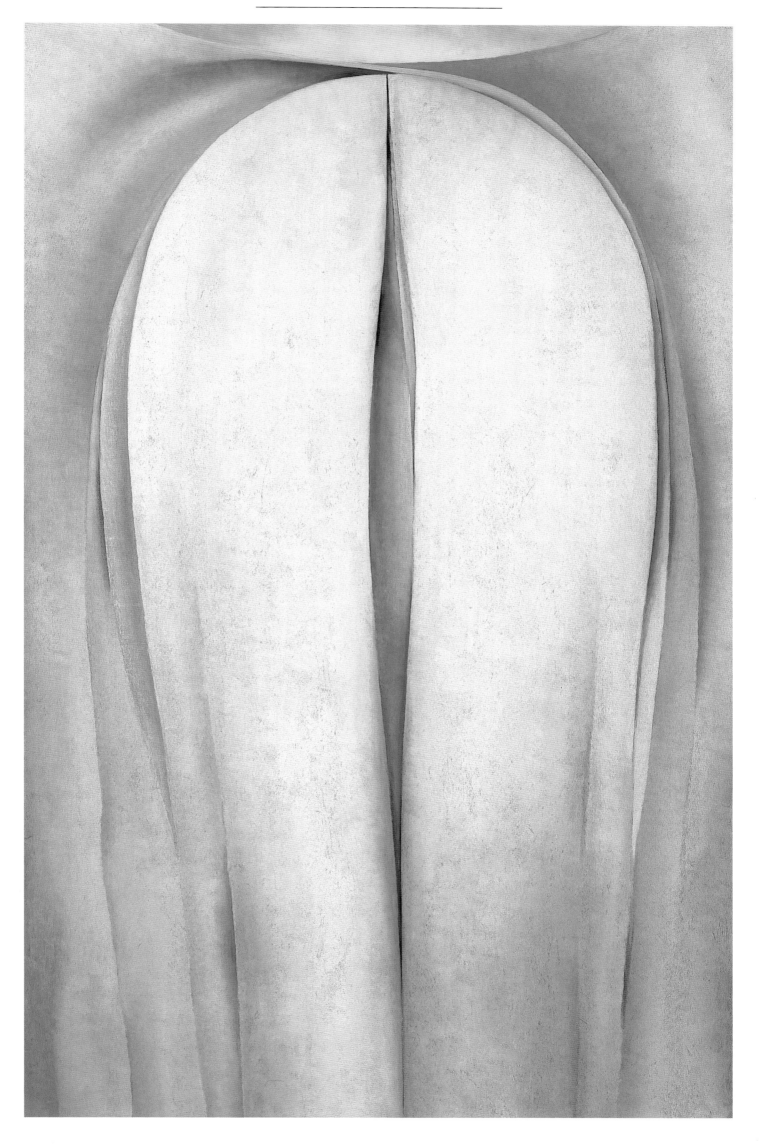

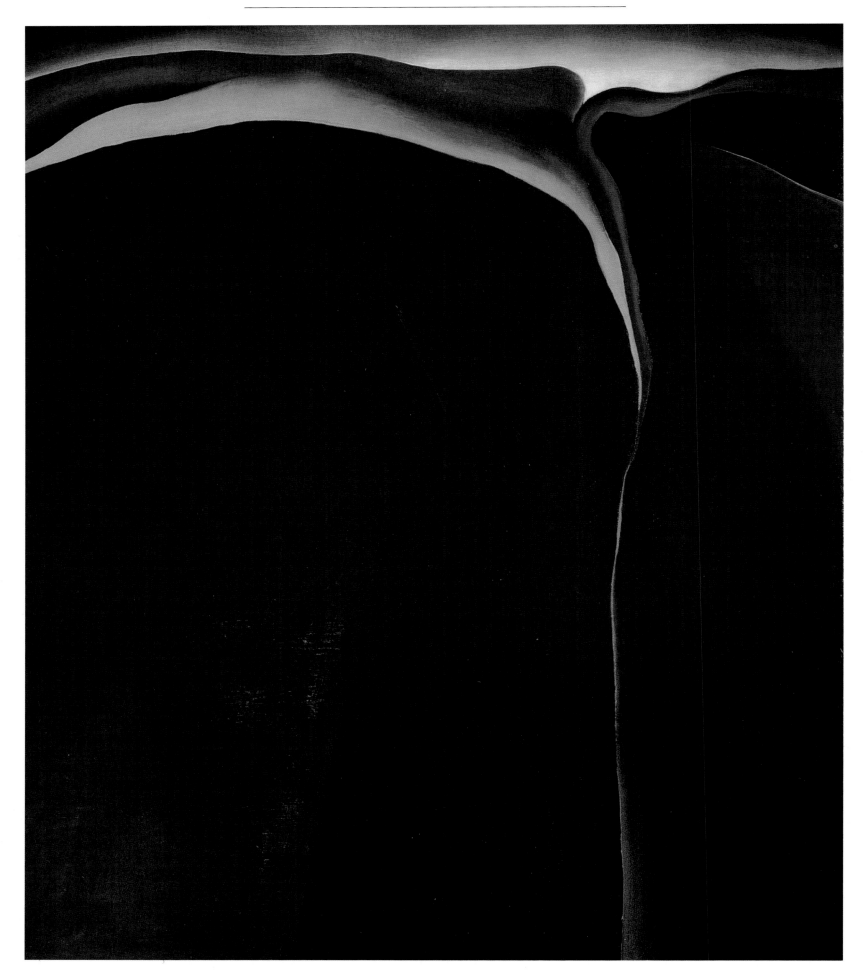

Left:
Gray Line with Lavender and Yellow c.1923
Oil on canvas, 48×30 inches
Alfred Stieglitz Collection,
Bequest of Georgia O'Keeffe, 1986,
The Metropolitan Museum of Art, New York, NY (1987.377.1)

Above:
Dark Abstraction 1924
Oil on canvas, 24⅞×20⅞ inches
Gift of Charles E. and Mary Merrill,
The Saint Louis Art Museum, St. Louis, MO

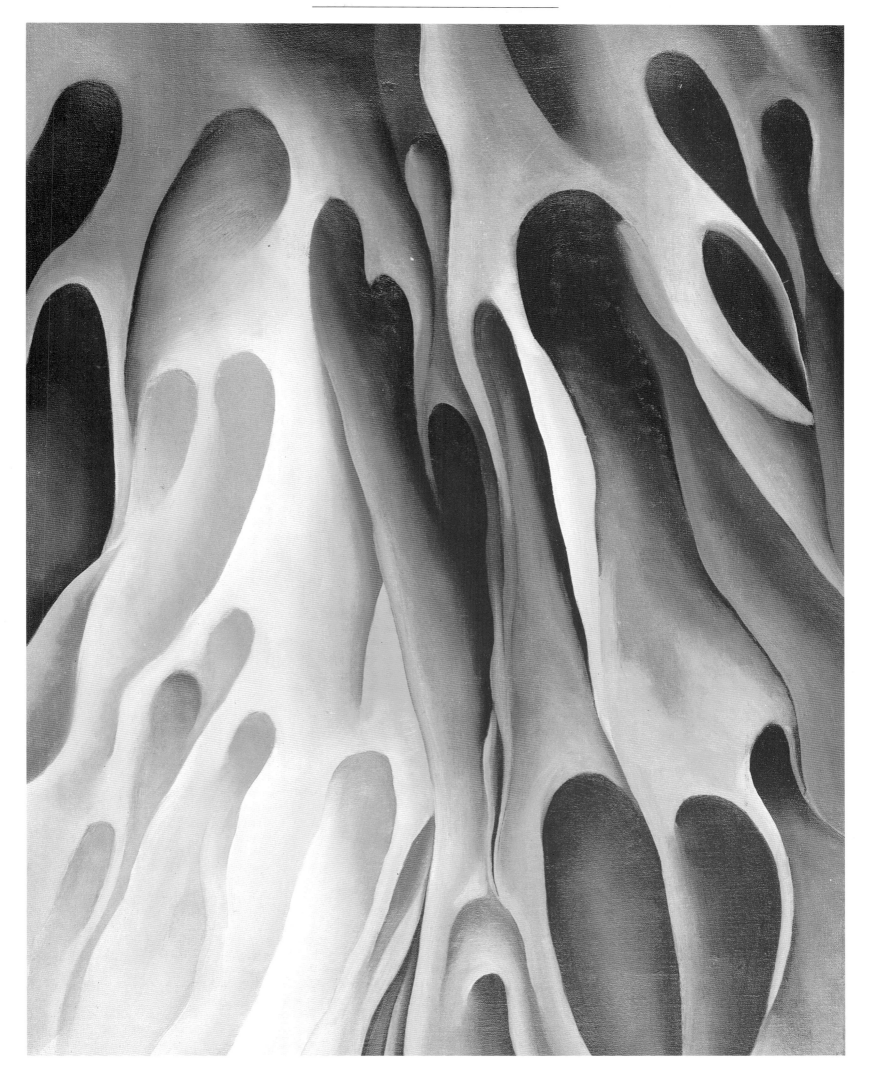

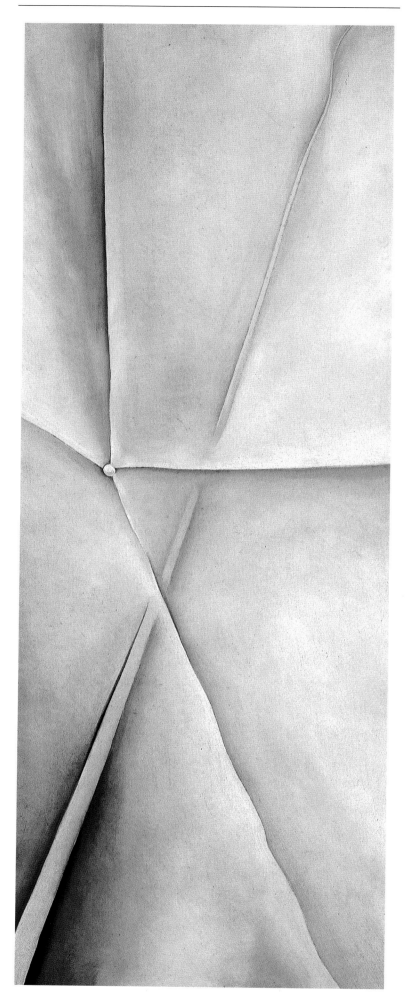

Left:
Red and Pink 1925
Oil on canvas, 16×12 inches
Private collection

Above:
White Abstraction (Madison Avenue) 1926
Oil on canvas, 32½×12 inches
*Gift of Charles C. and Margaret Stevenson Henderson
in Memory of Hunt Henderson,
Collection of Museum of Fine Arts, St. Petersburg, FL*

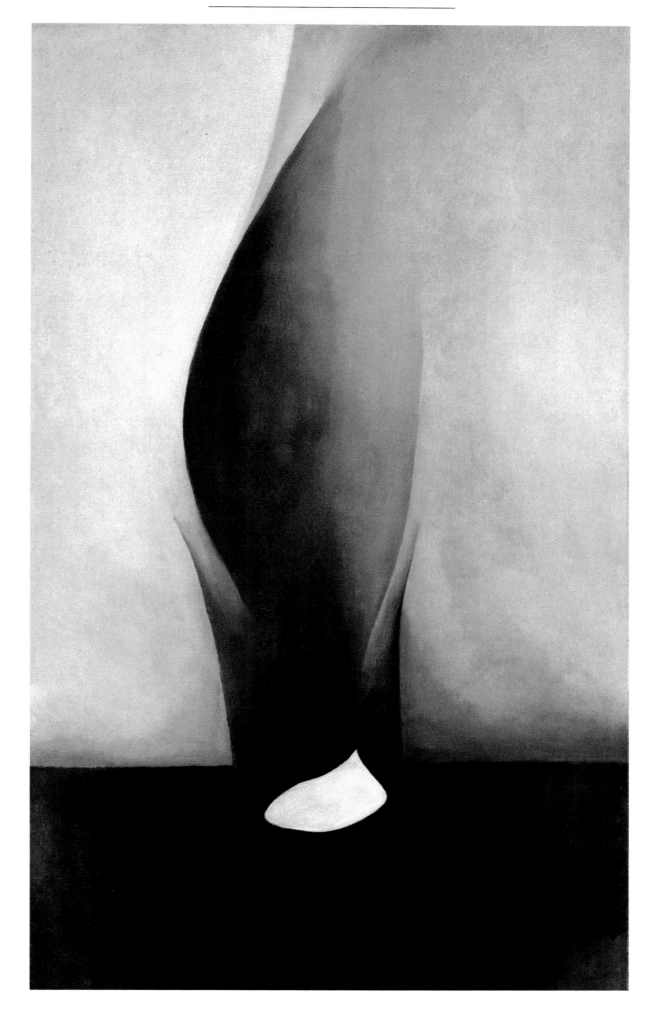

Shell and Shingle VI 1926
Oil on canvas, 30¹⁄₁₆×17⅛ inches
Gift of Charles E. Claggett in Memory of Blanche Fischel Claggett,
The Saint Louis Art Museum, St. Louis, MO

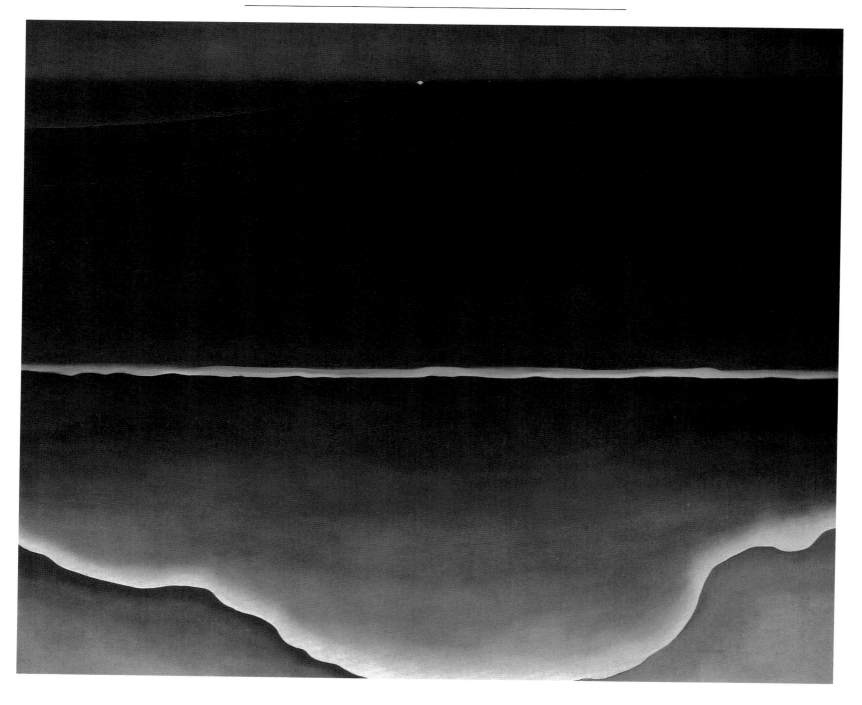

Wave, Night 1928
Oil on canvas, 30×36 inches
Gift of Charles L. Stillman,
© Addison Gallery of American Art,
Phillips Academy, Andover, MA (1947.33)

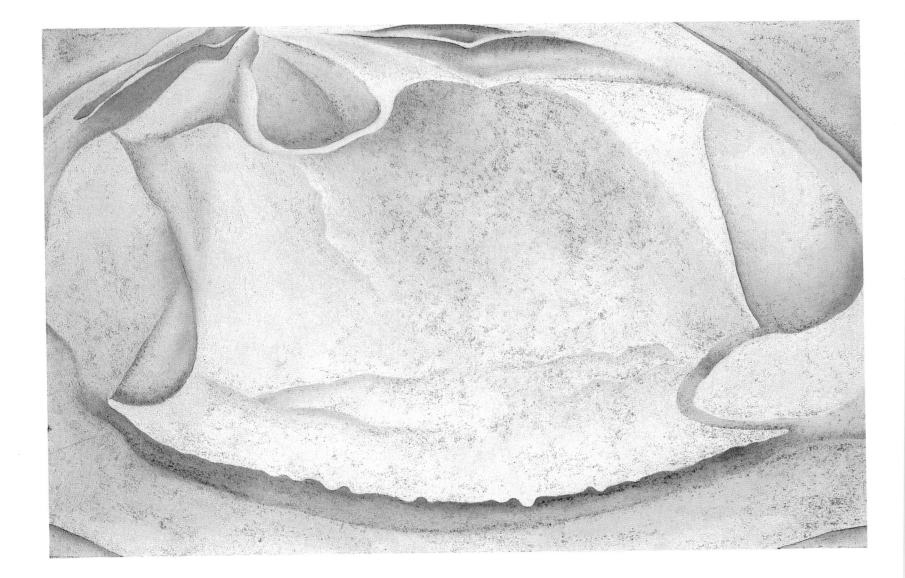

Clam Shell 1930
Oil on canvas, 24×36 inches
Alfred Stieglitz Collection, 1962,
The Metropolitan Museum of Art, New York, NY (62.258)

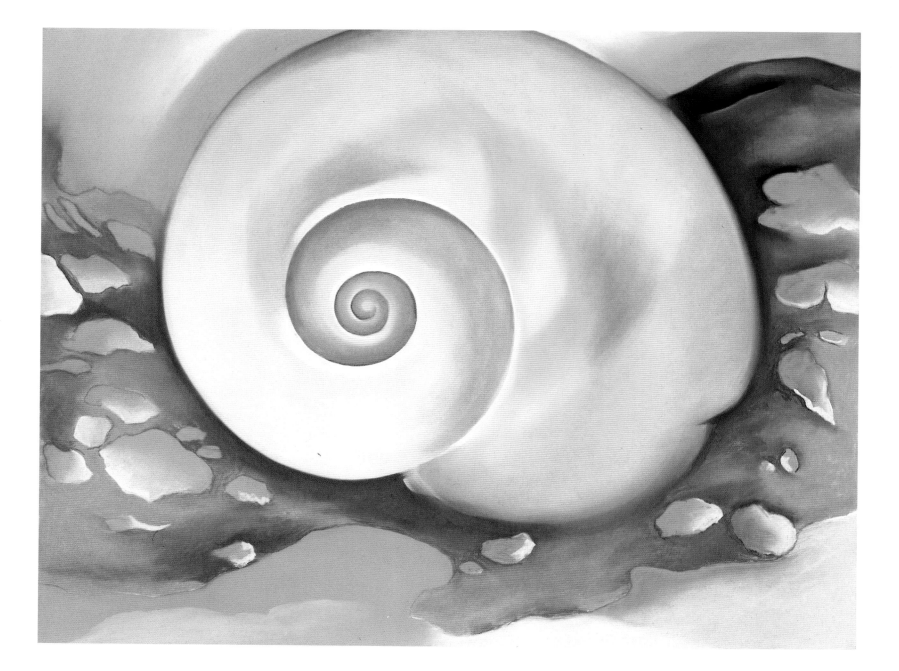

Pink Shell with Seaweed c.1937
Pastel, 22×28 inches
Mr. and Mrs. Norton S. Walbridge,
San Diego Museum of Art, San Diego, CA (1978.088)

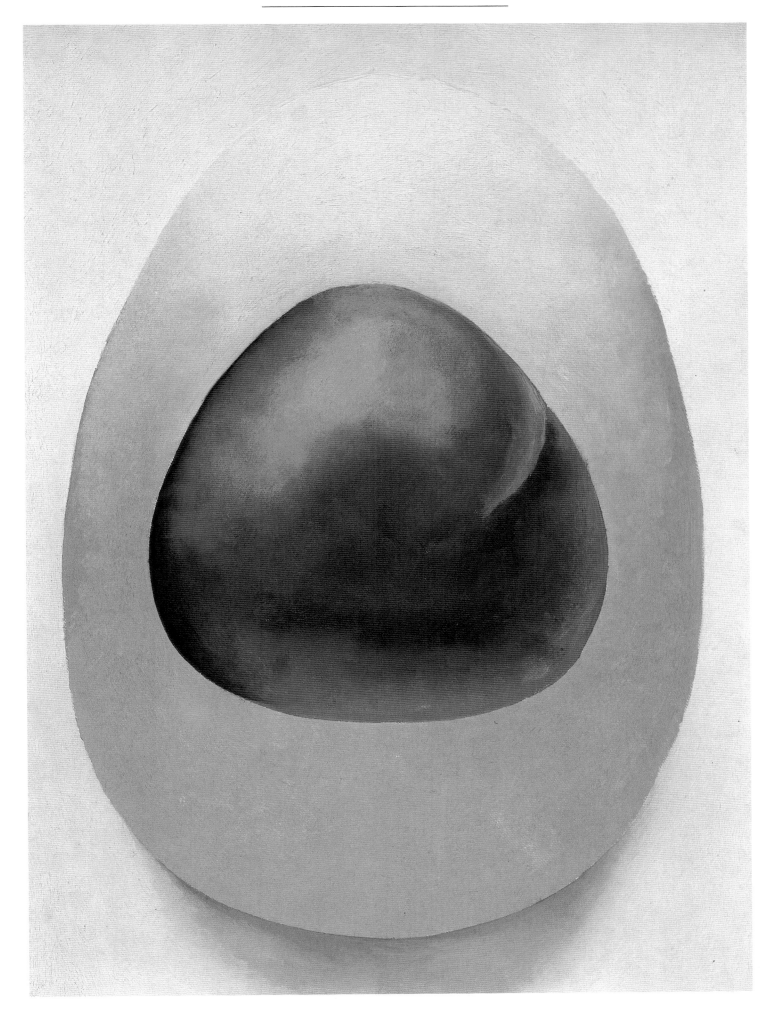

Above:
Red and Pink Rocks 1938
Oil on canvas, 18×13 inches
The Collection of James and Barbara Palmer

Right:
Red and Pink Rocks and Teeth 1938
Oil on canvas, 21×13 inches
Gift of Georgia O'Keeffe,
Photograph courtesy of The Art Institute of Chicago,
Chicago, IL (1955.1223)

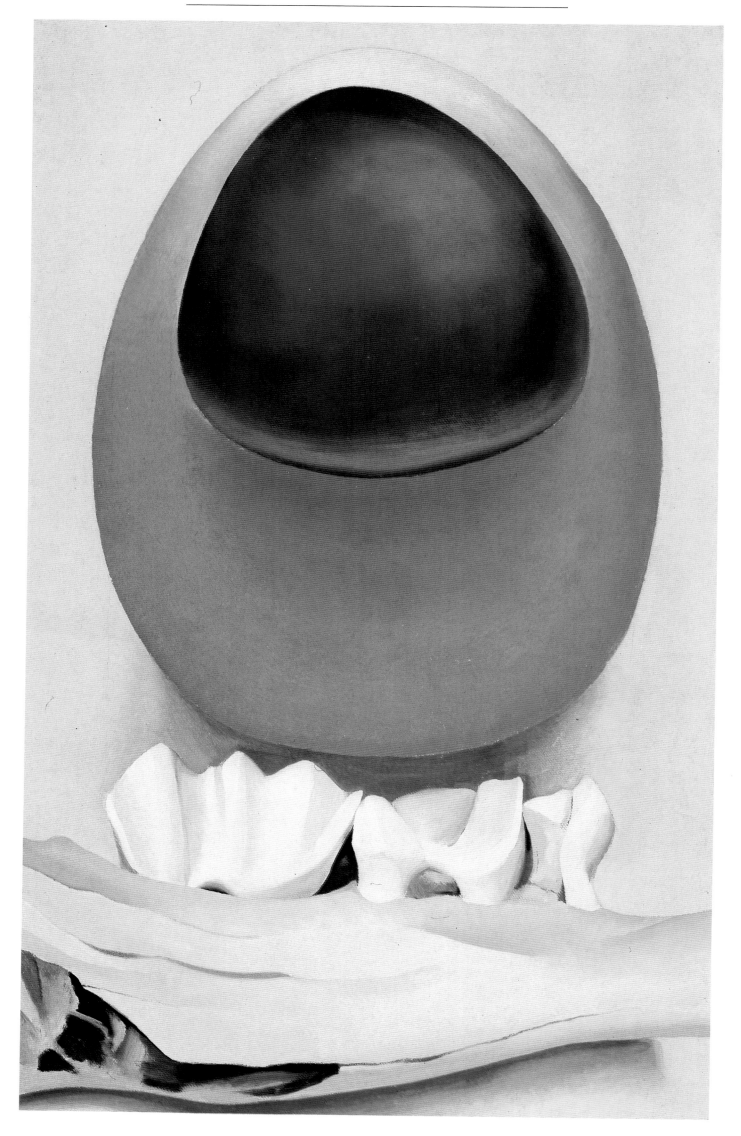

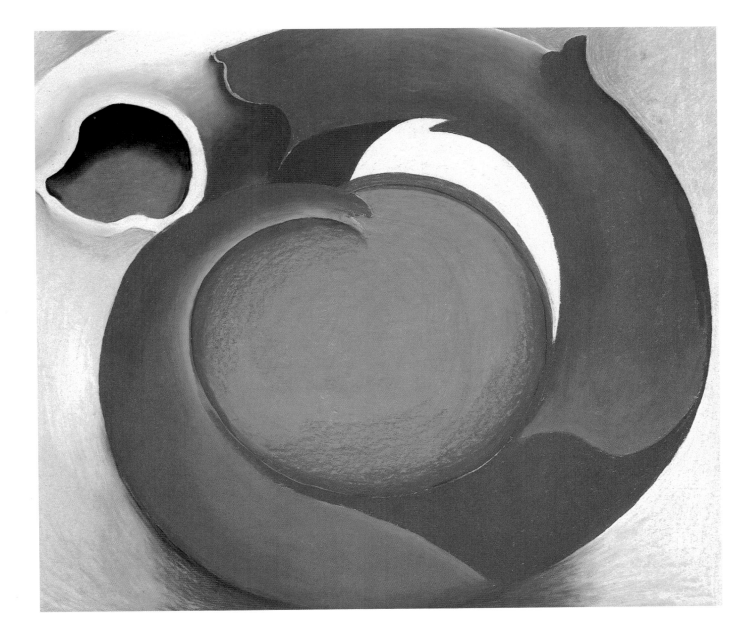

Goat's Horn with Red 1945
Pastel on paperboard, 27⅞ × 31¹¹⁄₁₆ inches
Gift of Joseph H. Hirshhorn, 1972,
Hirshhorn Museum and Sculpture Garden,
Smithsonian Institution, Washington, D.C. (HMSG 72.217)

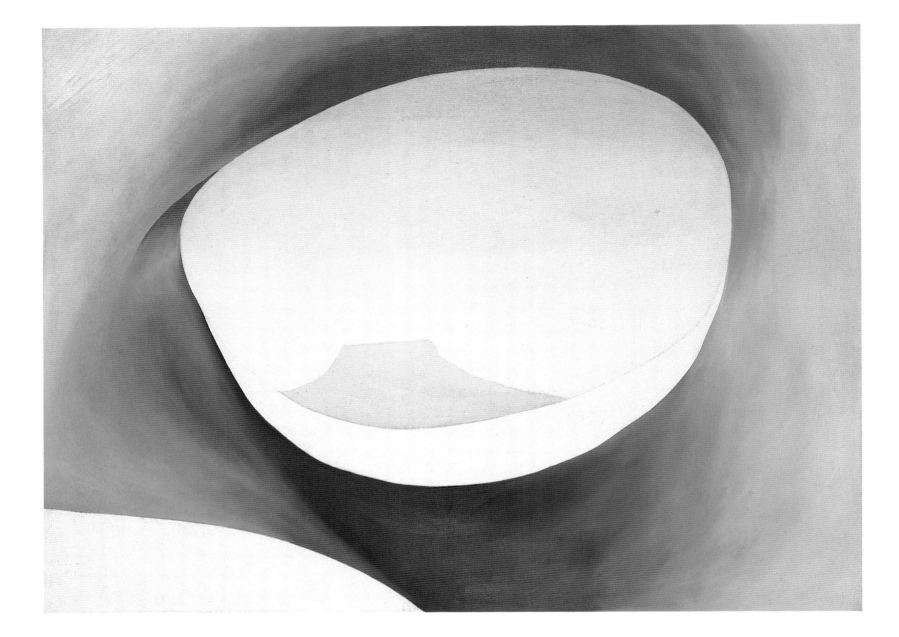

Pedernal – From the Ranch I 1956
Oil on canvas, 30½×40½ inches
Gift of Mr. and Mrs. John Cowles,
The Minneapolis Institute of Arts, Minneapolis, MN

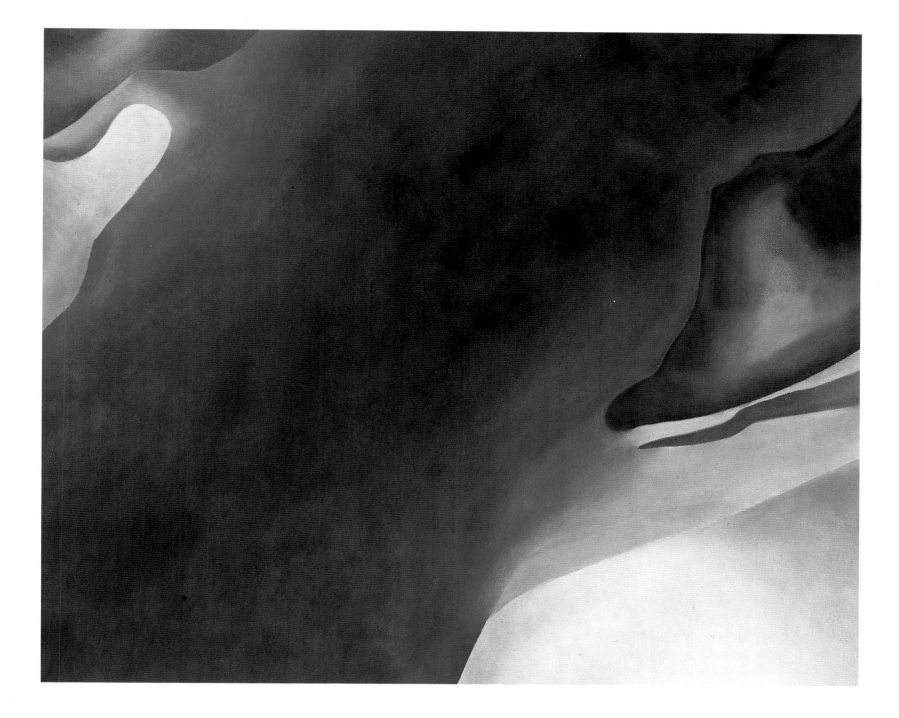

Blue B 1959
Oil on canvas, 30×36 inches
Gift of Mrs. Harry Lynde Bradley,
Milwaukee Art Museum, Milwaukee, WI

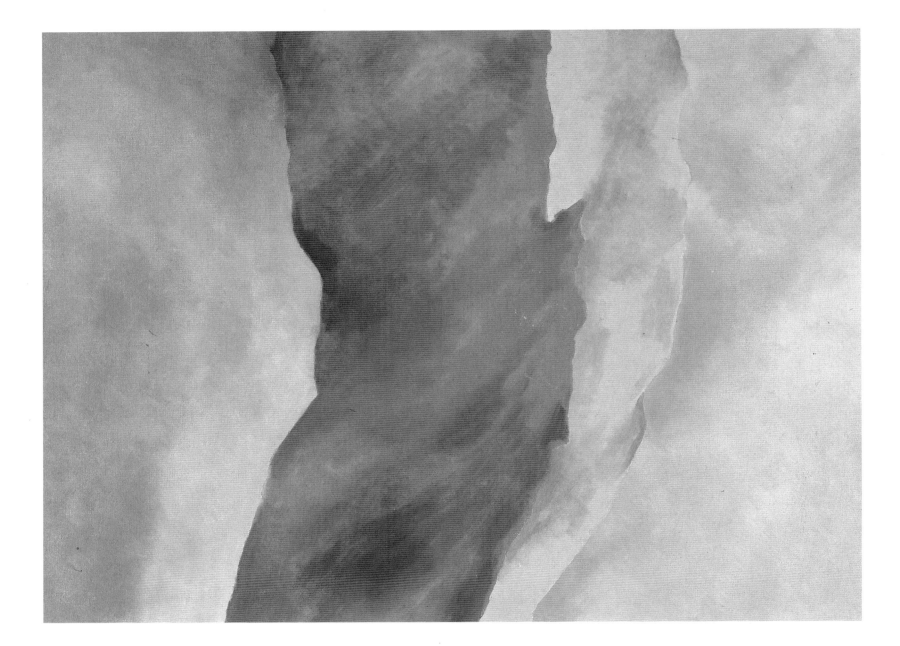

Overleaf:
It was Blue and Green 1960
Oil and canvas, 30×40 inches
Lawrence H. Bloedel Bequest,
Collection of The Whitney Museum of American Art, New York, NY
(77.1.37)

Above:
It was Red and Pink 1959
Oil on canvas, 30×40 inches
Gift of Mrs. Harry Lynde Bradley,
Milwaukee Art Museum, Milwaukee, WI

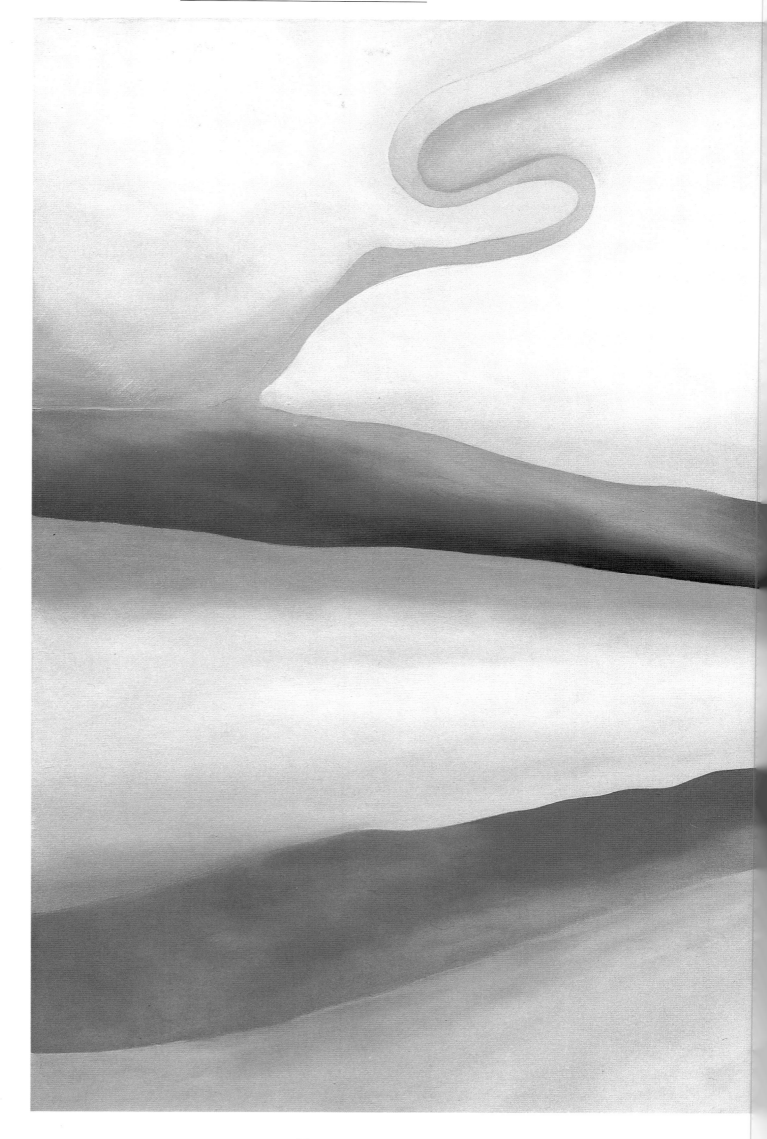

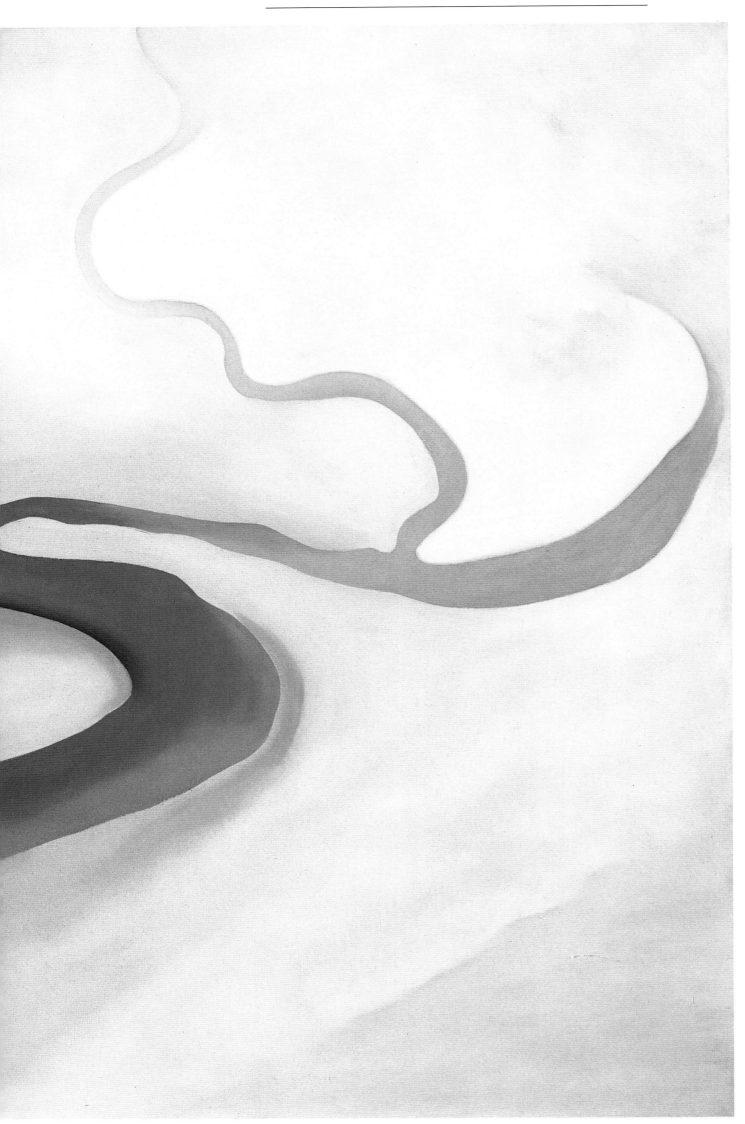

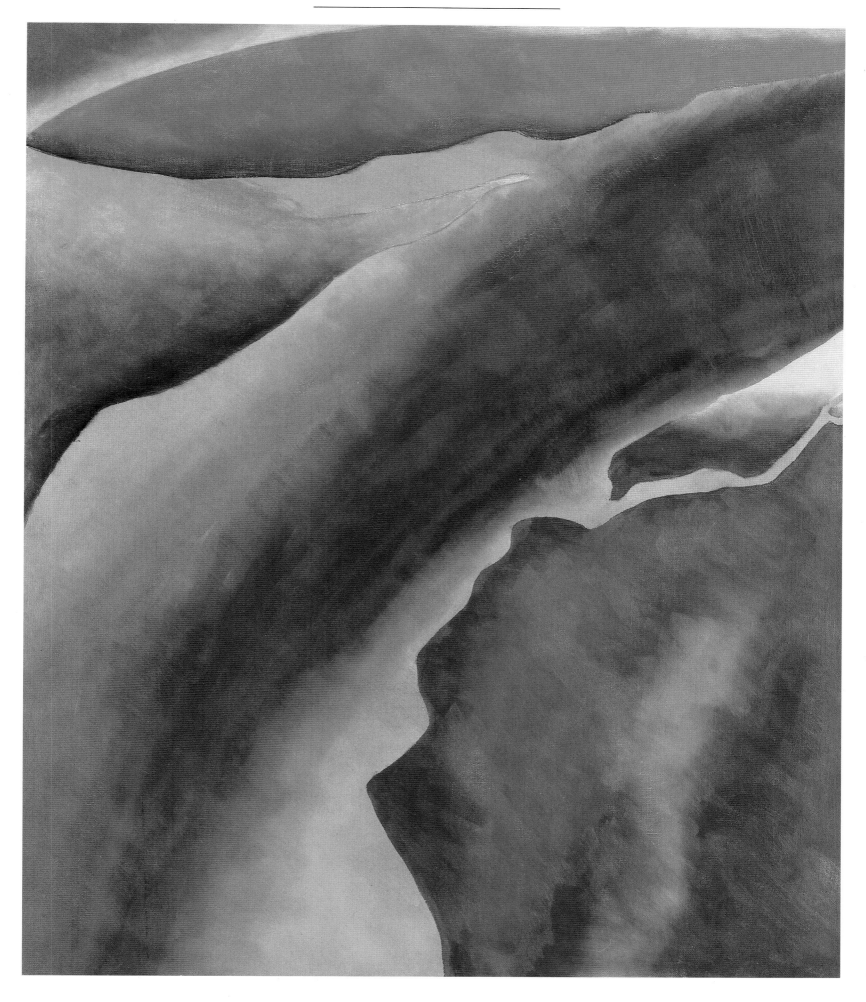

Only One 1959
Oil on canvas, 36×30⅛ inches
Gift of S. C. Johnson & Son, Inc.,
National Museum of American Art, Smithsonian Institution,
Washington, D.C./Art Resource, New York, NY (1969.47.69)

174

Sky Above Clouds IV 1965
Oil on canvas, 96×288 inches
Restricted Gift of The Paul and Gabriella Rosenbaum Foundation,
Gift of Georgia O'Keeffe, photograph © 1992,
The Art Institute of Chicago, Chicago, IL (1983.821)

LIST OF COLOR PLATES

Acknowledgments

The publisher would like to thank the following people for preparing this book: Martin Bristow, the designer; Clare Haworth-Maden, the editor; Susan Brown for production; and Sara Dunphy, the picture researcher.

All pictures were provided by the credited museum or gallery, except for those supplied by the following:

Archives of American Art, Smithsonian Institution, Washington, D.C.: page 10
The Art Institute of Chicago, All Rights Reserved, Photograph © 1993: page 40
The Bettmann Archive: pages 13, 28, 30-31, 32, 33, 35, 37, 47
Brompton Photo Library: pages 8-9
Gilman Paper Company: page 24
The Metropolitan Museum of Art, Alfred Stieglitz Collection, 1949 (49.55.45): page 25
Courtesy Museum of Fine Arts, Boston: page 22
State Historical Society of Wisconsin: page 6
University of Wisconsin-Madison Archives, Madison, WI: page 39
UPI/Bettmann Newsphotos: pages 1, 9, 17, 29, 34, 38, 44, 48, 49, 53
University of Virginia Library, Holsinger Studio Collection, Special Collections Department, Manuscripts Division: pages 15 (both), 19